S0-AFD-652

CHINESE PAINTINGS

IN THE ASHMOLEAN MUSEUM, OXFORD

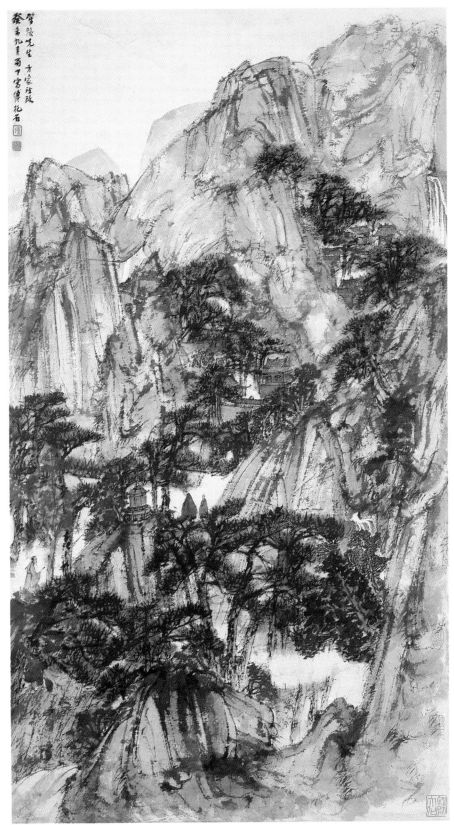

CHINESE PAINTINGS

IN THE ASHMOLEAN MUSEUM, OXFORD

SHELAGH VAINKER

ASHMOLEAN MUSEUM OXFORD
2000

This catalogue publishes the collection of Chinese paintings
in the Ashmolean Museum, with the exception of the
130 works presented in 1995 in honour of Jose Mauricio and
Angelita Trinidad Reyes, which are published separately in
*Modern Chinese Paintings: The Reyes Collection in the Ashmolean
Museum, Oxford* (Oxford, 1996). A complete list of the combined
collection appears at the end of this catalogue.

Text and illustrations
© Copyright the University of Oxford:
Ashmolean Museum, Oxford, 2000
All rights reserved
(Every effort has been made to trace all copyright owners and seek
their permission for the inclusion of their works in this catalogue. If any
copyright owner has been overlooked, and so notifies the Museum,
any error or omissions can then be corrected in future editions)

British Library Cataloguing in Publication Data
A catalogue record for this book is available from the British Library

ISBN 1 85444 132 9 (paperback)
ISBN 1 85444 145 0 (hardback)

Cover illustration: WU CHANGSHUO *Wisteria*
Catalogue number 138

Designed and set in Monotype Bembo by Behram Kapadia
Printed and bound in Singapore by Craft Print Intenational Ltd., 2000

CONTENTS

ACKNOWLEDGEMENTS

My first debt of gratitude is to Mary Tregear, who not only played a large part in the formation of the collection presented in this catalogue but also spent many hours introducing me to it in my first years at the Ashmolean. Her guidance has been invaluable. I have subsequently received assistance in the cataloguing from Katharine Bogle, in summer 1997, and with the inscriptions on the paintings from Zhang Hongxing, Hsiao Li-ling and James Lin, and to all of them I am grateful. I am indebted to Ellen Johnston Laing for valuable bibliographical advice, and to James Lin for additional help with final checking at proof stage. Dee Zhang typed the Chinese character text and the Ashmolean Museum Photographic Service photographed the entire collection. This book provides a companion volume to *Modern Chinese Paintings: the Reyes Collection in the Ashmolean Museum, Oxford* (1996) and I am particularly grateful to the anonymous benefactor who has helped with the production of both publications. The cataloguing of the Ashmolean's Chinese painting collection was undertaken over several years but its publication coincides with the opening in October 2000 of the Museum's Khoan and Michael Sullivan Gallery of Chinese Painting; I should like to express my thanks to its architects Joanna van Heyningen, Meryl Townley and James McCosh of van Heyningen and Haward, and above all to the benefactors, The Christensen Fund and an anonymous donor, who have made the gallery possible.

Shelagh Vainker
DEPARTMENT OF EASTERN ART

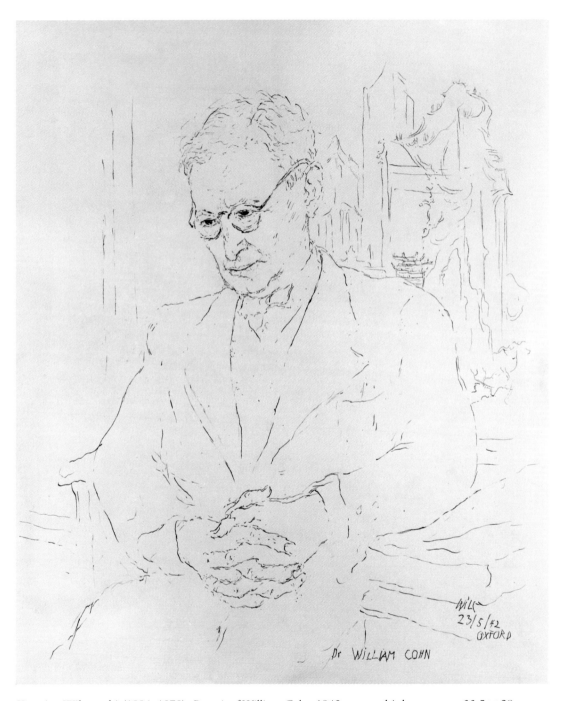

Katerina Wilczynski (1894–1978), *Portrait of William Cohn*, 1942, pen and ink on paper, 33.5 × 28 cm, one of a series of 73 drawings of Oxford figures. Ashmolean Museum, Department of Western Art.

INTRODUCTION: CHINESE PAINTING AND OXFORD, 1900–2000

THE BEGINNINGS OF CHINESE ART COLLECTING IN BRITAIN

The earliest Chinese paintings in the Ashmolean are dated shortly before the founding of the Museum itself in 1683 and yet, despite the coincidence of the collection's range with the Museum's existence, almost all the paintings have been acquired within the last fifty years. This has as much to say about the collecting of Chinese paintings in Europe as about Oxford in particular, for the arts of calligraphy and painting have long been and probably remain more demanding of the unfamiliar viewer than the porcelains, silks, carvings, metalwork and other objects which have been admired for so much longer outside China.

Paintings were not evident at all in British collections of Chinese art before the late nineteenth century and were systematically acquired in the two public collections to include them, the Ashmolean Museum and the British Museum, only from the late 1950s onwards. The collections differ in their scope and focus, for while the British Museum has since the 1880s been concerned with acquiring classical Chinese paintings[1] the Ashmolean, since the founding of the Department of Eastern Art in 1963, has built a collection centred on modern, often contemporary, works in the literati tradition. It is these paintings that form the main part of the present catalogue.

Prior to the Department's foundation the Ashmolean's Chinese collections formed part of the Department of Fine Art and comprised porcelain, metalwork and paintings in late nineteenth-century and early twentieth-century English

decorative taste. The porcelains thus belong to that class of well-potted, brightly decorated blue and white or enamelled wares produced between 1700 and 1800 to supply an expanding middle-class market in China and an increasingly middle-class one in England.[2] The metalwork is of similar date and came almost entirely from C. D. E. Fortnum, who presented his collection of Renaissance maiolica and bronzes to the Musuem in 1899. Fortnum's oriental bronzes were acquired as examples of technique, to round out his collection along with some classical bronzes, and are a mixture of Chinese and Japanese pieces.[3] The Chinese paintings are for the most part similarly anonymous and decorative: their subjects are principally figures, sometimes representing well-known narratives, and they are executed in bright colours on silk. As such their status in China would have been low, and indeed most of them are the sort of mass-produced works aimed at the market for foreigners working in or visiting China in the nineteenth and early twentieth centuries. They include paintings on paper made of the pith of the *tongcao* plant (often erroneously called 'rice' paper paintings) and decorative panels, and are usually designated 'export watercolours' or 'trade paintings'.[4] The two hundred or so trade paintings in the Ashmolean have been omitted from the present catalogue but are represented by a few, of slightly better quality, that appear in Appendix Two. Other groups of works acquired before 1962 and excluded from the catalogue are: paintings after Ming and Qing dynasty masters which are of insufficient quality to contribute to the study of those artists' *oeuvres*; calligraphy, as the holdings are modest; and rubbings, which represent a quite different category of graphic art. In addition to the rubbings the collection includes some woodblock prints, mainly popular pieces in low-quality materials, produced for festivities associated with the New Year.

The trade paintings, late copies and ink rubbings do not represent developments in the mainstream of Chinese art, nor, with a few exceptions, is it clear at what point in the early twentieth century they entered the Ashmolean Museum,[5] and yet they are all associated with an increasing

awareness of Chinese painting within British understanding of the Far East. An early collection of paintings acquired by a public collection in Britain was that of William Anderson of the Imperial Naval College, Tokyo, purchased by the British Museum in 1881, though the larger part of his collection consisted of Japanese painting.[6] The Chinese works were mostly figure, bird and flower paintings with very few landscapes, and this balance of subject matter still prevails in *Chinese Paintings in English Collections*,[7] published some forty years later by Laurence Binyon. Landscapes, which do form the mainstream of the Chinese painting tradition, were not displayed prominently or in quantity in Britain until the 1935–36 Chinese Exhibition at Burlington House, when, of more than three thousand objects, the 254 paintings included seventy-six landscapes, of which the greater part was lent by the Chinese government.[8] It seems that only later were landscapes collected in Britain on any significant scale, and so the figure paintings in the Ashmolean, if they did enter the Museum much before the founding of the Department of Eastern Art, are in keeping with English taste in Chinese art in the first part of the twentieth century. The same may be said of the *tongcao* pith paper paintings depicting trades, figures and flowers, often mounted in albums with pale blue ribbon borders. These arrived in England in considerable quantity as early as the eighteenth century and throughout the nineteenth, typically brought back by merchants involved in trading other commodities, to whom they may well have been offered for sale at the ports.

While the trade paintings represent a taste in Chinese painting generally shared amongst those who had any familiarity with things Chinese, the ink rubbings and copies after old masters illuminate a more ambitious acquaintance with Chinese culture. The ink rubbings are taken from a mixture of ancient stelae carved with inscriptions and images, and from newer stones re-cut for the purpose of replicating the texts, calligraphic styles and pictorial contents of the original stelae without wearing them away.[9] Most are from well-known monuments in the Beilin (Forest of Stelae), which

was founded in the Song dynasty at a Confucian temple in Xi'an, Shaanxi province, as a repository of important literary and official works,[10] and thus show some engagement on the part of those who collected them, with sinology and China's historical past. The copies of old masters meanwhile venerate not just those artists but also two ever-present and often overlapping currents in Chinese painting: studying from the classics, and simple deception.[11] Copies were produced partly because there was no tradition in China of the public display of painting, and the study of painting therefore depended on the practice to a certain extent; the complexities the consequent traditions of imitation presented to collectors of Chinese painting posed a particularly acute challenge to foreigners, since so little writing on the subject was available in European languages, and, furthermore, identification of paintings is closely tied to the inscriptions and seals they bear.[12] Though the collections of George Eumorfopoulos[13] and Sir Percival David did include early paintings, these did not remotely approach the importance of their ceramic collections, which included numerous pieces from the former Imperial collection. Eumorfopoulos's paintings were sold to the national museums in London in 1935 along with the bulk of his ceramics, bronzes and other objects, while Sir Percival David's were not included in the great gift of his ceramics collection to London University in 1952 but remained part of his private collection; the best of these were purchased by the Metropolitan Museum, New York, in the late 1970s.[14] A more recent collection of both porcelain and painting, though quite different in taste, was that of Gerald Reitlinger. His bequest to the Ashmolean in 1978 of several thousand Chinese, Japanese, Islamic and European ceramics was accompanied by some fifty trade paintings (not included in the catalogue), so that the balance if not the content of the collection is in keeping with the slightly earlier collecting of Chinese art in England.

THE STUDY OF CHINESE ART

The study of Chinese art in Oxford can be said to have been initiated and developed by one man, William Cohn. Born in 1880, Cohn arrived in Oxford in 1938 after an already lengthy academic career in Berlin to become Adviser to the University in Eastern Art and later, from 1948 until his retirement in 1955, Director of the Museum of Eastern Art. He was born and educated in Berlin, studying art history (under Wölfflin), archaeology and East Asian ethnology, and, as a postgraduate, philosophy; in his twenties and thirties he travelled in India, Southeast Asia, China, Japan and the USA, and his subsequent publications on Asian art were wide-ranging. He concentrated on Indian art, and the painting and Buddhist sculpture of China and Japan, while editing several academic journals. In 1912 he founded, and until 1935 co-edited with Otto Kümmel, the *Ostasiatische Zeitschrift*; from 1921 he was editor of the eleven-volume series *Die Kunst des Osten*, and from 1924 he co-edited the *Jahrbuch der Asiatischen Kunst*. In 1929 he was appointed curator in the Department of East Asian Art in the Volkerkundemuseum of the Berlin State Museums, and from 1934 to 1938 continued in that museum as Secretary to the Society for East Asian Art (Gesellschaft der Asiatischen Kunst). There is no detailed record of Cohn's curatorial work, but it is clear from Chinese sources that he was instrumental in the setting up of an important loan exhibition of modern paintings from China under the auspices of the Chinese government. According to one account, the exhibition was conceived when Cohn asked during a seminar in Berlin by the painter Liu Haisu whether it might be possible for him to bring real paintings from China to Berlin to illustrate future lectures.[15] Liu Haisu's own preface to one of the three publications accompanying the exhibition mentions Cohn as one of a group of scholars involved in planning the exhibition,[16] while a copy of another now in the University's Eastern Art Library bears a dedication, in his own calligraphy, from Liu to Cohn.[16] A third, much smaller,

catalogue includes a complete list of the works displayed; since between 1933 and 1935 both Liu Haisu and the painter Xu Beihong set up exhibitions of their own paintings and of Chinese painting in general in cities throughout Europe,[18] the complete list can be used to trace which works were sold and which continued on tour, or were added.

The exhibition had been shown in several German cities, and it seems that, in terms of exhibitions and private collections, Germany was more active in the field of modern paintings, at least, than England at the same period. Understanding of Chinese painting in general was due largely to the work of Cohn himself, and of his erstwhile co-editor and colleague Otto Kümmel,[19] and also of Otto Fischer. All three wrote about Indian, Chinese and Japanese art, though Fischer wrote specifically on Chinese painting as well. At the time of Cohn's arrival in Oxford, English scholarship on Chinese painting was in a slightly different situation from that in Germany, for while Cohn, Kümmel and Fischer all worked exclusively in the field of East Asian art, none of the English writers on the subject was primarily an historian of oriental art. The most prolific was Laurence Binyon (1869–1943), whose *Flight of the Dragon* (London, 1911), for example, provided an early introduction for English readers to what was an extremely remote subject. Binyon was in charge of the sub-department of oriental prints and drawings at the British Museum from 1913 until 1933, following twenty years in the departments of printed books, and of prints and drawings. He continued to write on European art and is indeed, despite his prominence in the field of Chinese art history, best known for his work on English watercolours and for his plays and poems, most notably *For the Fallen* (1914), which continues to be recited on Remembrance Day each year.[20]

In 1925 Binyon contributed the section on painting to *Chinese Art: an Introduction*, which was published as a Burlington Magazine Monograph with an introductory essay on Chinese art by Roger Fry (1866–1934), editor of *The Burlington Magazine*. Fry, a champion of modern art and

also uncommonly receptive to non-European art, was enthusiastic about Chinese art, even calling in an essay published in 1926[21] for greater commitment to the Far East on the part of the national museums. In the same year that the Burlington Monograph appeared, he contributed to an informal collaborative handscroll with some of the most distinguished Chinese artists of the day.[22] There is no later evidence for Fry's interest in Chinese painting; the claim in a Chinese source that he attended a preview of the 1935 New Burlington Galleries exhibition at the Chinese Ambassador's residence[23] is impossible, and though his Slade Lectures at Cambridge in 1933–4 include Chinese art, his discussions are limited to Buddhist sculpture and ancient bronzes, the latter having become a particular enthusiasm.[24] While as an English painter and art critic Fry undoubtedly was ahead of his contemporaries in recognising the strength of the Chinese painting tradition, his comments on the subject in his collection of writings *Vision and Design* imply that in fact he regarded Chinese art as one more example of the purity of line and form evident in African, early American and other Primitive art.[25] Indeed his private collection included almost as much African sculpture as Chinese ceramics and bronzes, and seems to have omitted Chinese paintings entirely.[26]

While Binyon and Fry wrote effectively about Chinese painting from the standpoint of European art history and criticism, the great linguist Arthur Waley (1889–1966) brought a sinological view to the subject. Though Waley was in the British Museum sub-department of oriental prints and drawings from 1912 to 1929, during which time he catalogued the Buddhist paintings brought from Central Asia by Sir Aurel Stein and wrote *An Introduction to the Study of Chinese Painting*, he, like Binyon, is better known for other work. His translations from Chinese and Japanese literature were more prolific by far than his writings on Chinese art, and earned him added recognition as a poet.

Waley, self-taught in both Chinese and Japanese, was in fact one of the outstanding sinologists of the early twentieth

century in Britain. He never accepted a university post –
indeed there were few posts in Chinese language and
literature in British universities, where it was very much less
established as an academic discipline than in Germany.[27] At
the time of Cohn's arrival, the Oxford chair in Chinese,
founded in 1876, was held *in absentia* by Ye Keyin, though
the following year an Honours School in Chinese was estab-
lished. There was a reasonable holding of Chinese books, the
Bodleian having accepted successive gifts since the seven-
teenth century from scholars, former missionaries and
colonial servants in China, most notably Edmund
Backhouse. The holdings on Chinese art were, however,
negligible, the core collection of the University's present
Eastern Art Library being none other than Wiliam Cohn's
own library. Cohn's first years in Oxford were spent con-
ducting independent research, and included a spell working
in the British Museum; it was not until June 1946 that the
University appointed him as Adviser in Eastern Art. The idea
of an oriental museum was already under discussion within
the University,[28] and this duly opened in November 1949 as
the Museum of Eastern Art on one floor of the Indian
Institute (now the Modern History Faculty) in Broad Street.
It was described in the *University Handbook* of 1952: '.....it
contains the joint collections of Asiatic Art (representing
India, Pakistan, Burma, Ceylon, Siam, Indo-China,
Indonesia, China, Japan, Korea, Tibet and Islam) of the
Ashmolean Museum and the Indian Institute, acquired
mostly by gift or loan from old members of the University.
Indian Sculpture, and Chinese and Islamic Ceramics and
Metalworks are particularly well represented.' It was here
that Cohn worked until his retirement in 1955.

THE DEPARTMENT OF EASTERN ART

Peter Swann (1921–97), who had been assistant to William
Cohn for several years, was appointed to succeed him. The
teaching of Chinese art begun by Cohn as informal seminars

was continued by him, more often as supervision of individual students, and has since become an established part of the teaching of the Faculty of Oriental Studies. Swann had more success in acquiring objects by purchase than Cohn had enjoyed, but also oversaw the gift by Sir Herbert Ingram of his substantial collection of early bronzes, jades and ceramics which still forms the main part of the Museum's pre-Ming Chinese collections; he also oversaw the establishment of the Department of Eastern Art within the Ashmolean in 1963, when the Indian Institute and Ashmolean oriental collections were combined. Swann was particularly interested in painting, and a large proportion of the works in this catalogue was acquired during the period of his keepership (1955–65), assisted from 1962 by Mary Tregear, who joined the Department from Hong Kong University Museum. The difficulties of authentication, expense and availability associated with early paintings, so lamented by Binyon in the 1920s,[29] applied no less thirty years later, and it was decided to concentrate the collection on later Chinese paintings, to which these hindrances applied in much lesser degree.

The paintings in the present catalogue are therefore mostly in the traditional medium of ink and colour on paper, and represent the literati tradition as it developed from the late nineteenth century. That same period saw the emergence of new styles of traditional painting centred in Shanghai and Guangzhou (Canton) while more conservative styles prevailed in Peking. The map on p. 21, showing the birthplaces of artists represented in the Museum's collection, gives an indication of this regional development, while confirming the persistent prominence of the eastern region for poets, painters and scholars. The question of authentication has been less pressing in this field, particularly so since many of the paintings by modern artists were acquired before their work began to be faked; the paintings that follow are considered to be genuine either for that reason, or because there is or has been sufficient opinion in favour of their authenticity, in a field where debate about individual paintings can continue over decades and generations.

The early 1960s was the period when many of the major modern works in the Museum were acquired. They were bought mostly from Collett's in London, then run by Mary Shen, who bought direct from China (the gallery, now called Jimei Zhai Eastern Art Gallery, is still run by Mary Shen's partner Colette Hawes). The upheavals of the Cultural Revolution (1966–76) however meant that by the late 1960s, paintings were no longer available from the Chinese mainland, and this is reflected to some extent in the rate of acquisition by the Ashmolean. The Museum continued to purchase paintings, but more intermittently, and more often from private collections. By the time of her retirement in 1991, Mary Tregear had not only acquired some of the finest paintings in the collection,[30] but also extended it back into the late Qing period with a number of nineteenth century and earlier works. Since then the Museum has continued to purchase paintings, but the most significant development has been the gift in 1995 of 130 modern paintings presented in honour of Jose Mauricio and Angelita Trinidad Reyes.[31] This important group, published in 1996, complements the collection in the present catalogue and extends it again, by including some works by young artists painting at the end of the twentieth century.[32]

NOTES

1. For the early history of the British Museum's collection of Chinese painting see R. Whitfeld, 'Landmarks in the Collection and Study of Chinese Art in Great Britain', in M. Wilson and J. Cayley, ed., *Europe Studies China: Papers from an International Conference on The History of European Sinology*, London, 1995, pp.202–214.

2. The main bequests were Farrer (1947), and Mallett (1948). For the status of these ceramics within China see S. Vainker, 'Luxuries or Not? Consumption of Silk and Porcelain in Eighteenth Century China' in M. Berg and E. Eger, ed., *Luxury: A Cultural History*, Oxford, Macmillan (forthcoming).

3. J. Warren, *Renaissance Master Bronzes from the Ashmolean Museum, Oxford: the Fortnum Collection*, Oxford, 1999. Catalogue no.45 is a Chinese inlaid bronze vessel.

4. For eighteenth-century and nineteenth-century export paintings see C. Clunas, *Chinese Export Watercolours*, London, Victoria and Albert Museum, 1984. See pp. 77 and 80 for types of paper.

5. Approximately one thousand oriental acquisitions by the Department of Fine Art are recorded in the Museum's *Annual Reports* between 1900 and 1950, though these include only five Chinese paintings.

6. See W. Anderson, *Descriptive and Historical Catalogue of a Collection of Japanese and Chinese Paintings in the British Museum*, London, 1886.

7. L. Binyon, *Chinese Paintings in English Collections*, Paris and Brussels, 1927.

8. F. Wood, 'From Ships' Captains to the Bloomsbury Group: the late arrival of Chinese Paintings in Europe', *Transactions of the Oriental Ceramic Society* 61 (1996–7), pp.121–131; pp.123–6 gives details of the statistics of this exhibition and of the ratio of decorative to landscape paintings in British collections. See also the exhibition catalogue *International Exhibition of Chinese Art*, London, Royal Academy of Arts, London, 1935.

9. There are also rubbings taken from pottery tiles. A gift of twelve such rubbings is recorded from the archaeologist Cheng Te-Kun in 1947, and a further group from Professor C. S. Lo in 1948.

10. I am grateful to Jean-Pierre Drege, Paris, for his identification of the rubbings in the Ashmolean Museum during the period of his research in Oxford in December 1998.

11. The issue of imitation has informed or been the subject of much scholarship on the history of Chinese painting. J. Stanley-Baker, *Old Masters Repainted: Wu Zhen (1280–1354) Prime Objects and Accretions*, Hong Kong, 1995, provides a penetrating study. Richard Wollheim's discussion of textuality and borrowing in *Painting as an Art*, Washington, D.C., 1987 pp.187–204, although giving Poussin as example might also be applied to Chinese painting of the seventeenth century.

12. The introduction in L. Binyon, *The George Eumorfopoulos Collection: Catalogue of the Chinese, Corean and Siamese Paintings*, London, 1928 elaborates on the difficulties of collecting Chinese painting, which in fact anticipate the rationale in Oxford some thirty years later for collecting modern, rather than classical, works.

13. Most of the Eumorfopoulos Collection, comprising paintings, sculpture, bronzes, jades and ceramics, was sold to the nation, divided equally between the British Museum and the Victoria and Albert Museum, in 1935–6. Some three hundred ceramics were offered for sale. See Bluett & Sons, *Eumorfopoulos Collection: Exhibition of the Chinese Pottery and Porcelain available for private purchase*, London, 1935.

14. Whitfeld, *op. cit.*, n.8.

15. Ke Wenhui, ed., *Yishu dashi Liu Haisu zhuan*, Jinan, 1986, p.195.

16. Liu Haisu, *Bolin renwen bowuguan suocang zhongguo xiandai minghua ji*, preface dated Shanghai, 1936, reprinted in series Wang Yunwu, ed., *Jingyin lidai shuhua zhenpin di yi ji di sanshiyi zhong*, Taipei, 1976.

17. *Chinesische Malerei der Gegenwart*, Berlin, 1934. The inscription is dated 30 May 1934.

18. See S. Vainker, 'Exhibitions of Modern Chinese Painting in Europe, 1933–1935', in Cao Yiqiang and Fan Jingzhong, ed., *Chinese Painting and the Twentieth Century: Creativity in the Aftermath of Tradition*, Hangzhou, 1997, pp.554–561.

19. For Kümmel's formation of a major public collection, see L. Ledderose, 'Collecting Chinese Painting in Berlin', in M. Wilson and J. Cayley, ed., *Europe Studies China: Papers from an International Conference on The History of European Sinology*, London, 1995, pp.175–201.

20. J. Hatcher, *Laurence Binyon: poet, scholar of East and West*, Oxford, 1995.

21. R. Fry, 'Art and the State', in *Transformations: Critical and Speculative Essays on Art*, London, 1926, p.53.

22. M. Sullivan, 'A Small Token of Friendship', *Oriental Art* NS XXXV no. 2 (Summer 1989), pp.76–85.

23. Ke Wenhui, *op. cit.*, p.219 . This event took place four months after Fry's death in September 1934, and is indicative therefore of a wish for recognition for Chinese painting on the part of major Western figures. The same source claims that while in Berlin in 1934, Liu Haisu visited Käthe Kollwitz. Kollwitz at that time was living virtually in hiding, and no mention of Liu and his companions is recorded in her *Tagebücher: Briefe an den Sohn, 1904 bis 1945*, Berlin, 1992.

24. *Roger Fry: Last Lectures*, with an introduction by Kenneth Clark, Cambridge, 1939, pp.97–132. Clark states in the introduction that at the time of his death Fry had been intending to write a historical survey of art up to modern times, though it is not clear whether this might have included Chinese painting. The mid-1920s have been described as a period when Fry was particularly open-minded – see F. Spalding, *Roger Fry: Art and Life*, Berkeley and Los Angeles, 1980, p.247.

25. R. Fry, *Vision and Design*, London, 1920, pp.32, 97, 103, 110–113.

26. C. Green, *Art Made Modern: Roger Fry's Vision of Art*, London, 1999. See also C. Reed, 'The Fry Collection at the Courtauld Institute Galleries', *The Burlington Magazine* CXXXII no. 1052 (November 1990), pp.766–772.

27. T. Barrett, *Singular Listlessness: a Short History of Chinese Books and British Scholars*, London, 1989, pp.73–4.

28. Letter from K. T. Parker to W. Cohn, 3rd July 1946.

29. See note 12.

30. Most notably the Zha Shibiao album, Cat. nos.157–160, formerly in the collection of Ling Su-hua, for whom see Oxford 1983 in the Bibliography.

31. S. Vainker, *Modern Chinese Paintings: The Reyes Collection in the Ashmolean Museum*, Oxford, Oxford, 1996.

32. See S. Vainker, 'Modern Chinese Painting in the Ashmolean Museum', *Oriental Art* XLII No. 3 (Autumn 1996), pp.3–10.

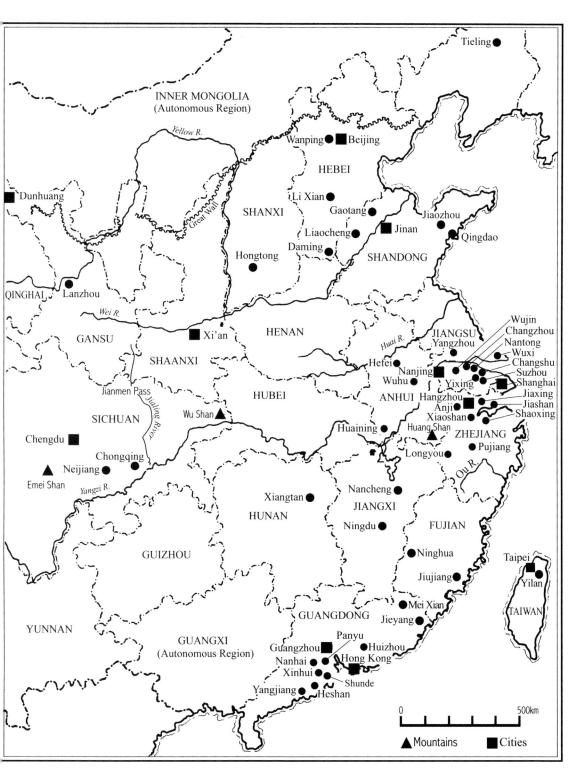

Map of China showing the birthplaces of artists represented in the catalogue

NOTE
TO THE CATALOGUE

The Chinese paintings in the Ashmolean Museum are mostly nineteenth and twentieth century in date, with only a few examples from the Ming (1368–1644) and earlier part of the Qing (1644–1911) dynasties. The catalogue is not therefore divided according to period, but lists artists alphabetically according to the romanization in *pinyin* of their names. Where artists not from the mainland are known by other romanizations, they appear under that name, with the *pinyin* equivalent being given below. Artists' alternative names, *zi* and *hao*, appear following the principal name in both romanization and Chinese characters. Inscriptions are reproduced in Chinese characters as completely as transcription and computer programmes allow; dates and occasionally other information are included in the catalogue entries, otherwise the inscriptions are not translated. Seals are listed by number and where they belong to the artist, that is indicated. Artists' biographies are followed by bibliographic references to monographs and exhibition catalogues.

THE CATALOGUE

CHAN, PAUL TAI-WAI 陳大衛

b. 1937

Paul Chan was a pupil of Lui Shou-kwan (Cat. nos. 85–99), with whom he studied painting in Hong Kong from 1968 to 1972. His paintings follow Lui's Chan (Zen) Buddhist style rather than his linear, more calligraphic works. He lives in Oxford, where he practises and teaches traditional Chinese painting.

1 Essence of Lotus

C.1970
INK ON PAPER
SIGNED: 大衛
ARTIST'S SEAL
45.7 × 30.9 CM
EA 1971.19
Given by the artist
Exhibited: Ashmolean Museum, Oxford, 1971

2 Form

1970
INK AND COLOUR ON PAPER
SIGNED: 大衛
ARTIST'S SEAL
87.3 × 37.5 CM
EA 1999.52
Given by the artist

Exhibited: Hong Kong, City Hall, October 1970; Ashmolean Museum, Oxford, 1971; Birmingham, Barber Institute, November 1998–January 1999

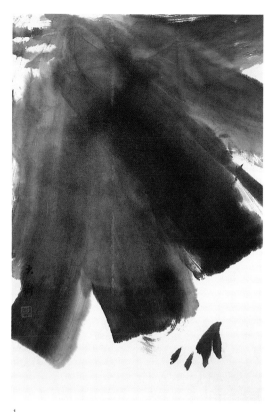

1

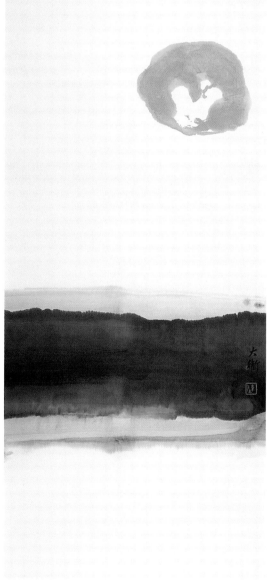

2

CHEN CHI KWAN 陳其寬

Chen Qikuan

b. 1921

Chen Chi Kwan was born in Peking in 1921 but spent his youth in Sichuan province, where he qualified as an architect in 1944, at the Central University then displaced from the capital Nanking. In the 1950s he worked in the United States as both an architect, including a stint as instructor in architecture at Massachussetts Institute of Technology, and as a painter; he has been equally involved in both fields in Taiwan, where he now lives.

Chen 1981; Rahman-Steinert 1996

3 Toleration

1995

ALBUM LEAF MOUNTED AS A HANGING SCROLL, INK AND COLOUR ON PAPER

SIGNED: 陳其寬寫

ARTIST'S SEAL

34.3 × 45.2 CM

EA 1999.51

Given by the artist

Exhibited: Ashmolean Museum, Oxford, 1999

CHEN CHONGGUANG 陳崇光

zi Ruo Mu 若木

1839–1896

Chen Chongguang was born in Yangzhou, Jiangsu province. Before studying painting, he worked as a woodcarver.

4 The hero's happy encounter

1878

HANGING SCROLL, INK AND SLIGHT COLOUR ON PAPER

INSCRIBED: 英雄奇遇圖 戊寅秋月 若木 陳崇光

ARTIST'S SEAL

126 × 52 CM

EA 1966.85

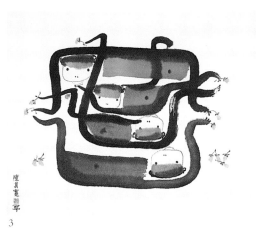

陸其寬瓢壺

3

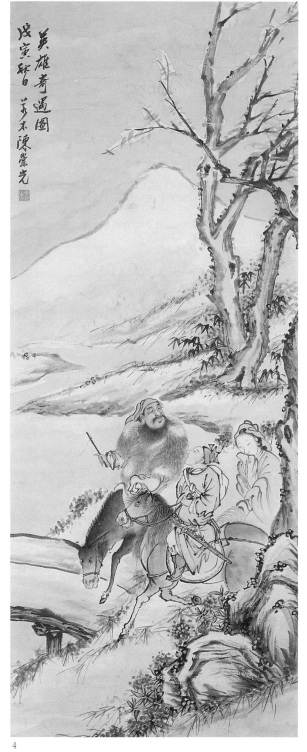

英雄奇遇圖
戊寅暮春
芋禾陳崇光

4

CHEN FEN 陳芬
zi Bo Xin 柏心
Qing dynasty

Chen Fen was from Panyu (now Guangzhou) in Guangdong province. He specialised in bird and flower painting and was a prominent pupil of the leading Guangzhou painter Ju Lian (1828–1904), three of whose other followers went on to found the Lingnan School.

5　Plum blossom amid praying mantis

1881
FAN PAINTING, INK AND COLOUR ON PAPER
INSCRIBED: 少舫二兄大人法家指正辛巳夏月　陳芬
ARTIST'S SEAL; ONE FURTHER SEAL
D. 52.7 CM
EA 1966.200

CHEN HENGKE 陳衡恪
zi Shi Zeng 師曾 ; *hao* Xu Zhe 朽者 ,
Xu dao ren 朽道人
1876–1923

Chen Hengke was born into a prominent literati family from Xiushui (then Yining) in Jiangxi province. As an artist he was particularly interested in the late Ming and early Qing Individualist painters, many of whose works he encountered in Japanese collections while he was a student in Tokyo. On his return he taught at Nantong in Jiangsu province and at Changsha in Hunan; later he was active in Peking, where he taught and where in 1920 he founded the Society for Chinese Painting. He helped establish Qi Baishi as a mainstream artist, and to further the acceptance of the Shanghai School painters.

6　*The pine and the chrysanthemum endure*

HANGING SCROLL, INK AND SLIGHT COLOUR ON PAPER
INSCRIBED: 松菊猶存　醒俠仁兄屬　陳衡恪
TWO SEALS OF THE ARTIST; ONE FURTHER SEAL
101.7 × 37.5 CM
EA 1969.63

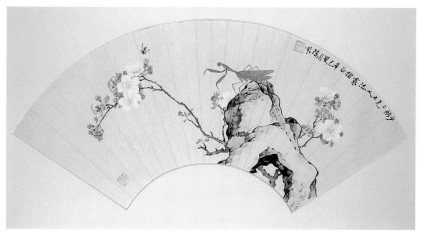

5

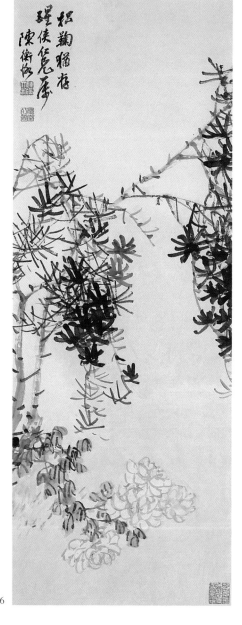

6

CHEN TIANXIAO 陳天嘯

Active early 20th century

Chen Tianxiao, from Lingdong, is best known for mounting an exhibition of modern paintings in Shanghai, which earned him the admiration of such leading figures as Cai Yuanpei and Wang Zhen.

7 Fish amongst waterweed

1935
HANGING SCROLL, INK AND COLOUR ON PAPER
INSCRIBED:
洋洋手得其所哉得其所哉馬衞康先生雅屬三十四年夏　陳天嘯寫
ARTIST'S SEAL; ONE FURTHER SEAL
90 × 31.5 CM
EA 1960.237

CHEN WENXI 陳文希

1906–1991

Chen Wenxi was from Jieyang in Guangdong but at the age of sixteen moved to Shanghai, where his teachers at the Xinhua Academy included Pan Tianshou. He graduated in 1932, and taught and exhibited throughout south China and southeast Asia. His work includes oils and paintings combining Chinese and Western styles, as well as those in traditional Chinese technique. In 1949 he settled in Singapore, where he was lecturer at the Nanyang College of Fine Arts.
Singapore 1949; Chen 1964.

8 Bamboo and squirrels

HANGING SCROLL, INK AND COLOUR ON PAPER
SIGNED: 文希□
ARTIST'S SEAL
133 × 33.5 CM
EA 1967.151
Given by the artist

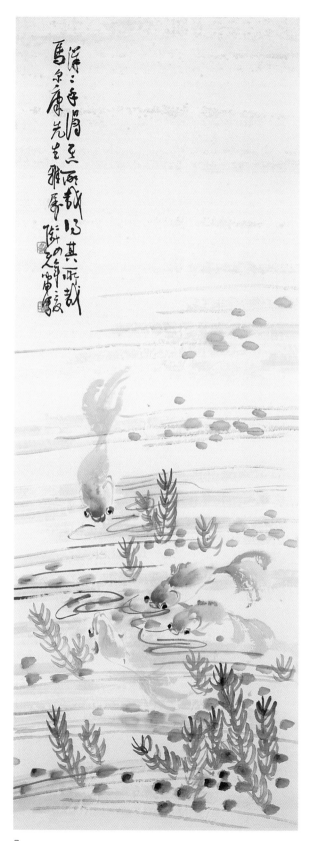

7

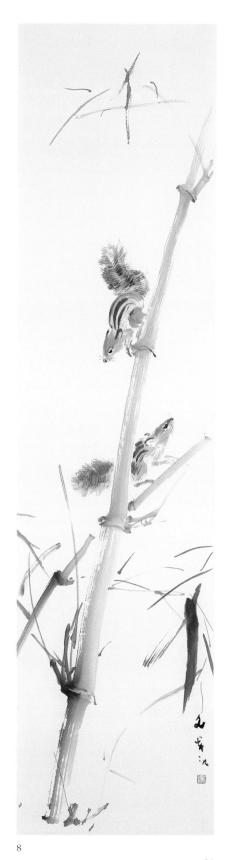

8

CHEN ZHE 陳者
zi Ming An 明庵
20th century

Chen Zhe was active in Peking during the 1930s, and painted in a conservative style. The present work is dedicated to Ling Su-hua.

9 Landscape

1961
HANGING SCROLL, INK AND COLOUR ON PAPER
INSCRIBED: 叔華先生大雅法正　　一九六一年二月子明　陳哲
TWO SEALS
66 × 33.3 CM
EA 1981.50
Given by Ling Su-hua

CHENG SHIFA 程十髮
b. 1921

Cheng Shifa was born in Songjiang county in the vicinity of Shanghai. He studied traditional Chinese painting at Shanghai Art Academy in the late 1930s, and subsequently earned a living through book illustration and New Year pictures. He concentrated on figure painting, in which he was influenced by Ren Yi, and after visiting southwest China in the late 1950s he specialised in paintings of China's national minorities. In 1956 he joined the Shanghai Academy of Chinese Painting, of which he later became a director. During the 1970s his attention turned to bird and flower painting.
Cheng n.d.; Cheng 1979.

10 *Long drum dance*

1972
HANGING SCROLL, INK AND COLOUR ON PAPER
INSCRIBED: 長鼓舞　壬子塗月浣　程十髮寫于黃浦西岸
THREE SEALS OF THE ARTIST
59.5 × 39 CM
EA 1978.126

The long drum depicted here is used by the Yao and Chaoxian nationalities.

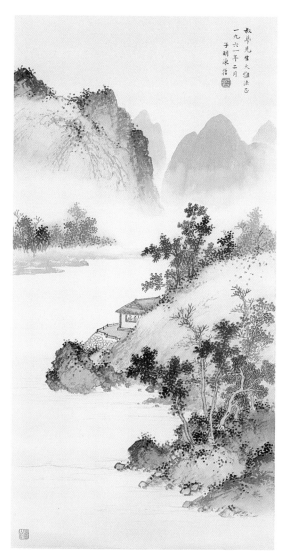

9

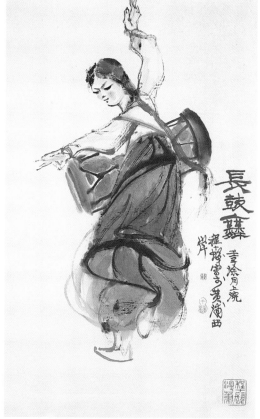

10

CHENG WAINA 鄭薇娜
b. 1946

Waina Cheng, also known as Waina Cheng-Ward, was born in Lanzhou, Gansu province. She grew up in Singapore, where she studied painting with Chen Wenxi (q.v.), and later settled in Oxford. She is particularly interested in wildlife painting, and has travelled throughout Asia, Africa and the Americas to produce works in both Chinese and Western techniques.
Cheng-Ward 1991.

11 Thistles

HANGING SCROLL, INK AND COLOUR ON PAPER
SIGNED: 薇娜
ARTIST'S SEAL
69.5 × 31.8 CM
EA 1988.78
Given by the artist

CHOU CH'ENG 周澄
b. 1941

Chou Ch'eng (Zhou Cheng) was born in Yilan, Taiwan. He studied painting, calligraphy and seal-carving at National Taiwan Normal University, where he later taught; he has exhibited regularly in Taiwan, Japan, Singapore and Thailand, as well as in America and Europe.

12 Landscape

1986
HANGING SCROLL, INK AND COLOUR ON PAPER
INSCRIBED:
丙寅避暑加州,遊黃石公園等處,巨岩磐石,氣勢壯麗,偶寫其境或似之,
簝□ 周澄畫
TWO SEALS OF THE ARTIST; ONE FURTHER SEAL
69 × 33.5 CM
EA 1987.32
Given by the artist

Exhibited: Ashmolean Museum, Oxford, 1987.

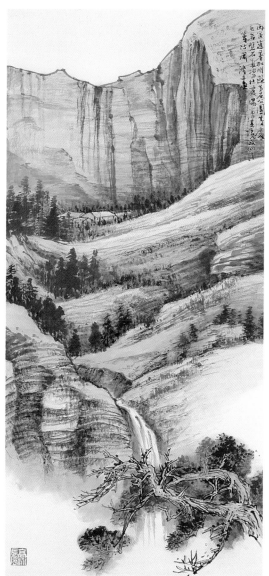

12

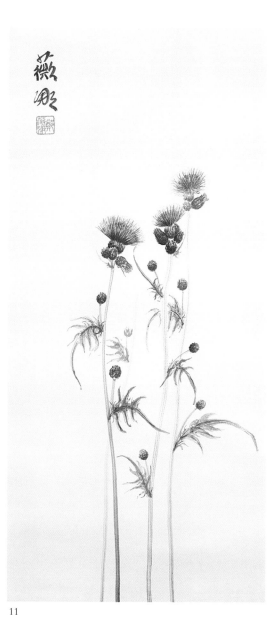

11

CHUI XIAOXING
b. 1958

Chui Xiaoxing began painting in 1976 when he joined an artists' commune in Jiangsu. Such communes were established to enable untrained workers and peasants to produce paintings which usually depicted rural activities. This coincided with the Cultural Revolution (1966–76), when established artists were forbidden or discouraged from painting.

13 *Apple harvest*

WATERCOLOUR ON PAPER

58 × 50.8 CM

EA 1998.213

Given anonymously

Published: Horstmann Godfrey 1992

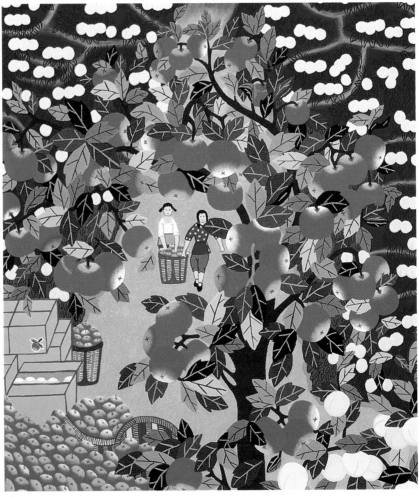

13

14

DAI XI 戴熙

zi Chun Shi 醇士; *hao* Yu An 榆庵, Chun Xi 蓴溪,
Song Ping 松屏

1801–1860

Dai Xi was a prominent official and painter from a literati family in
Hangzhou (then Qiantang), who spent part of his official career in
Guangzhou. He retired from public life in the 1850s, though he later
accepted the imperial command to defend Hangzhou against the Taiping
army; on the fall of the city to the rebels in 1860 he drowned himself.
His painting style is influenced by Wang Hui and other orthodox mas-
ters of the 18th century.

Brown and Chou 1992, pp.50–57; Leong 1991.

14 Landscape

ALBUM LEAF, INK AND COLOUR ON PAPER

INSCRIBED:

青綠一法惟石谷子最擅其長，後人摹臨終不逮其嚴重爽朗 余生平
所作亦（多）秀逸一種，此幀背臨其法，較諸平日筆致，略見重厚
醇士戴熙寫於金台旅舍 併識

TWO SEALS OF THE ARTIST

25.3 × 31.2 CM

EA 1982.10

15 Landscape

HANGING SCROLL, INK AND COLOUR ON GOLD-FLECKED PAPER

INSCRIBED: 幽人渺行處，石徑吟霜葉，欲往從之游，
白云千萬疊。

愛堂老前輩大人雅屬 錢塘侍戴進
醇士 戴熙

TWO SEALS OF THE ARTIST

129 × 33.5 CM

EA 1991.189

DING YANYONG 丁衍庸
1902–1978

Ding Yanyong was born in Maoming, Guangdong province. From 1921–1925 he studied at Tokyo School of Fine Arts, which had established a Western Art department in 1896. This period coincided with the return to Japan of many artists who had visited Europe, and Ding studied oil painting and was influenced by the Impressionists, Post-Impressionists and Fauves. Amongst Chinese painters he was influenced most by Zhu Da, whose paintings and calligraphy he collected. On his return from Japan Ding was appointed professor of Western-style painting at Shanghai College of Art; subsequently his career was divided between Shanghai and Canton until 1949, when he moved to Hong Kong, and taught in the fine art department of the Chinese University of Hong Kong.

Hong Kong 1973; Hong Kong 1979; Hong Kong 1986; Paris 1973; Nishida 1976; Teng 1976;

16 Lotus and goldfish

1972

HANGING SCROLL, INK AND COLOUR ON PAPER

INSCRIBED: 壬子☐☐丁衍庸寫

ARTIST'S SEAL

71 × 34.9 CM

EA 1993.401

15

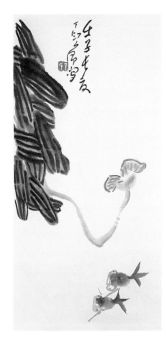

DONG SHOUPING 董壽平
b. 1904

Dong Shouping was born in Hongtong, Shanxi province. He studied in Beijing and was initially a bird and flower painter. Later he concentrated on landscape painting; Mt. Huang in Anhui province proved to be a favourite subject. In 1953 he joined the staff of the Rongbaozhai (studio) in Beijing.
Dong n.d.

17 *Morning on Mount Erlang*

HORIZONTAL SCROLL, INK AND SLIGHT COLOUR ON PAPER
INSCRIBED: 二郎山之晨 董壽平寫
ARTIST'S SEAL
64 × 111.5 CM
EA 1964.209

A vertical scroll with the same title and dated 1964 is published in Dong n.d., pl.1.

16

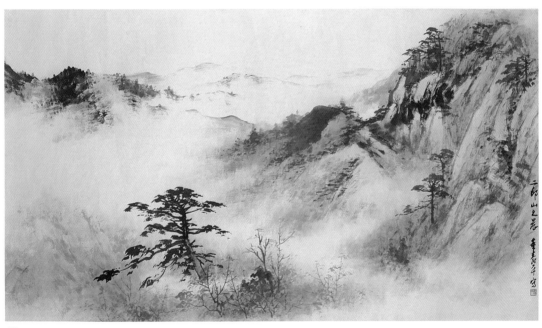

17

18 Landscape

HANGING SCROLL, INK ON PAPER
INSCRIBED: 甲辰立春後二日寫于大雪紛飛之時　　董壽平並記
ARTIST'S SEAL
85 × 46 CM
EA 1965.245

FANG ZHAOLIN 方召麟
zi Qisheng 麒生
b. 1914

Fang Zhaolin, also called Fang Zhaoling, was born at Wuxi in Jiangsu province. Her painting teachers included Qian Songyan (q.v.), Zhao Shao'ang (see Reyes Catalogue) and Zhang Daqian (q.v.). From 1937 onwards she travelled and lived in many different places, including Oxford (1956–58), and exhibited her paintings widely in the United States, Europe and East Asia. Since 1980 she has exhibited chiefly in China and Hong Kong.
Fang 1968; Fang 1972; Fang 1981; Fang 1983; Fang 1988; Fang 1992.

19 Peonies

1958
HANGING SCROLL, INK AND COLOUR ON PAPER
INSCRIBED:
昔人稱得筆法易得，墨法難得，墨法易得水法難，此紙水墨相發，未知筆法為何如也 戊戌初冬 梁谿 方召麟

TWO SEALS OF THE ARTIST; ONE FURTHER SEAL
132 × 67 CM
EA 1966.90

20 *Red flowers*

HANGING SCROLL, INK AND SLIGHT COLOUR ON PAPER
INSCRIBED: 蓓英
TWO SEALS
76 × 30 CM
EA 1978.123
Given by the artist

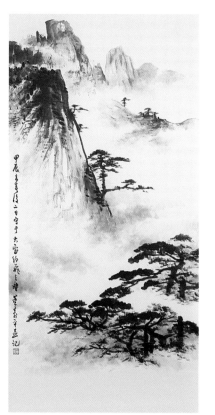

18

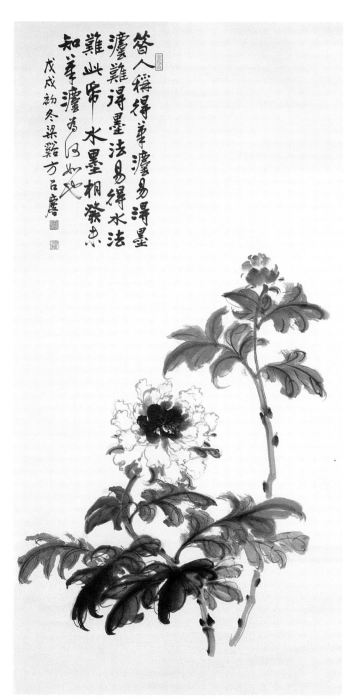

答人稱得筆灣易得墨
灣難得墨法易得水法
難此乃灣水墨相縈忠
知此筆灣為同如此
戊戌初冬梁谿方召麐

19

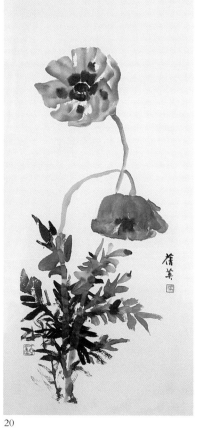

20

FEI CHENGWU 費成武

b. 1914

Fei Chengwu studied under Xu Beihong and specialised in Western-style painting, later becoming professor at the Central University in Nanjing. In 1947 he arrived in Great Britain on a British Council scholarship; he settled in London and switched to traditional Chinese painting.
Fei 1957.

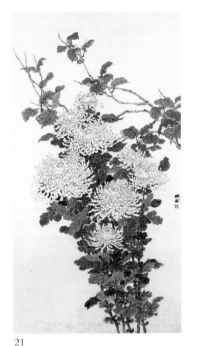

21

21 White chrysanthemums and autumn leaves

HANGING SCROLL, INK AND COLOUR ON PAPER
SIGNED: 成武
ARTIST'S SEAL
120 × 60.7 CM
EA 1978.124
Given by the artist

FU BAOSHI 傅抱石

ming Ruilin 瑞麟
1904–1965

Fu Baoshi was born in Nanchang, Jiangxi province. From 1933 to 1935 he studied in Tokyo at the Imperial Art Academy, and on his return taught at the Central University in Nanjing where he was professor from 1935 to 1952; during the Sino-Japanese War he moved with the University to Chongqing (Chungking) in Sichuan and in 1946 he returned to Nanjing where he spent the rest of his life. He sat on artists' committees at both national and local levels and in 1959 collaborated with Guan Shanyue (q.v.) on the huge painting 'This land with so much beauty aglow' in the Great Hall of the People at Tiananmen Square, Beijing. Fu wrote widely on the history of painting and in the 1930s developed his own style, to which he remained true throughout his career; he was deeply influenced by the Qing individualist painter Shi Tao, of whom he wrote a biography. Together with Huang Binhong (q.v.) he is regarded as the greatest literati painter of the twentieth century. See also Cat.No.30.
Beijing 1988; Fu 1958; Fu 1960; Fu 1981; Fu 1983; Fu and Guan 1964; Hu 1994; Hong Kong 1968; Nanchang 1992

22 Landscape

1943
HANGING SCROLL, INK AND COLOUR ON PAPER
INSCRIBED: 笙陔先生　方家法政　癸未九月蜀中寫　傅抱石
TWO SEALS OF THE ARTIST, ONE FURTHER SEAL
110 × 61 CM
EA 1962.222

23 Landscape

1961
HANGING SCROLL, INK AND COLOUR ON PAPER
INSCRIBED: 一千九百六十有一年三月廿五日　傅抱石
南京并記
TWO SEALS OF THE ARTIST
100 × 54 CM
EA 1963.71
Published: Vainker 1996

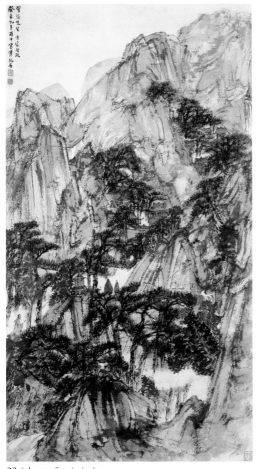

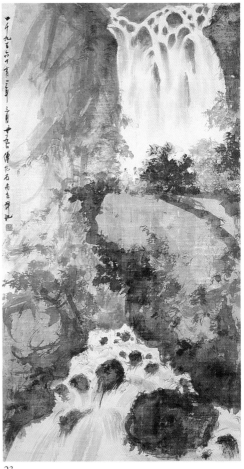

22 (also see frontispiece)

23

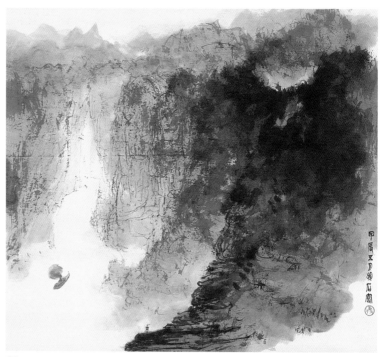

24

24 River landscape

1964
HANGING SCROLL, INK AND COLOUR ON PAPER
INSCRIBED: 甲辰五月抱石寫
ARTIST'S SEAL; DATE SEAL
54 × 60.5 CM
EA 1965.254

GAI QI 改琦

zi Bo Yun 伯蘊; *hao* Qi xiang 七薌, Xiang bai 香白,

Yu hu wai shi 玉壺外史

1774–1829

Gai Qi was born in Xiyu, west China but as an artist was active in Songjiang (now Shanghai) in Jiangsu. His subject matter included figures, Buddhist subjects, beauties and plants, though he was also a prolific landscape painter; in 1816 he illustrated the novel *Hong lou meng* (Dream of the Red Chamber). He was an accomplished poet, favouring the *ci* rhyming form, and often included his own compositions on his paintings.
Gai n.d.

25 Epidendrum, bamboo and rocks

1818
HANDSCROLL, INK ON PAPER
INSCRIBED:

為□幽蘭作野人, 偶然遣興筆生春, 三湘風月憑誰畫, 慣寫□騷麵目真

戊寅孟春三月　改琦

TWO SEALS OF THE ARTIST
COLOPHON BY GU WENBIN, DATED 1877
29.5 × 350.5 CM
EA 1962.225

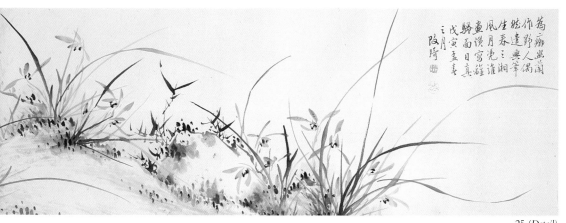

25 (*Detail*)

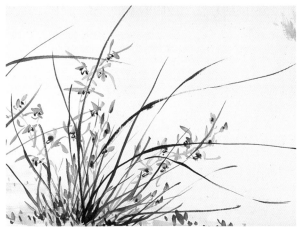

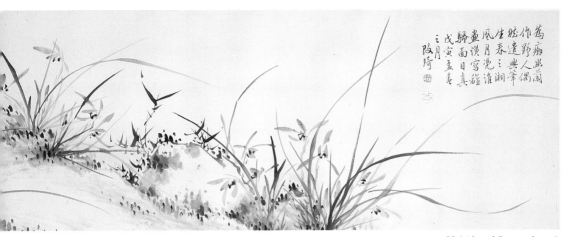

為作癡蘭幽人偶興筆三湘遺春月滿風生紙上作畫真日宮罐誰漢月騙畫面戊寅孟秋三月陂耆

25 (*right to left, top to bottom*)

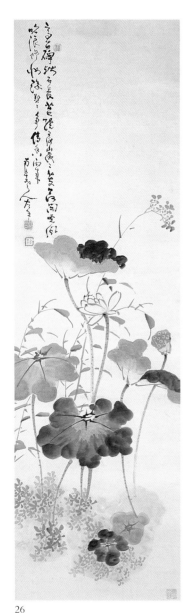

26

GAO FENGHAN 高鳳翰

zi Xi Yuan 西園; *hao* Nancun 南村, Nanfu 南阜,
Laofu 老阜, Shi wan lao zi 石頑老子,
Song lan dao ren 松嬾道人, Nie qin lao ren 櫱琴老人

1683–1749

Gao Fenghan was born in Jiaozhou, Shandong province, but his career as an official was spent in the Jiangnan region, where he associated with the Yangzhou painters. Although he is not one of the artists defined in the late nineteenth century as the Eight Eccentrics of Yangzhou, Gao Fenghan is now regarded as part of the same group, along with Min Zhen (q.v.) and Hua Yan. The Yangzhou painters were known for their individuality in painting style, and for their rejection of the orthodox painting tradition promoted in the seventeenth century by the theorist and painter Dong Qichang (1555–1636). From 1737 onwards rheumatism in his right hand forced Gao to paint with his left, and these latter paintings were particularly sought after by his contemporaries. In 1741 he retired, and returned to his native province in the north.
Gao 1983; Li 1963.
For the Yangzhou Eccentrics see Chang 1970; Giacalone 1990; Gu 1962; Jiangsu 1985; Qin 1985.

26　Lotus

HANGING SCROLL, INK AND COLOUR ON PAPER
INSCRIBED:

高台碑殘石長苔, 繞廊崴崴芰荷開, 曉風吹浪修恨後, □□爭傳魚兩來
南阜老人左手　　高鳳翰

ARTIST'S SEAL; TWO FURTHER SEALS
154.7 × 44.9 CM
EA 1965.253

GAO JIANFU 高劍父
ming Lun 崙
1879–1951

Gao Jianfu was born in Panyu district, Guangdong province. He is best known as one of the masters, together with his brother Gao Qifeng, of the Lingnan School which is associated with Guangdong and was noted for its modernity and assimilation of foreign painting styles. Gao Jianfu was a pupil of the influential plant and insect painter Ju Lian (1828–1904)

who, with his brother Ju Chao, advocated painting from life and direct observation. Gao also studied painting in Japan, at the Tokyo Institute of Fine Arts; while there he became involved in the anti-Manchu revolutionary campaign and thereafter engaged in educational and publishing work, most notably the *Zhenxiang huabao* (Truth Pictorial), as well as art. He held numerous academic posts and in 1923 he founded the teaching establishment Chunshui Art Studio.

Gao 1977; Kao 1995; Wen 1936; Wong 1972

27 Flowering branch

HANGING SCROLL, INK AND COLOUR ON PAPER
INSCRIBED: 天南樹樹皆峰火　　不及攀枝花可憐　　七三年春　　劍父
TWO SEALS OF THE ARTIST
91 × 42.2 CM
EA 1991.73

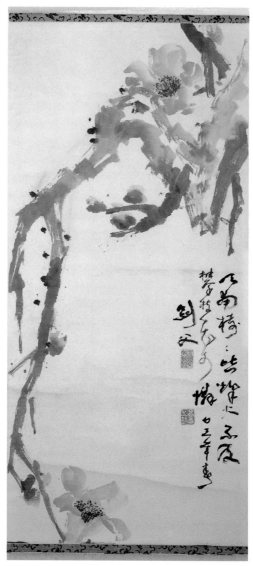

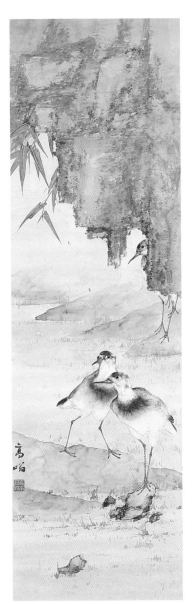

28

GAO QIFENG 高奇峰

ming Weng 翁, studio name Tian feng lou 天風樓

1889–1933

Gao Qifeng, born at Panyu, Guangdong, was the younger brother of
Gao Jianfu. His career closely followed that of Jianfu and included study
in Japan, where in 1907 he was a painting pupil of Tanaka Raisho, and
involvement in the revolutionary movement. He too was engaged in
publishing in Shanghai and educational work in Guangdong. In 1933
the government appointed him to the committee of the Sino-German
Art Exhibition, (see Introduction, p. 13) but he died in Shanghai shortly
before the exhibition left.
Hong Kong 1981; Kao 1995

28　Water birds

HANGING SCROLL, INK AND COLOUR ON PAPER
SIGNED: 翁
ARTIST'S SEAL; ONE FURTHER SEAL
121 × 37.5 CM
EA 1986.27

GAO QIPEI 高其佩

zi Wei zhi 韋之, Wei san 韋三; *hao* Qie Yuan 且園,
Qie dao ren 且道人, Nan cun 南村

1660–1734

Gao Qipei grew up in Jianchang (present Nancheng) in Jiangxi province, though his family had Manchurian connections. He had a successful career as an official in southern China but was better known as a painter. His earlier works were predominantly figure paintings and landscapes in meticulous traditional style, though he later built up a reputation as an eccentric and is particularly well-known for finger-painting. The eighth-century painter Zhang Zhao was the first to use finger instead of brush, but the technique became closely associated with Gao. Nanjing 1959; Ruitenbeek 1992; Tregear 1979; Xu 1986; Yang 1979; Yang 1989.

29 *The four seasons*

HANDSCROLL, INK AND COLOUR ON PAPER

SIGNED: 高其佩指墨

FOUR SEALS

28.6 × 333 CM

EA 1977.6

Given by Sir John Addis, KCMG

Published: Tregear 1979

The authenticity of this work has been doubted by both Ruitenbeek and Yang.

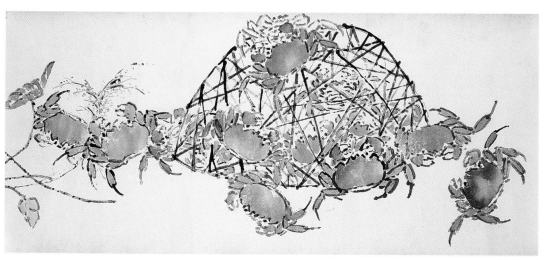

29 (detail)

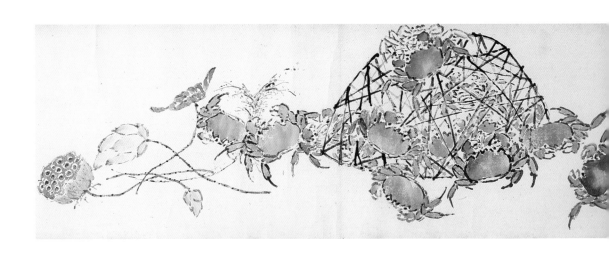

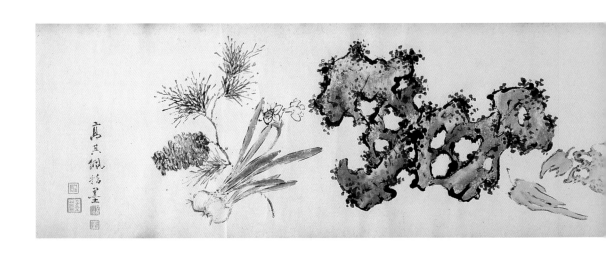

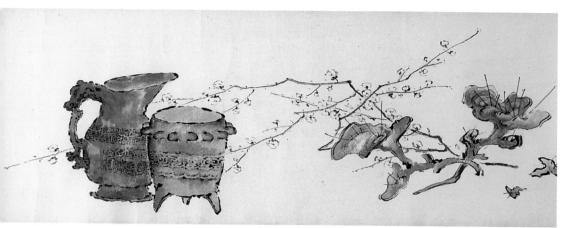

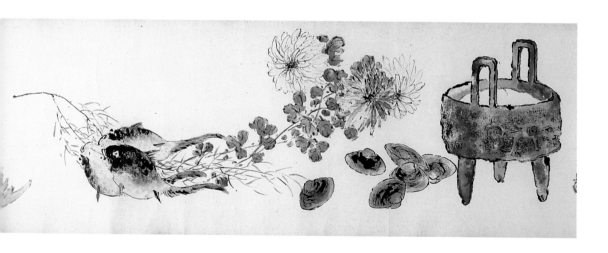

GAO YUAN 高原

ming Ri Guan 日觀, *zi* Chu tai 處泰

Qing dynasty, 18th–early 19th century

Gao Yuan was from Qiantang (present Hangzhou) in Zhejiang province. He was a painter, calligrapher, and pupil of Gao Shucheng, who was awarded a degree in 1777.

30 Birds on a branch

ALBUM LEAF, INK AND COLOUR ON SILK
INSCRIBED: 踏翻繡麥風　團嘯高原雨
TWO SEALS
28 × 20 CM
EA 1960.227

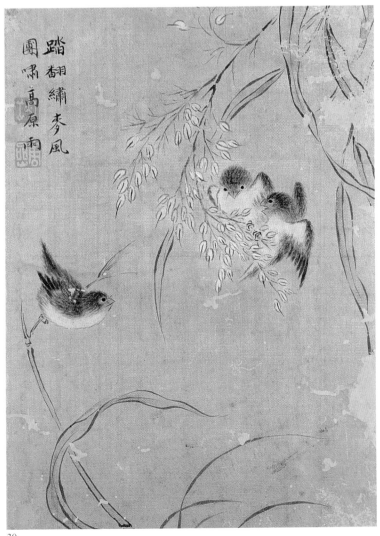

30

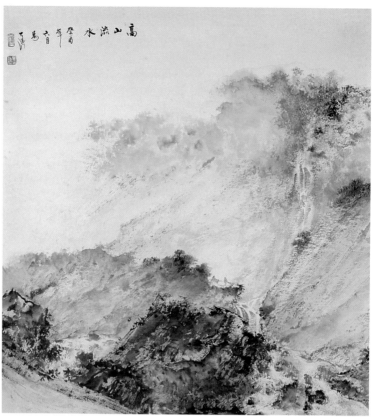

31

SIGNED

GU TAO 古濤

The only recorded artist named Gu Tao was a pupil of the monk painter Dao Cun, who was in turn a follower of Zha Shibiao (q.v.) and by whom a landscape album dated 1709 survives in Japan. However, the name is almost certainly a pseudonym, and may have been used by a later painter. The figure in this painting compares closely with those in the landscapes of Fu Baoshi; given Fu's veneration of the Qing Individualist painter Shi Tao (Dao Ji), and the fact that his assumed name Baoshi means 'embracing Shi (Tao)', the possibility that this is a work by Fu Baoshi should not be ruled out. The seal of Ni Tian (1855–1919) (q.v.) remains anomalous.

31 Waterfall in a high mountain

1933

HANGING SCROLL, INK AND COLOUR ON PAPER

INSCRIBED: 高山流水　癸酉年六月寫　古濤

ARTIST'S SEAL; SEAL OF NI TIAN

68 × 64 CM

EA 1996.129

For Ni Tian seal see Brown 1992 no.75.

GUAN LIANG 關良

1900–1986

Guan Liang was born in Panyu, Guangdong province, and studied in Japan between 1917 and 1922. On his return he taught at several art colleges across southern China, and introduced Western methods with which he had become acquainted while abroad. After 1949 he served on the committees of several artists' associations. He frequently painted in oils; in ink he is particularly well-known for his paintings of opera figures. Guan 1984.

32 Actors

HANGING SCROLL, INK AND COLOUR ON PAPER
SIGNED: 關良
ARTIST'S SEAL
34 × 38.1 CM
EA 1968.74

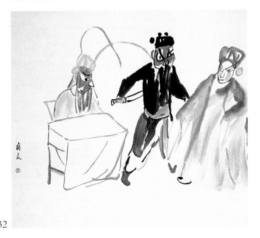

32

GUAN SHANYUE 關山月

ming Zepei 澤霈, *zi* Ziyun 子雲
b. 1912

Guan Shanyue was born in Yangjiang in Guangdong province. During the 1930s, having graduated from Guangzhou Provincial College of Education, he studied painting with Gao Jianfu (q.v.) at the latter's Chunshui Art Studio, and may be regarded as a Lingnan School painter. Though most of his life was spent in Canton, where he held several senior academic positions, he travelled widely within China and worked regularly with Fu Baoshi in the late 1950s and early 1960s. He also travelled abroad. Guan is known for plum blossom and figure paintings in addition to landscapes.
Fu and Guan 1964; Guan 1964; Guan 1979; Guan 1991.

33 Man and horse beneath a city wall

1944

HANGING SCROLL, INK AND COLOUR ON PAPER

INSCRIBED:

季雨先生方家雅屬即正　　甲申盛暑於蜀郡客次　　嶺南關山月

TWO SEALS OF THE ARTIST

112 × 38.1 CM

EA 1964.81

Exhibited: Edinburgh 1967, no. 30

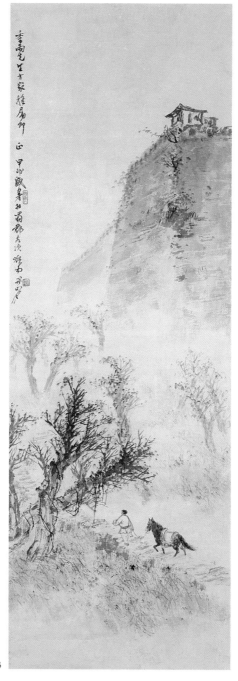

34 Yunnan landscape

1942

HANGING SCROLL, INK AND COLOUR ON PAPER

INSCRIBED: 三十一年暮春於滇池寫生　嶺南關山月

TWO SEALS OF THE ARTIST

81.3 × 40 CM

EA 1965.258

35 Sparrow and wisteria

HANGING SCROLL, INK AND COLOUR ON PAPER

INSCRIBED: 嶺南　關山月

TWO SEALS OF THE ARTIST

131 × 32.7 CM

EA 1981.4

Given by Dr. A. G. Sanders

Dr. Sanders was in China during the early 1940s; this painting is there-
fore likely to date from the early part of Guan Shanyue's career.

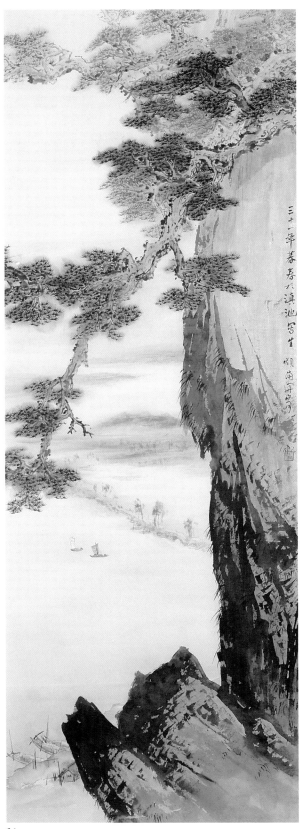

三十一年暮春於滇池寫生頤頑寫

34

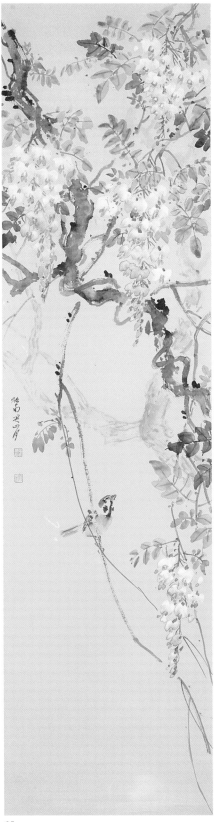

35

HE TIANJIAN 賀天健

zi Qianqian 乾乾; *hao* Ren xiang ju shi 幼香居士

1890–1977

He Tianjian was born in Wuxi, Jiangsu province. He edited art maga-
zines, including *Huaxue yuekan* and *Guohua yuekan*, and taught at art
schools in both Wuxi and Shanghai. In the 1930s and 1940s he lived
entirely by selling his paintings, and from 1949 onwards he was associ-
ated with Shanghai Art Academy, of which he was vice-president. His
works are predominantly landscapes in traditional style.
He 1982.

36 Landscape

1961
HANGING SCROLL, INK ON PAPER
INSCRIBED: 辛醜秋日　江東賀天健進寫時年七十有一
TWO SEALS OF THE ARTIST
34.5 × 34.5 CM
EA 1996.80

Given in honour of Jose Mauricio and Angelita Trinidad Reyes to mark
the opening of the exhibition "Modern Chinese Paintings from the
Reyes Collection", Ashmolean Museum, 1996.

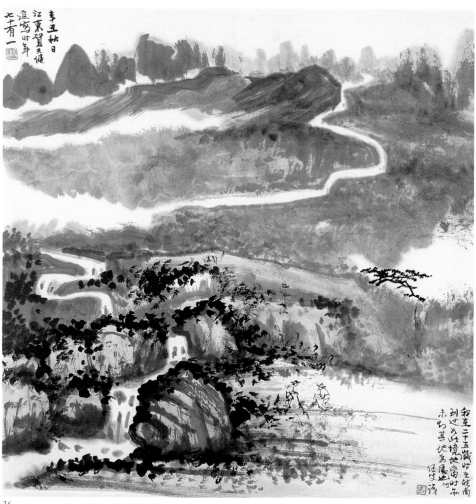

36

HO FUNG-LIN 何鳳蓮

Susan Ho

b. 1944

Ho Fung-Lin studied under the prominent Lingnan School artist Zhao Shao'ang (1905–1998; see Reyes Catalogue). As well as painting in accordance with Zhao's principles of innovation within tradition, she writes on contemporary Chinese art with particular reference to the Lingnan School. Her paintings often include her own poetry.

38

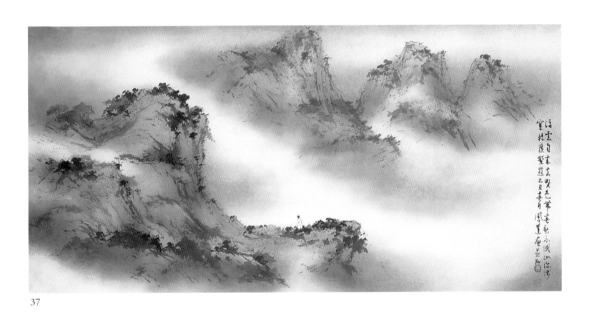

37

37 Landscape

1985

HORIZONTAL SCROLL, INK AND COLOUR ON PAPER

INSCRIBED:

浮雲自來去・野色帶春愁・不識山深涉・穿林度壑游
乙醜春月鳳蓮畫併題

TWO SEALS OF THE ARTIST

66 × 135 CM

EA 1986.11

Given by the artist

Exhibited: Ashmolean Museum, Oxford, 1985

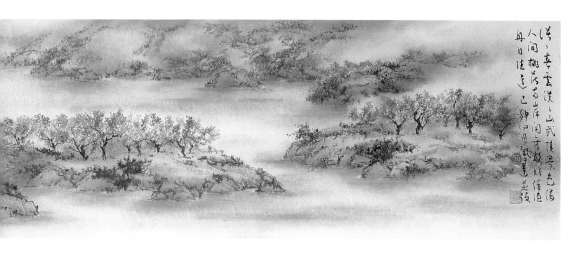

38 Spring

1999

HORIZONTAL SCROLL, INK AND COLOUR ON PAPER

INSCRIBED:

武陵春色
漠漠春雲淡淡山
武陵景色滿人間
桃花兩岸開無數
好借漁舟日往還
己卯四月鳳蓮並題

THREE SEALS OF THE ARTIST

30.5 × 131.5 CM

EA 1999.43

Given by the artist

The subject of the painting is the 'Peach Blossom Spring', a famous literary episode in which a scholar comes across an idyllic land inhabited by people of China's distant golden age. This poem is the artist's own composition.

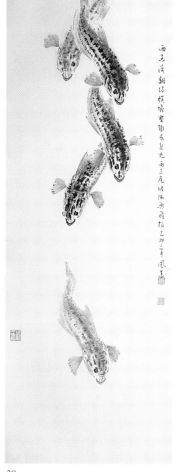

39 Pond Fish

1999

VERTICAL SCROLL, INK ON PAPER

INSCRIBED:

橫塘野趣
雨過荷翻綠
橫塘野趣長
魚兒兩三尾
彷彿興飛揚
己卯四月鳳蓮

THREE SEALS OF THE ARTIST

131.8 × 47.4 CM

EA 1999.44

Given by the artist

39

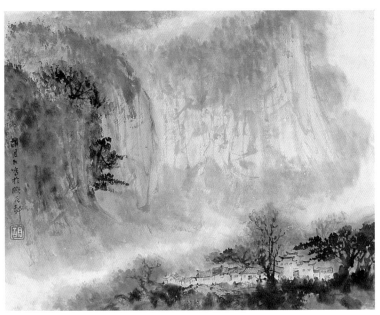

40

HU GUOREN 胡國仁
20th century

Hu Guoren is an unpublished painter, active in the mid-twentieth century.

40 Landscape

HANGING SCROLL, INK AND COLOUR ON PAPER
INSCRIBED: 胡國仁寫于晚花軒
ARTIST'S SEAL
28.2 × 36.1 CM
EA 1968.71

HU PEIHENG 胡佩衡
ming Xi Quan 錫銓 ; *hao* Leng an 冷庵
1899–1962

Hu Peiheng, from Zhuo Xian in Hebei province, was of Mongolian nationality and spent most of his career in Peking. He was a member of the traditionalist Peking-based painting society Hu She, which flourished in the 1920s, and was editor of its monthly journal *Hushe yuekan*. He taught at many institutions in Peking, and was a prolific writer of books on painting method; in conjunction with Yu Zhao (q.v.) he was responsible for a new edition of the seventeenth century Mustard Seed Garden Manual of Painting.

41 Landscape

HANGING SCROLL, INK AND COLOUR ON PAPER
INSCRIBED: 山光連日雨　水氣一天雲　擬董文敏　冷庵　胡佩衡寫
TWO SEALS OF THE ARTIST
64.1 × 28.2 CM
EA 1966.195

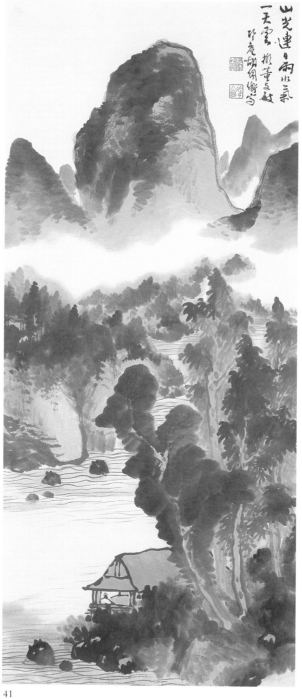

41

HUANG AIHONG 黃哀鴻

1914–1937

Huang Aihong was born in Guangdong province and studied at Gao Jianfu's Chunshui Studio. Like other Lingnan School painters, he spent time in Shanghai, where he had a one-man show and where he died at the age of twenty-three.

42 Horses at a fence

1937

HANGING SCROLL, INK AND COLOUR ON PAPER

INSCRIBED: 廿六年冬始 哀鴻

TWO SEALS OF THE ARTIST

151.5 × 68 CM

EA 1960.245

The inscription 'begun in winter 1937' suggests that the artist may not have completed this painting before his death that year.

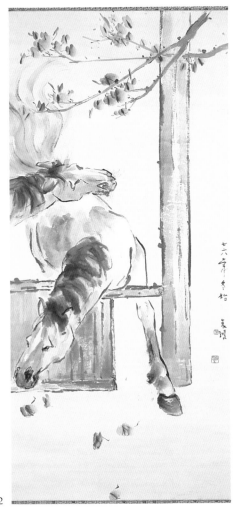

HUANG BINHONG 黃賓虹

ming Huang Zhi 黃質; *zi* Pu Cun 僕存;
hao Yu Xiang 予向, Da Qian 大千
1864–1955

Huang Binhong was one of the foremost literati painters and art historians of the early twentieth century. Born in She Xian, Anhui province, he was brought up in Zhejiang province and worked for some years in Peking before settling in Shanghai in 1909. In 1937 he returned to Peking. The art associations he was instrumental in establishing include the Society of Chinese Antiquities, Calligraphy and Painting (Zhongguo jinshi shuhua yiguan xuehui, 1926) and the Bees Painting Society (Mifeng huashe, 1927). His painting style, which is largely characterised by the use of dense, overlapping layers of ink, has been said to comprise one of the last major innovations in literati landscape painting. He wrote extensively on the history of Chinese painting, was a renowned connoisseur of both paintings and art objects, and edited many publications. His best-known published work is the *Meishu congshu* (1911) in 120 volumes, a collection of historical and modern writings on art which he compiled with Deng Qiumei. He lectured at several art colleges throughout his career and after 1949 held numerous prestigious academic and administrative positions.
Beijing 1991; Hong Kong 1980; Huang 1955; Huang 1961; Huang 1961a; Huang 1962; Huang 1978; Huang 1984; Kuo 1989; Hong Kong 1995; Lam 1972; Wang n.d.; Wang 1985; Wu 1958.

43 Landscape

HANGING SCROLL, INK ON PAPER
INSCRIBED:
雲間峰朵朵錦繡似芙蓉不待秋風至花光映日方尚惠句余於春暮來
此，山色清空如不著色漫興寫之　黃賓虹記遊

ARTIST'S SEAL
75.5 × 27.5 CM
EA 1962.226

44 Landscape

1941
HANGING SCROLL, INK AND SLIGHT COLOUR ON PAPER
INSCRIBED:
米海嶽畫紙不用膠礬, 墨瀋淋灘, 筆力健能扛鼎, 為得北苑正傳, □
東虞山競尚溔皴, 而古意盡替
辛巳一月無染學兄索余近作, 檢此貽之　予向

ARTIST'S SEAL
75.5 × 29 CM
EA 1965.248

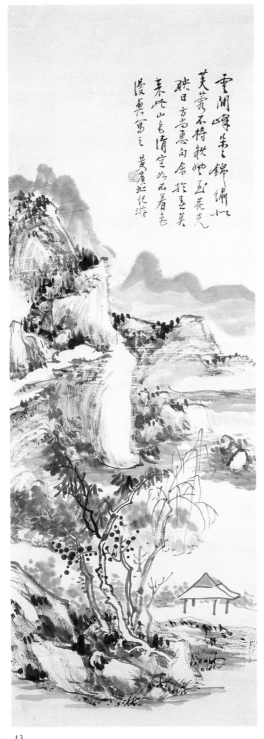

43

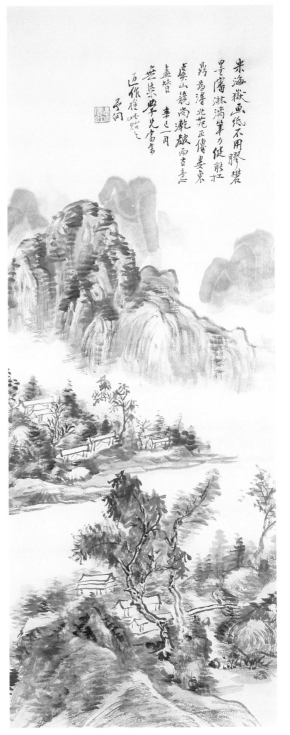

44

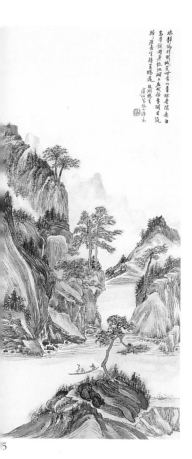

45 Landscape

HANGING SCROLL, INK AND COLOUR ON PAPER
INSCRIBED:
水靜偏明眠，城荒可當山，青林無限意，白鳥有餘閒。身致江湖上
名成伯季間。目隨歸雁杳，坐待英鴉還後湖晚坐　賓虹寫後山詩意
ARTIST'S SEAL
66.2 × 30 CM
EA 1965.250

46 Landscape

1934
ALBUM LEAF MOUNTED AS A HANGING SCROLL, INK AND
COLOUR ON PAPER
INSCRIBED:
甲戌春日游三□，舟中作奉致祥宗台先生鑒　　　賓虹
ARTIST'S SEAL
21.5 × 38.0 CM
EA 1966.192

5

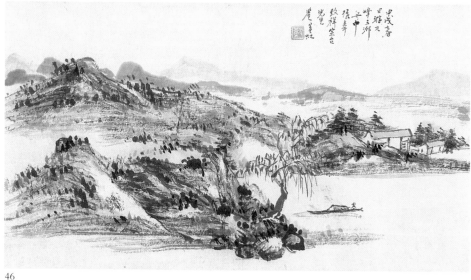

46

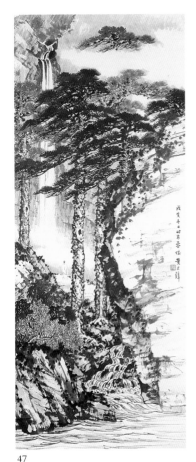

47

HUANG JUNBI 黃君璧

ming Yun Xuan 允瑄; *hao* Jun Weng 君翁

1898–1991

Huang Junbi was born in Nanhai, Guangdong province. At the age of twenty he began studying at the Chu Ting Art Institute in Canton, where he subsequently taught, and later moved to Nanjing. In 1934 he studied in Japan, and in 1941 became head of the Chinese painting department at the National Art Academy. He moved in 1949 to Taiwan, where he bacame well-known as a landscape painter and was Professor and head of the art department at National Taiwan Normal University. Huang 1966; Huang 1987.

47　Landscape

1938
HANGING SCROLL, INK ON PAPER
INSCRIBED: 戊寅冬日時客蓉城　　黃君璧
ARTIST'S SEAL
113 × 47 CM
EA 1962.231

48　*Sails on the autumn river*

1946
HANGING SCROLL, INK ON PAPER
INSCRIBED: 秋江帆影　丙戌寫嘉陵江所見　　君璧
TWO SEALS OF THE ARTIST; ONE FURTHER SEAL
94.7 × 49.5 CM
EA 1963.18

49　Landscape

1947
HANGING SCROLL, INK AND COLOUR ON PAPER
INSCRIBED:
歸帆帶日遲，丁亥夏至憶寫嘉陵江一角於秣陵客次　　黃君璧
TWO SEALS OF THE ARTIST; ONE FURTHER SEAL
98.5 × 58 CM
EA 1963.72

This landscape and cat. nos. 45 and 47 all depict the Jialing River which runs through northern Shaanxi and Sichuan provinces.

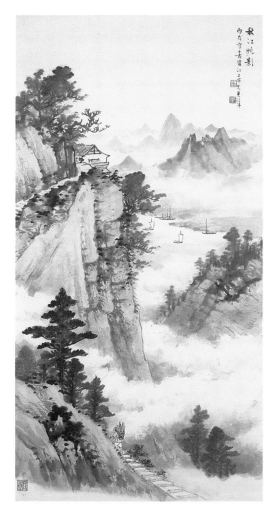

秋江帆影
丙戌冬畫於江上所見 墨禪牛

48

鮮飄幕日遠
丁亥夏之挽奇
嘉陵江之春林
杜陵風處又墨禪

49

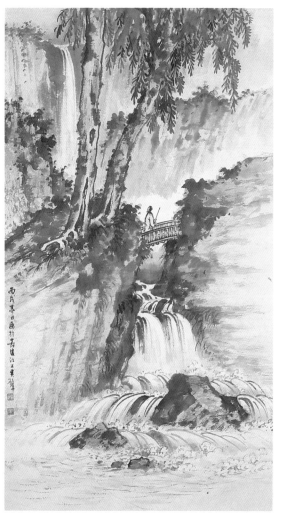

50

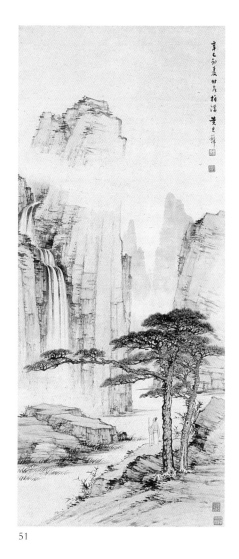

51

50 Landscape

1946
HANGING SCROLL, INK AND COLOUR ON PAPER
INSCRIBED: 丙戌春日畫于嘉陵江上　　君璧
TWO SEALS OF THE ARTIST
99.5 × 55.2 CM
EA 1965.252

51 Landscape

1941
HANGING SCROLL, INK AND COLOUR ON PAPER
INSCRIBED: 辛巳初夏時客　柏溪　　黃君璧
TWO SEALS OF THE ARTIST; TWO FURTHER SEALS
97.2 × 42 CM
EA 1966.199

HUANG SHEN 黄慎

zi Gong Mou 恭懋, Gong Mou 躬懋, Gong Shou 恭壽; *hao* Ying Piao 廮瓢, Dong hai bu yi 東海布衣
1687–1772

Huang Shen was born in Ninghua, Fujian province, where he spent his youth and the later part of his life. His middle years however were spent in the thriving city of Yangzhou in Jiangsu province, and he is among the painters known as the Eight Eccentrics of Yangzhou (Yangzhou baguai). His early, meticulous style gave way in maturity to a rough, splashed ink technique which proved highly lucrative in the prosperous mercantile environment of Yangzhou.
Liu 1979; Tokyo 1914. For the Yangzhou Eccentrics see Chang 1970; Giacalone 1990; Gu 1962; Jiangsu 1985; Qin 1985

52 Man on a donkey; calligraphy

DOUBLE ALBUM LEAF, INK AND COLOUR ON PAPER
ONE SEAL OF THE ARTIST; TWO FURTHER SEALS
30.5 × 48 CM
EA 1956.3920 A & B

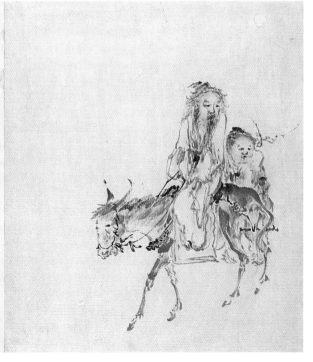

52

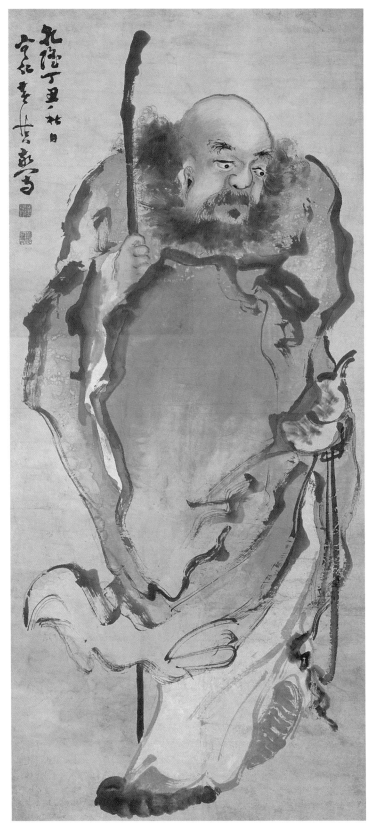

53

53 The hermit Li Tieguai

1757
HANGING SCROLL, INK AND SLIGHT COLOUR ON PAPER
INSCRIBED: 乾隆丁醜秋日寧化黃慎敬寫
TWO SEALS OF THE ARTIST
151 × 68 CM
EA 1965.60

54 Carp

ALBUM LEAF, INK ON PAPER
INSCRIBED: 一生快活　瓢子
ARTIST'S SEAL
22.3 × 28.4 CM
EA 1960.225

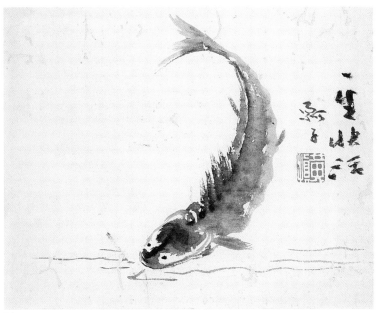

54

HUANG ZHOU 黃冑

Born Liang Gantang 梁淦堂 , *zi* Ying Zhai 映齋

b. 1925

Huang Zhou was born in Li Xian, Hebei province. He started painting at an early age as a pupil of Zhao Wangyun (q.v.). In 1955 became a professional painter, having spent six years in the People's Liberation Army as a reporter in the northwest border region; the national minority peoples of that area became a leading subject in his paintings. His interest in early paintings resulted in a fine collection of Song, Yuan, Ming and Qing works (see Huang 1988).

Huang 1963; Huang 1980; Huang 1986; Huang 1988.

55 Donkeys

HANGING SCROLL, INK ON PAPER
INSCRIBED:
尤物從來不自欺，□年曾未有閒時。戰事連年走峰火，平時日夜任勞驅。踏雪尋梅添雅趣，□山負囊吟小詩。文人筆下總遭貶，今慾還其窈窕姿。　　黃冑寫八驢圖

TWO SEALS OF THE ARTIST, ONE FURTHER SEAL
133.5 × 53 CM
EA 1983.218

JIN NONG 金農

zi Shou Men 壽門; *hao* Dong Xin 冬心 , Si Nong 司農 ; numerous other styles

1687–1763 or 4

Jin Nong was born in Renhe (present day Hangzhou) and is known as one of the Eight Eccentrics of Yangzhou, where he settled in 1748 following the death of his wife. He is known to have begun painting seriously at the age of fifty, possibly as a result of his failure in 1736 to pass the official examinations in Peking.

Jin 1959; Jin 1983; Jin 1985.

56 Plum blossom

1761

HANGING SCROLL, INK ON SILK

INSCRIBED:

蜀僧書來日之昨先問梅花後問鶴，野梅瘦鶴各平安，只有老夫病腰腳，腰腳不利嘗閉門，閉門便是羅浮村，月夜畫梅鶴在側，鶴舞一回清人魂，畫梅乞米尋常事，那得高流送米至。我竟長飢鶴缺糧，攜鶴且抱梅花睡 辛巳十月七十五叟杭郡　金農記

THREE SEALS OF THE ARTIST; TWO FURTHER SEALS

86.7 × 38.7 CM

EA 1965.62

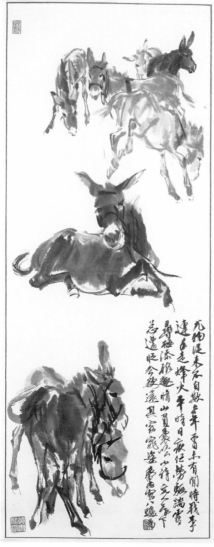

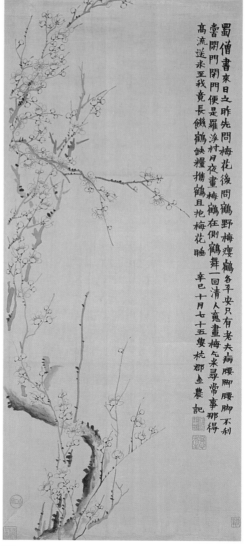

55

56

JIN XI 金熙
zi Shen Zhai 慎齋

Qing dynasty, late 18th–19th century
Jin Xi was a Qing dynasty painter from Shanghai. He was good at calligraphy, particularly in archaic styles, and seal carving. He published a collection of seals under the title *Jing xue zhai yinpu*.

57 *Geese amongst rushes*

CIRCULAR FAN MOUNTED AS ALBUM LEAF, INK AND
COLOUR ON SILK
INSCRIBED: 鳴岐三兄大人政之　□城金熙寫意
ARTIST'S SEAL
D. 27.5 CM
EA 1965.229

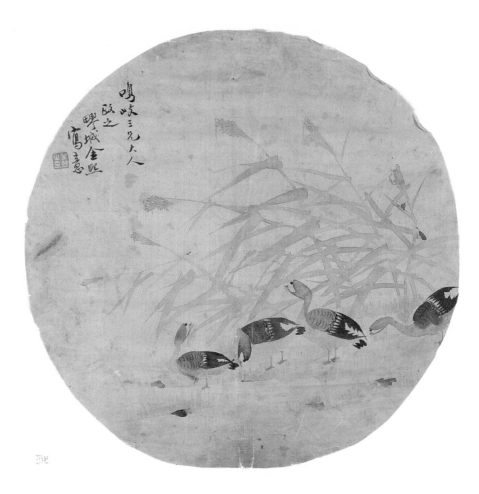

57

JIN YUAN 金元
zi Wen Yu 問漁

Jin Yuan, whose dates are unrecorded, was a late Qing dynasty painter from Shaoxing (then Shanyin) in Zhejiang province. He became prefect of Haiyang county in Guangdong province, and was admired for his bird paintings. His works are mentioned by the poet Chihongxuan. A hanging scroll by Jin Yuan is published in Chan 1977, pl.51.

58 Album of bird paintings

1857

ELEVEN LEAVES, INK AND COLOUR ON PAPER

INSCRIBED:

1964.221 a

六作盤桓謾計年 幽貞回傲歲寒天 濤聲盡是添籌屋 釀蔭中留不老僊
擬新羅山人法 三標

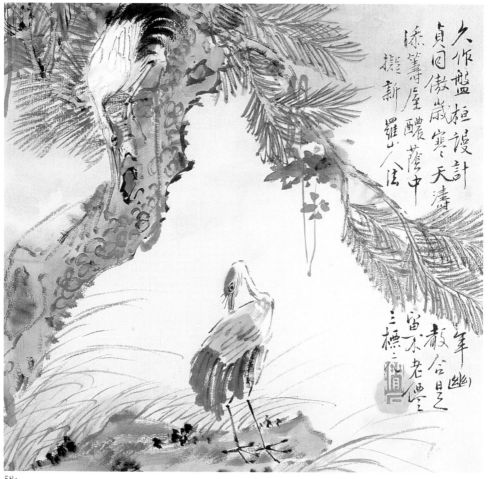

58a

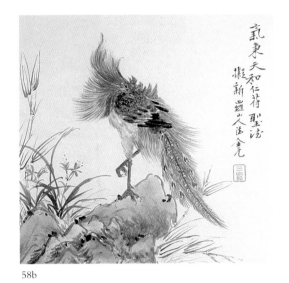

58b

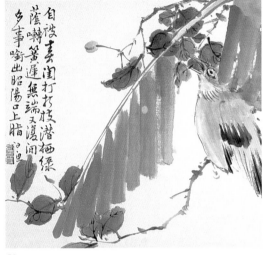

58c

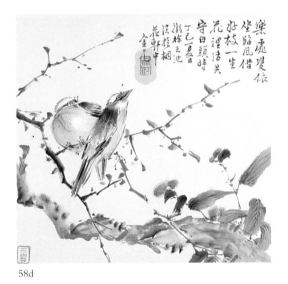

58d

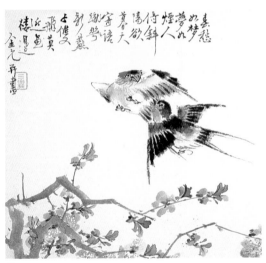

58e

1964.221 b
氣秉天和仁苻聖法
擬新羅山人法　金元

1964.221 c
自被春閨打□枝　鵝棲綠蔭囀簧遲　無端又復閒多事　銜出昭陽口上脂　問漁

1964.221 d
樂處雙依坐　臨風借好枝　一生花裡活　共守白頭時
丁巳夏日擬徐天池法　於桐花軒中
金元

1964.221 e
春愁如夢夢如煙　人倚斜陽慾暮天　寄語蹴華新燕子　雙飛莫近畫樓邊
金元併書

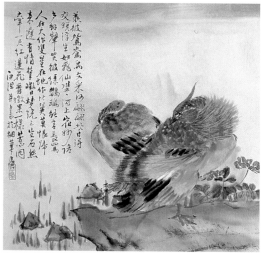

58f

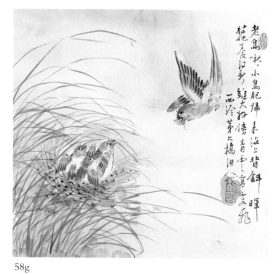

58g

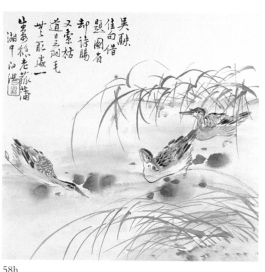

58h

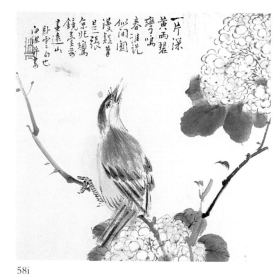

58i

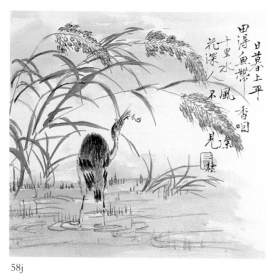

58j

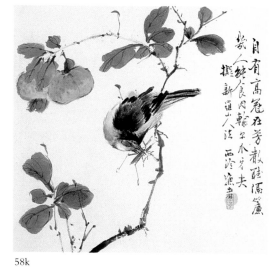

58k

1964.221 f

羨彼鴛鴦鳥 文採何翩翩 □日得交頸 浮生如飛仙 雙雙河上宿 妙語
多□罎 笑彼綠鸚鵡 能言長罵人 在天作雙星 在地作比翼 莫恨
歸來遲 有情誓皦日 夢繞三生石 絲牽一尺紅 蓮花看徵果 一樣
苦心同
問漁併書於桐華庵

1964.221 g

老鳥啾啾小鳥肥 歸來海上背斜暉 □他養河新雛大 好傍青雲高
處飛 西泠茅上橋漁人作
1964.221 h

吳融佳句借題圖 省卻詩腸又索枯 道是羽毛□取處 一生安穩老
菰蒲
湖中問漁

1964.221 i

一片深黃兩碧彎 鳴春誰咒似問關 漫疑□是張京兆 鸞鏡臺前畫遠
山
臥雲句也 問漁併書

1964.221 j

日暮上平田 得魚帶香□ 十里水風涼 花深人不見
三標

1964.221 k

自有高冠在 芳聲聽隔簾 幾人能食肉 輸爾爪牙尖
擬新羅山人法
西泠漁者

EACH 20.5 × 22 CM

EA 1964.221 A–K

Given by Dame Kathleen Courtney

KUN CAN 髡殘

zi Shi Qi 石溪 , Jie Qiu 介邱 ;
hao Can dao ren 殘道人 ,
Dian zhu dao ren 菴住道人 , Shi dao ren 石道人
1612–1674 or later

Kun Can was from Hunan province, and when he was still quite young became a Chan buddhist monk. He spent most of his life in Nanjing, where he associated with Ming loyalist painters and writers, and where he was abbot of a monastery on Niushou Shan.
Murck 1991, pp. 513–34; New York 1962; Xue 1996.

59 Landscape

HANGING SCROLL, INK AND COLOUR ON PAPER

INSCRIBED:

丙子秋月上浣　石溪

□出丘壑姿，嚴槓懸月點，爽氣與蒸嵐，不將洞門掩，驚昏忽策仗，
跳躑成夢□你老猿啼，起視光□□，鎮日□經行，發興在途險，遠岳
與近戲□，後先共天儼，瑰情出天表，宛翠撲人臉，日腳□近人，梳
雲生絕巘，五□即註之，決股瘦拘遍，撿石骨如前□，有松髮如染，
身望為小鳥，群峰忽然斂，望高而臨深，拳拳齊諫貶，路窮置我，源
門取架巇，既足供吾目，又足息吳吾□，一幅溪籐紙，寫此氣冉冉
丙子秋月賞浣值東田詞鑒，雨中乘興，過余雙樹軒，袖□□索，畫師
應此幽棲宵住石溪殘道人記筆

TWO KUN CAN SEALS

129.5 × 63.5 CM

EA 1956.3919

The very close similarity between this work and a painting in the
Crawford Collection, New York suggests that one, or both, of the
paintings may be copied. See New York 1962, no.71.

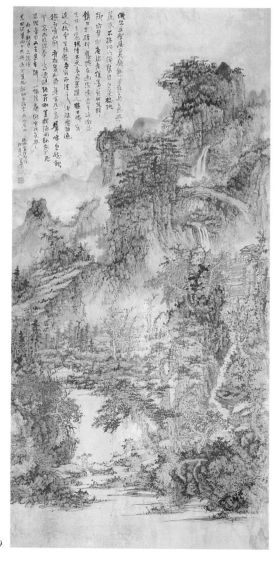

LI JUDUAN 李居瑞

ming Yaochen 耀辰 ; *zi* Yanshan 研山

1898–1961

Li Juduan was from Xinhui in Guangdong province. He studied Western painting while in Peking as a law student, and on his return to Guangzhou practised as a lawyer. He was a traditional ink painter, and calligrapher, and became head of the art college in Guangzhou. At the end of the Sino-Japanese War he moved to Hong Kong, where he and Lui Shou-kwan (q.v.) later became acquainted.

60 *Guqing Peak*

FAN PAINTING MOUNTED AS ALBUM LEAF, INK ON PAPER

INSCRIBED: 研山寫
 孤青峰 康候題

ARTIST'S SEAL; ONE FURTHER SEAL

D. 51.1 CM

EA 1965.27

Lady Cash Bequest purchase

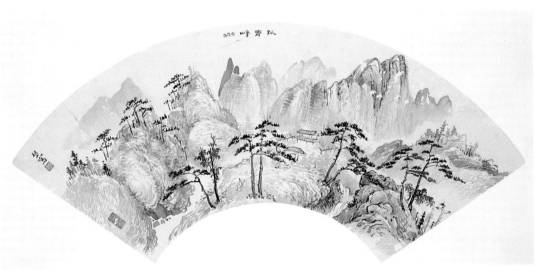

60

61 *Qingxia Cave*

FAN PAINTING MOUNTED AS ALBUM LEAF, INK ON PAPER

INSCRIBED: 青霞洞
 蘇真人修煉處即洗桂奇讀書台，又有湛甘泉書院 康候
 研山寫

THREE SEALS OF THE ARTIST; TWO FURTHER SEALS

D. 52 CM

EA 1965.28

Lady Cash Bequest purchase

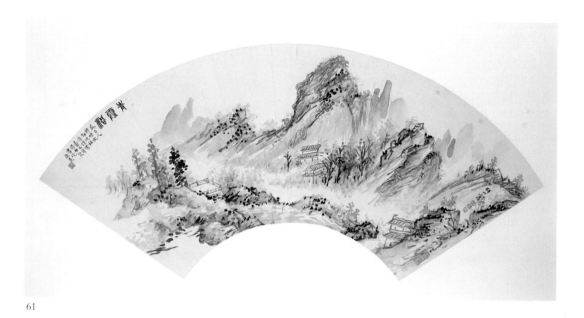

61

62　Peach Blossom Cave

FAN PAINTING MOUNTED AS ALBUM LEAF, INK AND COLOUR
ON PAPER

INSCRIBED:

桃源洞
羅浮東麓洞多桃，每春明花發，落花隨水而出，遂名其洞。康候
研山寫

ARTIST'S SEAL; TWO FURTHER SEALS

D. 50.8 CM

EA 1965.29

Lady Cash Bequest purchase

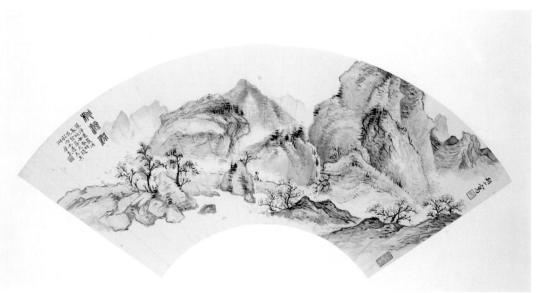

62

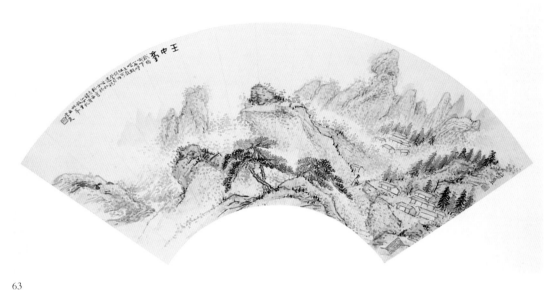

63

63 *Wangzhong Peak*

FAN PAINTING MOUNTED AS ALBUM LEAF, INK AND COLOUR
ON PAPER

INSCRIBED:

研山畫
王中峰　　鐵橋南下一石崢嶸挺立數似可躡而登。自遠視之如女梳
妝，舊志亦謂有仙女梳妝於此峰雲　　康候

ARTIST'S SEAL; TWO FURTHER SEALS

D. 51 CM

EA 1965.30

Lady Cash Bequest purchase

64 *Feiyun Peak*

FAN PAINTING MOUNTED AS ALBUM LEAF, INK AND COLOUR
ON PAPER

INSCRIBED:

研山寫
飛雲峰　　在羅山絕頂，其峰矗天，晴霽常有雲氣，朱子常登此，
晨起見煙雲在山下，衆山露峰尖，如在大海中雲氣往來。山若移動，
天下奇觀也　　康候書

ARTIST'S SEAL; TWO FURTHER SEALS

D. 51.2 CM

EA 1965.31

Lady Cash Bequest purchase

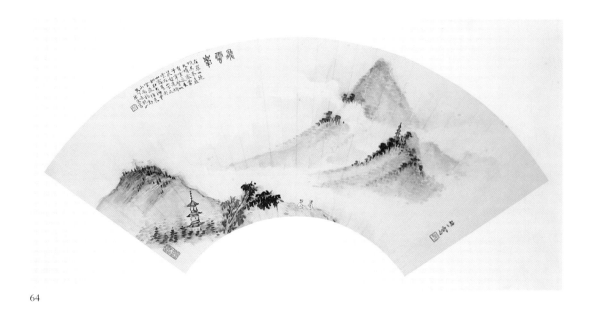

65 *Shuangji Peak*

FAN PAINTING MOUNTED AS ALBUM LEAF, INK ON PAPER

INSCRIBED: 研山寫

雙髻峰　　康候書

ARTIST'S SEAL; ONE FURTHER SEAL

D. 51.2 CM

EA 1965.32

Lady Cash Bequest purchase

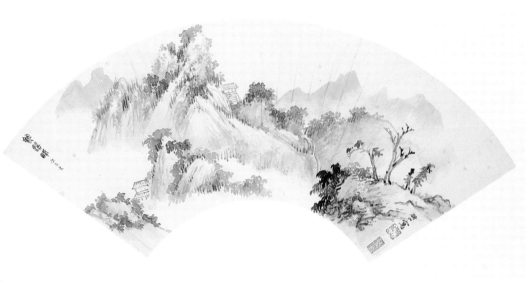

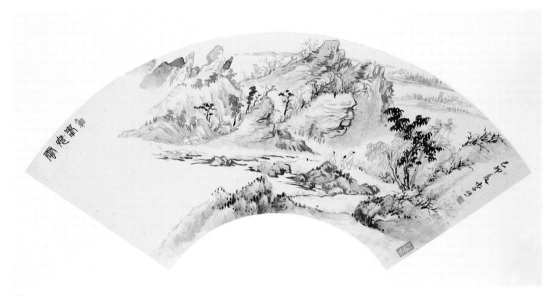

66

66 *Yunmei Peak*

1939

FAN PAINTING MOUNTED AS ALBUM LEAF, INK ON PAPER

INSCRIBED: 己卯夏 李研山

雲母峰　　康候

ARTIST'S SEAL; ONE FURTHER SEAL

D. 51.5 CM

EA 1965.33

Lady Cash Bequest purchase

67 *Fenghuang Gorge*

1939

FAN PAINTING MOUNTED AS ALBUM LEAF, INK AND COLOUR ON PAPER

INSCRIBED:

鳳皇谷 上界三峰下有夜樂洞，鳳皇谷左洞西時有五色□氣，瀑布泉

桂峰側　　康候

己卯夏李研山寫

ARTIST'S SEAL; TWO FURTHER SEALS

D. 51.5 CM

EA 1965.34

Lady Cash Bequest purchase

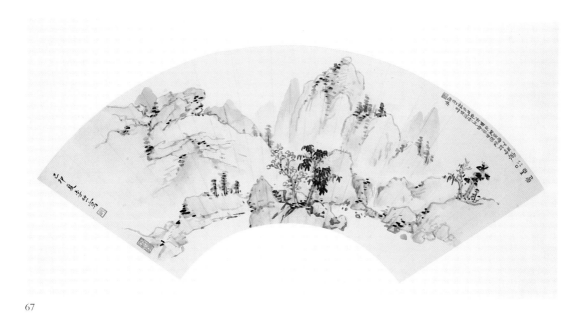

67

68 *Meihua Village*

1939

FAN PAINTING MOUNTED AS ALBUM LEAF, INK AND COLOUR
ON PAPER

INSCRIBED:

梅花村　　康候　　余未嘗至羅浮，此志備名。臆成十二麵。為消夏
清課雲　　己卯　　李研山

THREE SEALS

D. 51.4

EA 1965.35

Lady Cash Bequest purchase

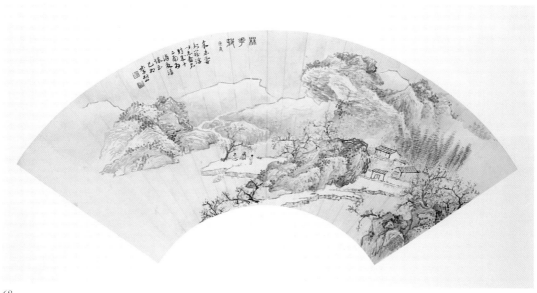

68

69

69 *Three Heavenly Peaks*

FAN PAINTING MOUNTED AS ALBUM LEAF, INK ON PAPER

INSCRIBED:

上界三峰　浮山絕頂、高三千六百丈，與羅山併峙，于四百三十二峰
為最高，故曰第一峰，或又稱為三界峰　康侯

TWO SEALS

D. 51.2 CM

EA1965.36

Lady Cash Bequest purchase

70 *Secluded Cave*

FAN PAINTING MOUNTED AS ALBUM LEAF, INK AND COLOUR
ON PAPER

INSCRIBED:

幽居洞　　洞中多庵堂，在沖虛觀，北有逍遙庵，白雲庵，庵有東
軒鄭公書堂在焉。洞後滴水巖、黃子書堂，禽聲樹色，陰翳闃寂
　　愚山馮康侯書

ARTIST'S SEAL; THREE FURTHER SEALS

D. 51.5 CM

EA 1965.37

Lady Cash Bequest purchase

71 *Nobleman's Cliff*

FAN PAINTING MOUNTED AS ALBUM LEAF, INK ON PAPER

INSCRIBED:

君子嵒　　在長春觀前近通天巖，舊志雲，其峰秀整端麗，類雅操
高潔之士故以君子名巖　　馮康候書
研山

SEAL OF THE ARTIST; TWO FURTHER SEALS

D. 51 CM

EA 1965.38

Lady Cash Bequest purchase

The above paintings are signed Li Yanshan but the inscriptions are all
signed Kang Hou or Feng Kang Hou (b. 1899, Guangdong) and most
bear his seal. The inscription in No. 66 says that twelve paintings were
completed on a trip to Luofu in 1939; Luofu is in the north of Li
Juduan's native province of Guangdong, close to the border with
Jiangxi province, and it is possible that the allusion is to this group of
twelve fan paintings. All twelve bear the same studio seal.

LI KERAN 李可染

1907–1989

Li Keran was born in Xuzhou in Jiangsu province. He attended art school in Shanghai at the age of fifteen, graduating in 1925, and later studied at the National Academy of Art in Hangzhou where his courses included sketching and oil painting. He spent some time in Chongqing, Sichuan, during the Sino-Japanese War and in 1947 went to Beijing, where he spent ten years as a pupil of Qi Baishi (q.v.); he was also taught by Huang Binhong (q.v.). He himself taught at the Central Academy of Fine Arts. He had a successful career as an artist until the Cultural Revolution, and painted again from the late seventies until his death a decade later.

Li 1959; Li 1962; Li 1986; Li 1990; Rychterova 1963.

72　Herdboy and buffalo

HANGING SCROLL, INK AND COLOUR ON PAPER

SIGNED: 可染

TWO SEALS OF THE ARTIST

70 × 46 CM

EA 1963.4

The same two seals appear on another herdboy subject in Rychterova 1963, p.18

Exhibited: Edinburgh 1967, no.33

73　*Sails in the Wu gorges*

HANGING SCROLL, INK AND COLOUR ON PAPER

INSCRIBED: 巫峽帆影　此圖吾屢屢畫之　可染

ONE SEAL OF THE ARTIST: TWO FURTHER SEALS

56.6 × 46 CM

EA 1964.79

Exhibited: Edinburgh 1967, no.34

74　Zhong Kui, the demon queller

HANGING SCROLL, INK AND COLOUR ON PAPER

INSCRIBED: 李可染 貝雅集同志屬正

TWO SEALS OF THE ARTIST

70.5 × 34.5 CM

EA 1981.45

Published: Rychterova 1963, pl.III

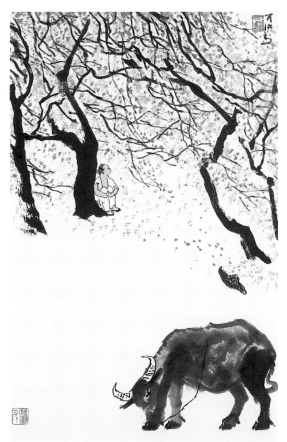

72

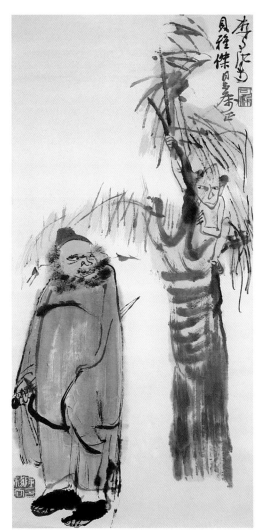

74

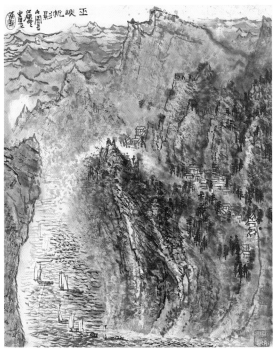

73

LI KUCHAN 李苦禪

ming Li Ying 李英；；*hao* Li Gong 厲公
1898–1983

Li Kuchan was born in Gaotang, Shandong province and moved to Peking in 1919. He studied painting at the After Hours Painting Research Society (*yeyu huafa yanjiu hui*), where he met Xu Beihong, and subsequently at the Peking Academy, where he was influenced by Qi Baishi. He graduated in 1925. He also studied Western art with the Czechoslovakian professor Vojtech Chytil. He taught Chinese painting at Hangzhou and then in Beijing, though he always retained his early interest in Western painting.
Li 1978; Li 1980; Li 1931; Li 1981; Li 1987.

75 Bird and lotus

HANGING SCROLL, INK AND COLOUR ON PAPER
INSCRIBED:
最可羨天邊飛鳥堪留戀，江湖風煙□送白雲、友古松而盤桓　　六月
大雨連綿殊感寂苦。爰同友人淡次寫此，不知荷花之已開也　　勵公

ARTIST'S SEAL
117 × 49.3 CM
EA 1964.77
Exhibited: Collett's, London, April 1964; Edinburgh 1967, no.35

76 Birds and bamboo

HANGING SCROLL, INK AND COLOUR ON PAPER
SIGNED: 厲公畫
ARTIST'S SEAL
95 × 43.5 CM
EA 1965.249

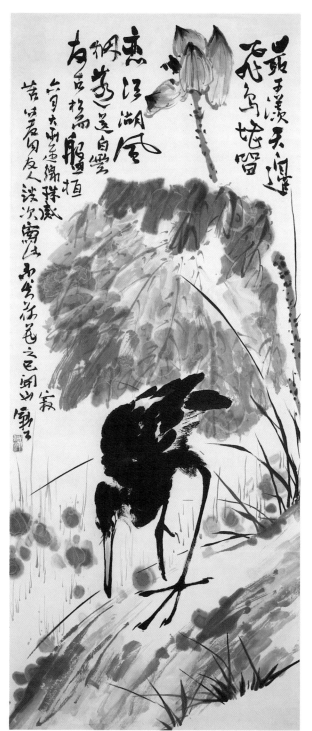

75

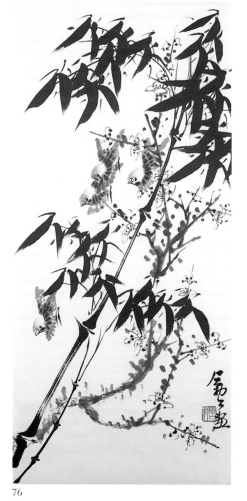

76

77 Fish

1964
HANGING SCROLL, INK AND COLOUR ON PAPER
INSCRIBED:
莫道昆明池水淺，觀魚勝過富春江　　一九六四年　　苦禪
ARTIST'S SEAL
99.1 × 49.5 CM
EA 1969.64

78 Hen

HANGING SCROLL, INK ON PAPER
INSCRIBED:
貝雅傑友行將歸國。不勝依依。謹贈此以作紀念　　苦禪
西夏寫 苦禪作
TWO SEALS OF THE ARTIST
75 × 43.5 CM
EA 1981.46

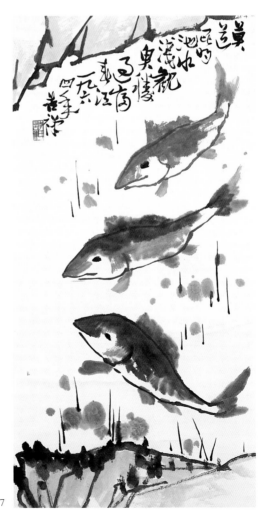

77

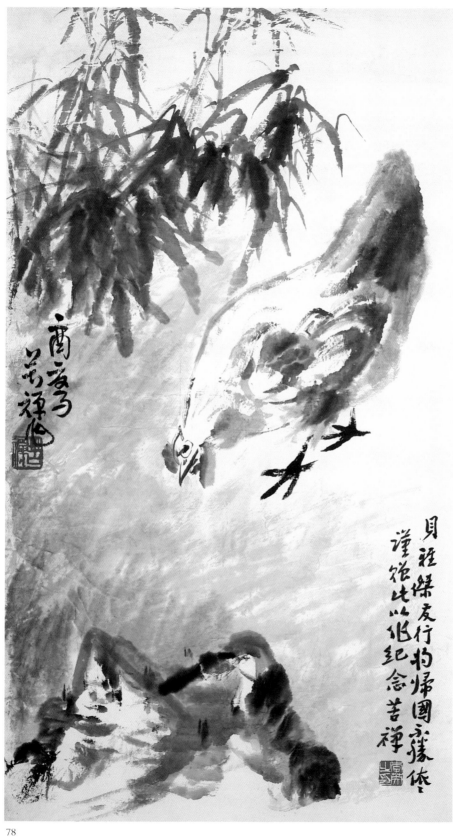

78

LI SHIZHUO 李世倬

zi Han zhang 漢章 , Tian tao 天濤 ;

hao Gu zhai 穀齋 , Lu yuan 菉園 , Xing ya 星崖

and others

c.1690–1770

Li Shizhuo was from Tieling in Liaoning province. He was a nephew of the individualist painter Gao Qipei, also from Tieling. Li served as an official in Taicang, where he learnt painting from the orthodox master Wang Hui. Between 1730 and 1750 he was at court in Peking, and spent the last twenty years of his life in impoverished retirement.
Cleveland 1980, nos.176, 177.

79 Landscape with water buffalo

HANGING SCROLL, INK ON PAPER

INSCRIBED: 三春圖 仿戴篙筆意　李世倬

TWO SEALS OF THE ARTIST; THREE FURTHER SEALS

81.5 × 37 CM

EA 1964.82

Dai Song, mentioned in the inscription, was a Tang (618–906) dynasty artist known for his paintings of buffalo.

LI WENXIN 李文信

ming Tao 濤

b. 1927

Li Wenxin was born in Shuangliu, Sichuan, and apart from a spell studying art in Hangzhou, has spent his career in Sichuan province. He originally specialised in figure painting, particularly the national minority peoples of the southwest, but in 1977 turned to landscape. During the 1980s his work was presented in individual exhibitions in Beijing, Guangzhou and other parts of the country.
Li 1994.

80 *Burbling waters of Spring*

1981

HANGING SCROLL, INK AND COLOUR ON PAPER

INSCRIBED: 春水潺潺　辛酉年三月下浣寫于山城

TWO SEALS OF THE ARTIST; TWO FURTHER SEALS

94.5 × 58 CM

EA 1982.23

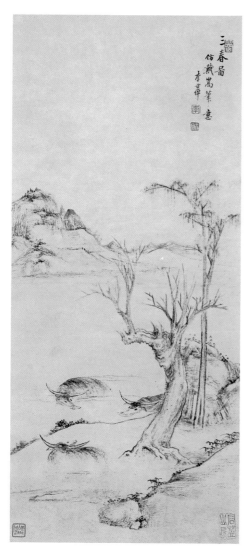

79

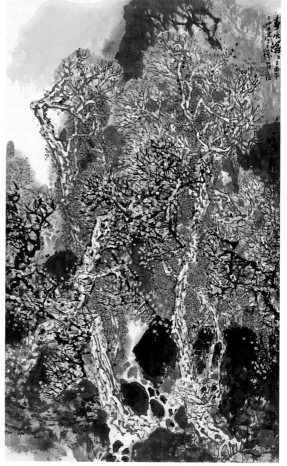

80

LIN FENGMIAN 林風眠

1900–1991

Lin Fengmian was born in Meixian, Guangdong province. From 1920 to 1925 he studied painting in France, initially in Marseilles but mostly in Paris, taking a great interest in Western art. Lin Fengmian was, with Liu Haisu and Xu Beihong, the principal artist responsible for the direct introduction of Western painting methods. On his return to China he became Professor of Painting at the National Art School in Peking, and in 1927 founding principal of the National Art Academy in Hangzhou. He gave up administration in the 1950s and thereafter concentrated on painting. Many of his pupils established successful careers, and his adoption of Western colour and painting style has been one of the major influences in twentieth century painting in China.

Hangzhou 1999; Hangzhou 1999a; Lin 1978; Lin 1979; Lin 1994; Zheng 1990; Zheng 1999.

81 Pair of birds on a flowering wisteria bough

HANGING SCROLL, INK AND COLOUR ON PAPER

SIGNED: 林風眠

SEAL OF THE ARTIST

45.1 × 42.3 CM

EA 1968.72

This was a favoured subject of Lin Fengmian; a closely comparable painting dated 1946, in the collection of Wu Guanzhong, is published in Lin 1994 vol.1, no.33.

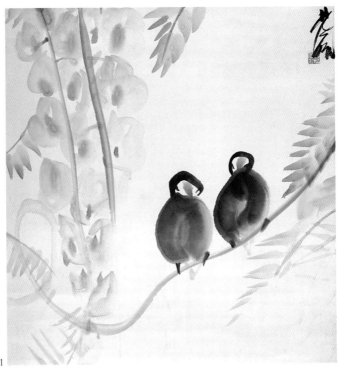

81

LIU XILING 劉錫玲

zi Zi Qian 梓謙 ; *hao* Long dao ren 聾道人 ,
Zi wen ju shi 自聞居士

Active in the Guangxu (1875–1908) period of the Qing dynasty
Liu Xiling was from Huayang (present-day Chengdu) in Sichuan
province, but as a painter was active in Zhejiang. His painting style and
subject matter were inspired by Gao Qipei (q.v.).

82 Birds and still life

ALBUM, SEVEN LEAVES, INK AND COLOUR ON PAPER
INSCRIBED:

X.5345 a: □團故應誇風味，爽口猶多醉醉時。　自聞居士作

X.5345 b: 五夜一燈尋樂處　黃金杯重壓銀臺
聾畫

X.5345 c: 燕子池邊聲相喚　柳偏東麵受多
自聞居士

X.5345 d: 焚香坐對青玉樂　時待飛花入硯池
我用香時
劉錫玲爪墨

X.5345 e: 家山風味納涼地　醉後逍遙自在時
錫玲指痕

X.5345 f: 美人初起姍朧眼　片石遙看是鏡臺
聾道人指戲

X.5345 g: 豆棚一角閒餘地　留與兒童作戰場
梓開戲題　聾道人

EACH WITH ARTIST'S SEAL
EACH 21.5 × 36.5 CM APPROXIMATELY
EA X.5345 A–G

82a

82b

82c

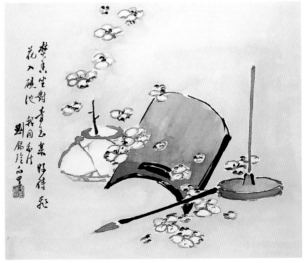

82d

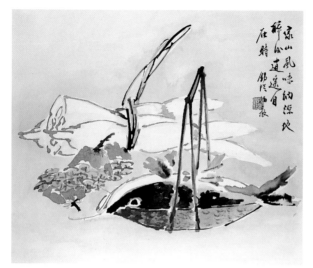

82e

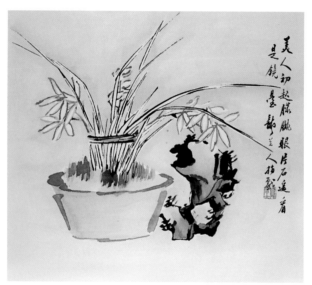

82f

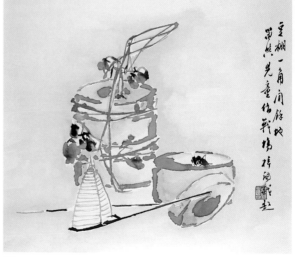

82g

LO CH'ING 羅青
b. 1948

Lo Ch'ing was born in Qingdao, Shandong province, but grew up in Taiwan where he is now Professor of English at Taiwan Normal University. At the age of thirteen he became a pupil of the Qing imperial prince Pu Hsin-yu, renowned for his traditional style. Lo Ch'ing later followed the Zen Buddhist monk painter Ju-yu and is now well-known as a poet and as a calligrapher and painter.
Lo 1990; Lo 1990a; Lo 1993.

83 Landscape

1981
HANGING SCROLL, INK AND COLOUR ON PAPER
INSCRIBED:
平靜的水麵有時也會波濤洶湧如奇峰 突起　　七十年夏　　羅青
TWO SEALS OF THE ARTIST
69 × 34 CM
EA 1993.38

LU ZHI 陸治
zi Shu Ping 叔平
1496–1576

Lu Zhi, born in Wuxian (present day Suzhou) in Jiangsu province, was a member of the close circle of the illustrious Ming painter Wen Zhengming. Lu was admired in his lifetime for his flower and bird paintings though today his landscapes, in Song style, are equally appreciated.
Taipei 1992.

84 Lily

FAN PAINTING MOUNTED AS ALBUM LEAF, INK AND COLOUR ON GOLD PAPER
INSCRIBED:
昔本簪頭玉，今為枝上花，只愁明月夜。飛去復還家　　　陸治
ARTIST'S SEAL; THREE FURTHER SEALS
D. 52.7 CM
EA 1965.184
Ex Seligman Collection

Exhibited: London, The Oriental Ceramic Society, 1957, The Arts of the Ming Dynasty

Published: *Transactions of the Oriental Ceramic Society* vol.30, no.23 and pl.12

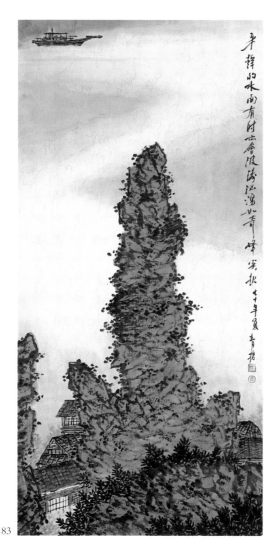

平静的水面有时亦奔波海陆温业青峰癸秋十年夏青揚

83

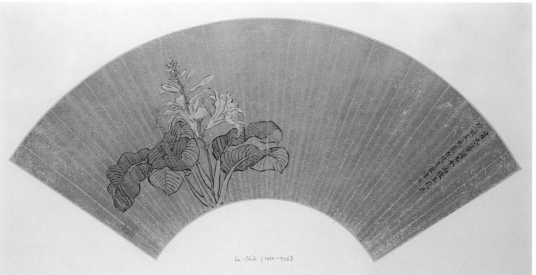

Lu-Chih (1496-1576)

84

LUI SHOU-KWAN 呂壽琨

Lu Shoukun
1919–1975

Lui Shou-kwan was from Heshan in Guangdong province. He graduated in economics at Guangzhou University and settled in Hong Kong in 1948. The following year he joined the Hong Kong and Yaumati Ferry Company as an inspector, working there until 1966, but he always continued to paint. He was an energetic teacher of ink painting both at the University of Hong Kong, Department of Architecture, and in the Extramural Studies Department of the Chinese University of Hong Kong. From 1954 until his death he was active in numerous Hong Kong art societies. His work falls broadly into two categories: Hong Kong landscapes, and Chan (Zen) paintings. Lui is noted for his use of abstraction, inspired at least as much by early Chinese precedents as by American painting, and for introducing Western styles of painting in Hong Kong. Lui exhibited frequently in Hong Kong and the U.K., with exhibitions in 1963, 1967 and 1974 at the Ashmolean Museum. A further Ashmolean exhibition was held in 1982.
Hong Kong 1964; Hong Kong 1985; London 1969; Wong 1979

85 *Shaukiwan, Hong Kong*

HORIZONTAL SCROLL, INK AND COLOUR ON PAPER
INSCRIBED: 筲箕灣本屋辛丑秋分呂壽
　　　　　　琨寫
THREE SEALS OF THE ARTIST
45.5 × 136 CM
EA X.5360

85

86

86 *Reflection*

1962
INK ON PAPER
INSCRIBED: 壬寅二月呂壽琨
ARTIST'S SEAL
46.5 × 37.4 CM
1962.246
Given by the artist

87 *Blue Houses*

1951
HANGING SCROLL, INK AND COLOUR ON PAPER
INSCRIBED: 辛丑呂壽琨寫
ARTIST'S SEAL
181.5 × 52.5 CM
EA 1968.3
The title does not appear in the inscription, but was used by the artist.

87

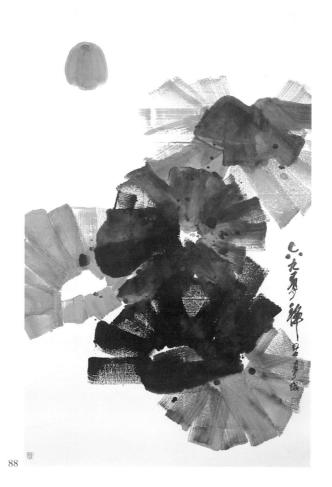

88

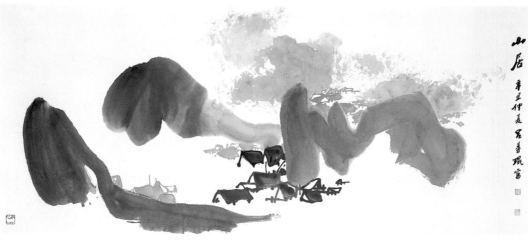

89

88 Chan painting

1969
VERTICAL SCROLL, INK AND COLOUR ON PAPER
INSCRIBED: 六九尋禪 呂壽琨
TWO SEALS
180 × 96.5 CM
EA 1975.4
Given by the artist

89 Dwellings among hills

1961
HORIZONTAL SCROLL, INK AND COLOUR ON PAPER
INSCRIBED: 山居 辛丑仲夏呂壽琨寫
THREE SEALS OF THE ARTIST
37.5 × 89 CM
EA 1981.61
Barker Bequest

90 Bird's eye view from Victoria Peak

1961
HORIZONTAL SCROLL, INK AND COLOUR ON PAPER
INSCRIBED: 辛丑冬至又上太手山在暮
　　　　　　色中鳥瞰塢　呂壽琨
TWO SEALS OF THE ARTIST
23 × 95.3 CM
EA 1981.62
Barker Bequest

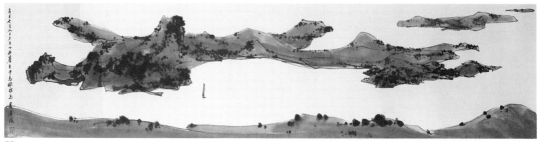

90

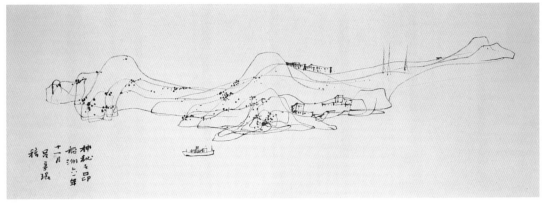

91

91 *Stonecutters' Island*

1961

HORIZONTAL SCROLL, INK ON PAPER

INSCRIBED: 神祕之昂船洲六一年十一月呂壽琨稿

NO SEALS

29.8 × 85 CM

1981.63

Barker Bequest

92 Abstract

1963

VERTICAL SCROLL, INK AND
COLOUR ON PAPER

INSCRIBED: 葵卯仲春呂壽琨寫

TWO SEALS OF THE ARTIST

94 × 37.4 CM

1981.64

Barker Bequest

92

93

93 Basket of flowers

1959
HORIZONTAL SCROLL, INK ON PAPER
INSCRIBED: 己亥夏日呂壽琨繪
THREE SEALS OF THE ARTIST
43 × 94.5 CM
EA 1981.65
Barker Bequest

94 *Shade*

1963
VERTICAL SCROLL, INK AND COLOUR ON PAPER
INSCRIBED: 蔭庇癸卯二月呂壽琨寫
TWO SEALS OF THE ARTIST
98.5 × 58.4 CM
EA 1981.66
Barker Bequest
The building depicted is St. John's Cathedral, Hong Kong.

95 *Tin Hao festival, Lyemun*

1963
HORIZONTAL SCROLL, INK AND COLOUR ON PAPER
INSCRIBED:　六九尋禪　呂壽琨
　　　　　　癸卯三月二三佛堂門天后誕□廟人潮靜
　　　　　　坐崗上，描繪□覺授入群眾狂熱中，無
　　　　　　我之不由自主歸而竟寫之優靈小子
　　　　　　呂壽琨
THREE SEALS OF THE ARTIST
58.4 × 121 CM
EA 1981.67
Barker Bequest

96 Chan painting

1969
VERTICAL SCROLL, INK AND YELLOW SPLASH ON PAPER
FOUR SEALS OF THE ARTIST
151.5 × 83 CM
EA 1981.68
Barker Bequest

97 Chan painting

1969
VERTICAL SCROLL, INK AND COLOUR ON PAPER
THREE SEALS OF THE ARTIST
151 × 82.1 CM
EA 1981.69
Barker Bequest

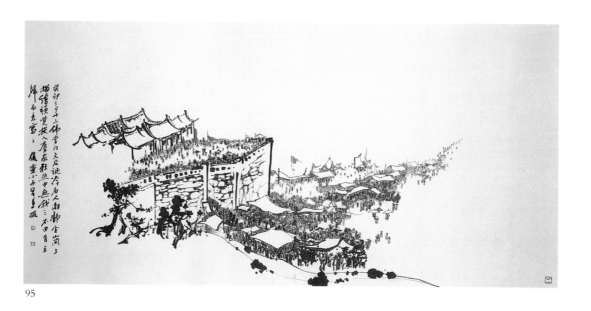

95

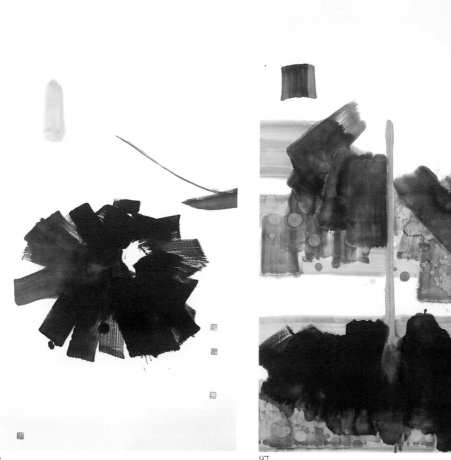

96

97

98 Chan painting

1969
VERTICAL SCROLL, INK AND COLOUR ON PAPER
THREE SEALS OF THE ARTIST
151 × 82.5 CM
EA 1981.70
Barker Bequest

99 *Naturalness*

PROBABLY 1963
VERTICAL SCROLL, INK AND COLOUR ON PAPER
INSCRIBED: 辛卯春日香港呂壽琨寫
THREE SEALS OF THE ARTIST
187 × 47 CM
EA 1981.71

There is no reference on the painting to the title, which must have been that used by the artist. The cyclical date in the inscription is 1951; however the style is not in keeping with Lui's work of that period, and a date in the 1960s is much more probable. See also the inscription in cat. no. 91.

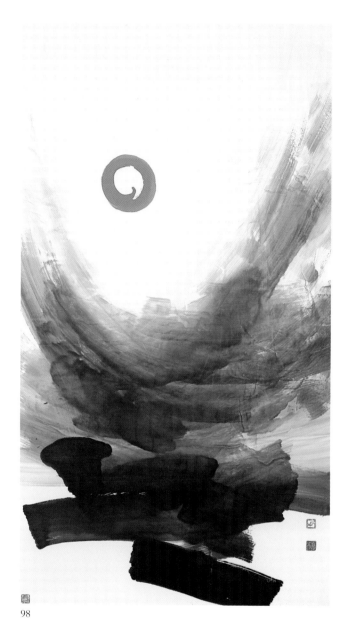

98

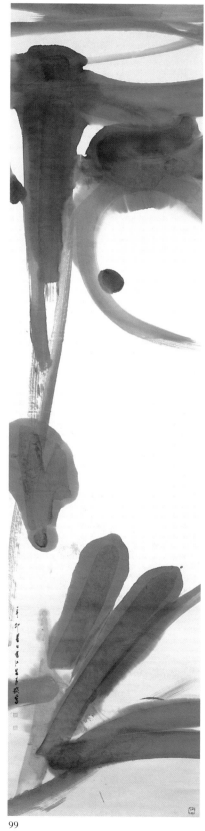

99

LUO MU 羅牧
zi Fanniu 飯牛
1622–after 1704

Luo Mu was from Ningdu in Jiangxi and lived mostly in the provincial capital, Nanchang. He had a reputation for conviviality and for being good at composing poetry.

100 Landscape

1685
HANGING SCROLL, INK ON PAPER
INSCRIBED:
乙酉夏五月畫得，赤日石林氣。青天江海流。□□山牧道者
TWO SEALS OF THE ARTIST
174.7 × 75 CM
EA 1965.175

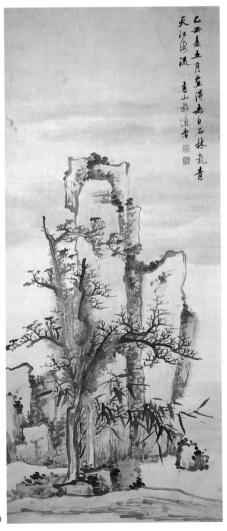

100

101

LUO YANG 羅陽

zi Jian Gu 健谷

Qing dynasty

Luo Yang was from Shunde in Guangdong, though little more is recorded about him. He was renowned for his careful brushwork.

101 Landscape

1823 OR 1883
ALBUM LEAF, INK AND COLOUR ON PAPER
INSCRIBED: 癸末冬十一月仿苦瓜道人筆意為　綽夫大兄鑒　羅 陽
SEAL OF THE ARTIST
23.3 × 26.5 CM
EA 1960.226

MIN ZHEN 閔貞

zi Zheng Zhai 正齋, Min Naizi 閔騃子

1730–after 1788

Min Zhen was born in Nanchang, Jiangxi province but lived mostly in Hankou, Hubei. He was orphaned at an early age and it is said that the indifferent quality of his family's ancestral portraits prompted him to apply himself particularly keenly to studying painting. He was also a skilled seal carver.

102 Man and boy watching a crane

HANGING SCROLL, INK ON PAPER

SIGNED: 正齋閔貞畫

SEAL OF THE ARTIST; ONE FURTHER SEAL

79 × 49 CM

EA 1964.83

102

103 Album of figure paintings

1775
TWELVE LEAVES, INK AND COLOUR ON PAPER
THE FIRST INSCRIBED: 乙未端陽　正齋閔貞畫
EACH WITH ARTIST'S SEAL
EACH LEAF APPROXIMATELY 22.5 × 19.5
EA 1964.233 I–XII

103a

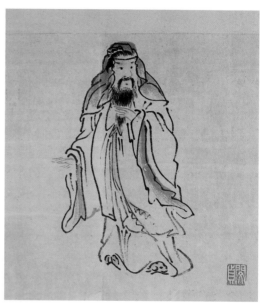

103b

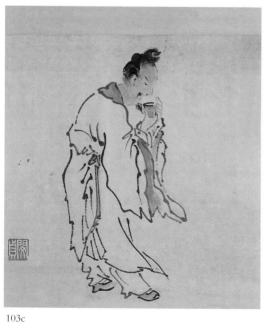

103c

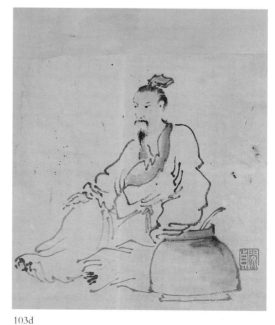

103d

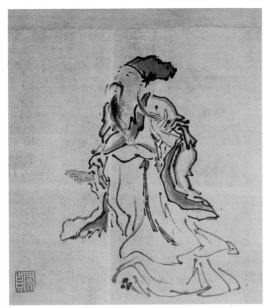

103e

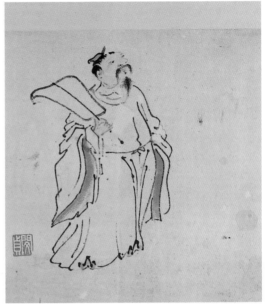

103f

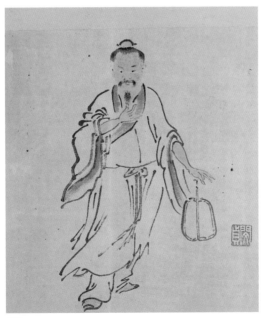

103g

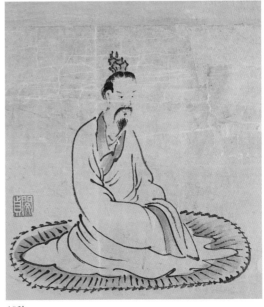

103h

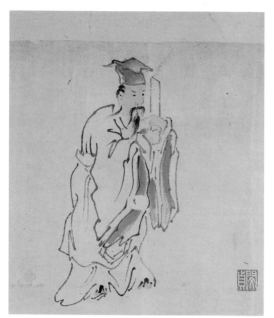

103i

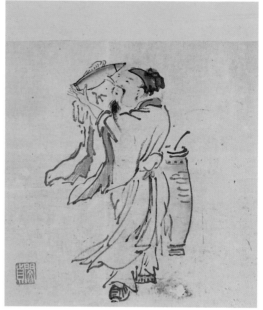

103j

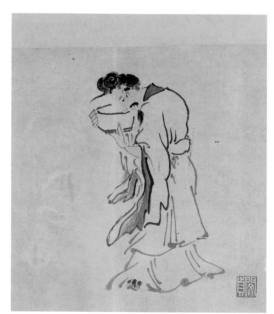

103k

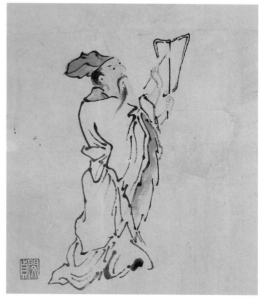

103l

NI TIAN 倪田

also Bao Tian 寶田; *zi* Mo Geng 墨耕

1855–1919

Ni Tian was from Yangzhou in Jiangsu, where as a painter he followed the eighteenth-century Yangzhou eccentric, Hua Yan. He first studied painting with Wang Su, and specialised in figures and Buddhist images. He settled in Shanghai, probably during the late 1880s or early 1890s, and he appears then to have immersed himself in the Shanghai School, with a particular regard for its leading painter, Ren Yi (d. 1895, q.v.). He has been credited with carrying forward Ren's style to a third generation of Shanghai painters. He was also well-known as a dealer in paintings. Brown and Chou 1992, pp. 202–7.

104 River landscape

HANGING SCROLL, INK AND COLOUR ON PAPER
INSCRIBED: 南宮煙雨圖，趙大年亦嘗為之 倪田寫意
86.5 × 33 CM
EA 1991.187

PAN DINGLAN 潘定瀾

zi Liu Tang 柳塘

Qing dynasty

Pan Dinglan was born at Changning near Huizhou in Guangdong province. Little is known of his life; he is reputed to have been good at calligraphy, and at landscape and figure painting. An undated landscape is in the collection of the Art Gallery and Museum, Chinese University of Hong Kong (Hong Kong 1981a, no.240).

105 *Landscape*

HANGING SCROLL, INK AND COLOUR ON PAPER
INSCRIBED: 青山瓊雨晚來晴，林木重
重畫意生，記得當年寓館夜，一窗燈火
讀書靜。 柳塘寫
136 × 33 CM
EA 1991.190.

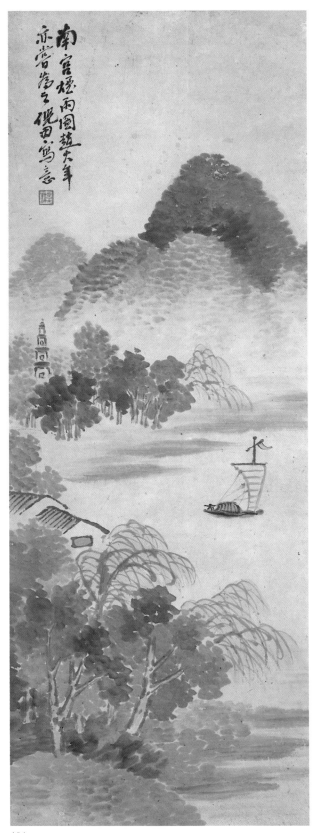

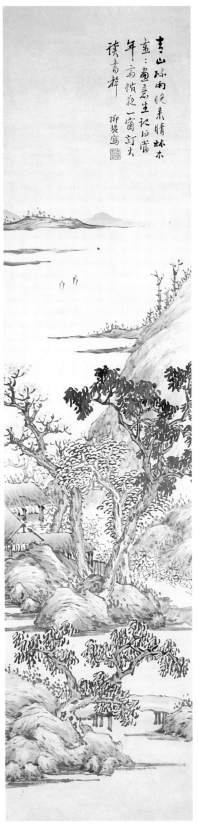

104

105

QI BAISHI 齊白石

zi Wei Qing 渭清, Huang 璜; *hao* Bin sheng 瀕生, and
others
1863–1957

Qi Baishi was born into a poor agricultural family in Xiangtan, Hunan
province, but spent most of his life in Beijing as one of the most illus-
trious painters of modern times. As a teenager he was apprenticed to a
carpenter and in his twenties began studying seal carving and painting.
He travelled widely within China and in 1912, at the age of fifty-five, he
settled in Peking. With the encouragement of Chen Hengke (q.v.) he
became extremely successful as both a painter and a seal-carver, event-
ually establishing a large household, many members of which were
engaged in painting. His work introduced new subject matter – he is
particularly known for paintings of crabs and shrimp, for example – and
is admired for its directness and simplicity. At the age of sixty he knocked
two years from his age for auspicious reasons, complicating the dating of
his later works.
Changsha 1982; Chen 1961; Chongqing 1988; Cui 1992; Qi 1952; Qi
1958; Qi 1963; Qi 1978; Qi 1980; Qi 1982; Taipei 1996; Tsao 1993;
Wang 1976; Wang and Li 1984; Woo 1986; Zhang 1989.

106 Chrysanthemum and bee

FAN PAINTING MOUNTED AS ALBUM LEAF, INK AND COLOUR
ON PAPER
SIGNED: 白石山翁
ARTIST'S SEAL
D. 55.6 CM
EA X.564

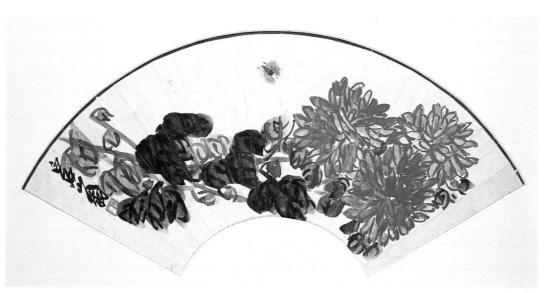

106

107 Plum blossom

1950

HANGING SCROLL, INK AND COLOUR ON PAPER

INSCRIBED: 寄萍堂上老人白石九十歲之作

94.2 × 35.1 CM

EA 1966.89

108 Chicks

1933

HANGING SCROLL, INK AND COLOUR ON PAPER

INSCRIBED: 齊璜 癸酉

99.1 × 33.5 CM

EA 1967.15

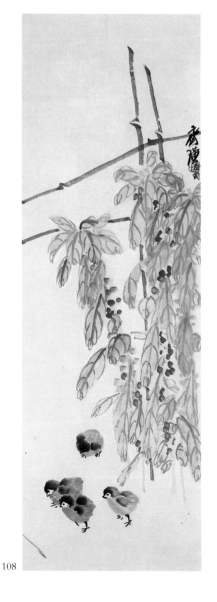

107

108

QI GONG 啓功

zi Yuan bai 元白

b. 1910

Qi Gong is a descendant of the Qing Imperial family, noted for his calligraphy as much as for his landscape painting. He was formerly Professor of Chinese at Fu-jen University in Peking.
Qi 1985.

109 Landscape

1944

HANGING SCROLL, INK AND COLOUR ON PAPER

INSCRIBED:

湘碧老人擬大痴秋山圖古秀天真想見真跡之勝，此幀略師其意
　　甲申長至　元白啓功

137 × 33.7 CM

EA 1964.78

QI SHUKAI 戚叔楷

zi Zimo 子模, *hao* Lan zhuang 蘭莊,

Tie jing dao ren 鐵井道人

Qing dynasty

Qi Shukai, whose dates are unrecorded, was from Wuhu in Anhui province. He was known for flower and plant painting.

110 Birds and branch

HANGING SCROLL, INK AND COLOUR ON PAPER

SIGNED: 鐵井道人寫

ARTIST'S SEAL

116 × 38 CM

EA 1960.242

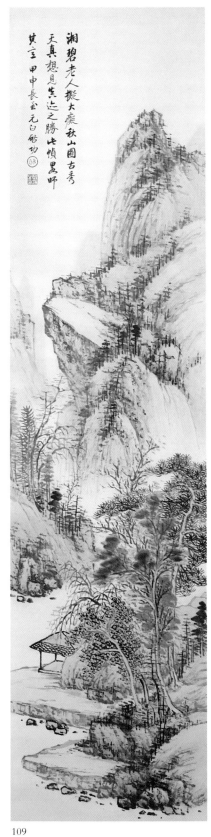

109

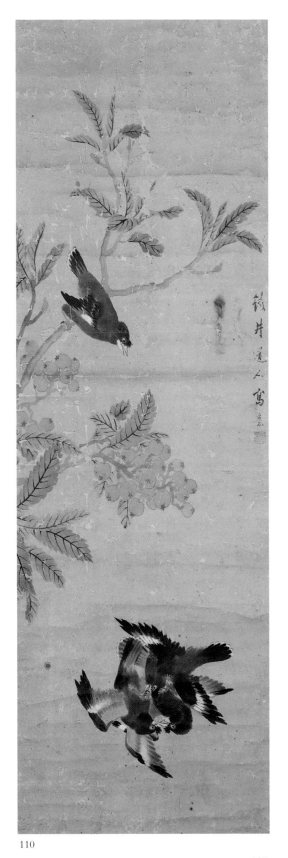

110

QIAN HUI'AN 錢慧安

ming Gui chang 貴昌; *zi* Ji sheng 吉生;

hao Shuang guanlou 雙管樓, Qing xi qiao zi 清谿樵子

1833–1911

Qian Hui'an was from an area of Jiangsu province that is now part of Shanghai, and though he spent some time in neighbouring Zhejiang, he settled in Shanghai proper. There he associated with Ni Tian (q.v.) and others, dealing in as well as producing his own paintings. He was active in at least two painting societies including the Yu Yuan Painting Society, of which he was elected founding president in 1909. He edited the painting catalogue *Qingxi huapu*.

111 *Listening for birds by the young willows at the riverside*

1875
FAN PAINTING MOUNTED AS AN ALBUM LEAF, INK AND
COLOUR ON PAPER
INSCRIBED:
汀前新柳聽有知鸎巳亥六月□為熾枏二兄大人雅屬清新樵子錢慧安
ARTIST'S SEAL; THREE FURTHER SEALS
D. 47.5 CM
EA X.1408

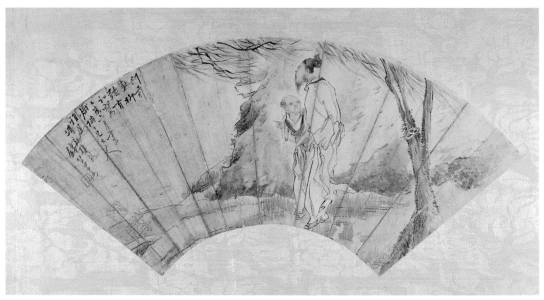

QIAN YA 錢崖

ming Shou tie 瘦鐵; *zi* Shu ya 叔崖

1896–1967

Qian Shoutie was from Wuxi in Jiangsu province, though he was active in Shanghai. In his youth he was apprentice in a stele-carving workshop; he was also interested in seal-carving, for which he became well-known, and was an acquaintance of Wu Changshuo (q.v.). He was also interested in ancient calligraphy. In 1923 he went to Japan. He was involved with numerous painting societies and after 1949 taught at the Shanghai Chinese Painting Academy.

112 *Seeking the marvellous at Mount Huang*

HANGING SCROLL, INK AND COLOUR ON PAPER

INSCRIBED: 黃山探奇　　此景在始信峰之側麵　今寫其大概叔崖

TWO SEALS OF THE ARTIST; ONE FURTHER SEAL

77 × 36 CM

EA 1966.86

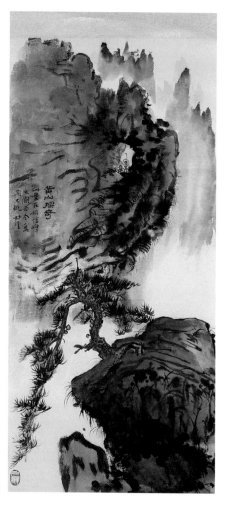

QIAN SONGYAN 錢松嵒

hao Qi lu zhu ren 芑廬主人

1899–1985

Qian Songyan was born in Yixing, Jiangsu province. He studied painting and calligraphy at a private school before attending a further education college. He subsequently taught at several schools, but spent most of his career at Wuxi Art College in the same province. He travelled extensively within China and is known primarily as a traditional landscape painter. Ma 1990; Qian 1979; Qian 1980; Qian 1984.

113 One thousand-foot spring

HANGING SCROLL, INK AND COLOUR ON PAPER
INSCRIBED: 百丈泉　　錢松嵒作于黃山紫雲峰
TWO SEALS OF THE ARTIST; ONE FURTHER SEAL
88.5 × 51 CM
EA 1965.68
The scene depicted is Mt. Huang.

QIN ZUYONG 秦祖永

zi Yi fen 逸芬 ; *hao* Leng yan wai shi 楞煙外史

1825–1884

Qin Zuyong was born in the town of Jinkui, present-day Wuxi, in Jiangsu province. He spent much of his official career as an administrator in Guangdong. He was well known as a poet and as a classicist, and his painting style follows the early Qing orthodox master Wang Shimin.

114 Landscape

1872
HANGING SCROLL, INK AND COLOUR ON SILK
INSCRIBED: 壬申新春寫於粵東寓次　　楞煙外史　秦祖永
TWO SEALS OF THE ARTIST
61.5 × 31.5 CM
EA 1991.191

Purchased by the Friends of the Ashmolean in recognition of Mary Tregear's Keepership of the Department of Eastern Art

Published: *The Ashmolean*, Number Twenty two, Spring/Summer 1992

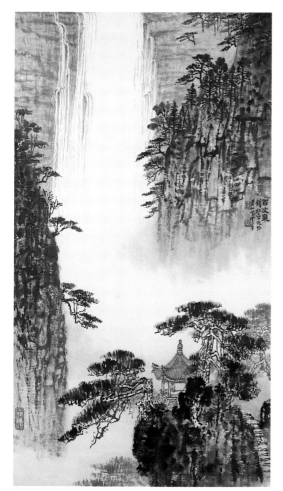

113

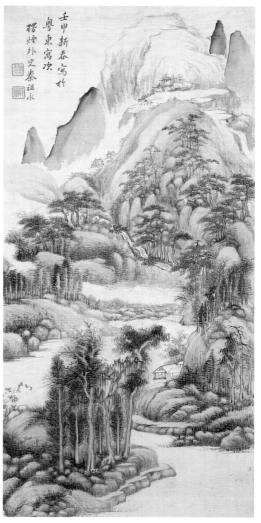

114

REN YI 任頤

zi Bonian 伯年; *hao* Xiao lou 小樓

1840–1896

Ren Yi was from Shanyin, present-day Shaoxing in Zhejiang province, the son of a portraitist. In the winter of 1868 he moved to Shanghai, where he lived for the rest of his life. Shanghai was a rapidly growing commercial centre at that time, and artists from all over China went there to sell their paintings. There emerged a 'Shanghai School' of painting , associated with a synthesis of popular and traditional style , in which Ren Yi is regarded as the leading figure. He is known for his bold brushwork and use of colour, particularly in figure and bird-and-flower paintings. The latter were mostly in Song style until he came across an album by the early Qing individualist painter Zhu Da (Ba da shan ren), by whose looser style he was influenced. He was more closely a successor to the Shanghai based painters Ren Xiong (1823–57) and Ren Xun (1834–93).

Beijing 1979; Cai 1960; Ding 1989; Gong 1982; Gugong 1979; Gugong 1992; Li 1979; Ren 1962; Ren 1983; van der Meyden 1992.

115 Hibiscus and flying kingfishers

1894

HANGING SCROLL, INK AND COLOUR ON PAPER

INSCRIBED: 光緒甲午孟冬　　山陰任頤伯年

ONE SEAL

64.9 × 46.1 CM

EA 1967.14

116 Bird on a branch

1886

ALBUM LEAF, INK AND COLOUR ON PAPER

INSCRIBED: 光緒丙戌冬十二月　　山陰任頤伯年寫于滬上禺齋

ONE SEAL

32.3 × 26.5 CM

EA 1972.25

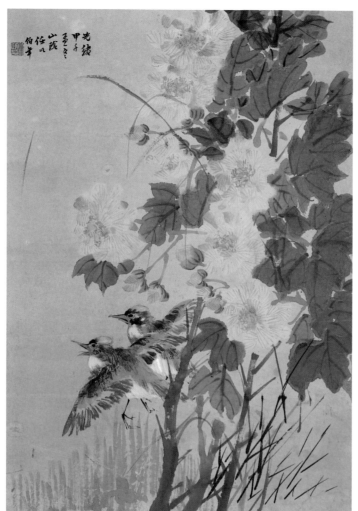

115

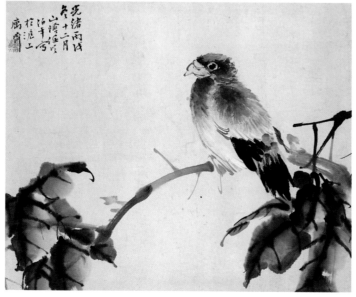

116

117 The God of Longevity, with attendant

1891

WITH CALLIGRAPHY BY WU CHANGSHUO (Q.V.), DATED 1919

HANGING SCROLL, INK AND COLOUR ON PAPER

INSCRIBED:

天頭： 美意延年　己未處暑節題於海上禪甓軒之南樓。　吳昌碩
年七十六

本幅： 光緒辛卯嘉平山陰任頤伯年甫

TWO SEALS OF THE ARTIST, (COMPARE CONTAG, P.101, NOS.6 & 7)

198.3 × 93 CM

EA 1987.31

Wu Changshuo was a pupil of Ren Yi.

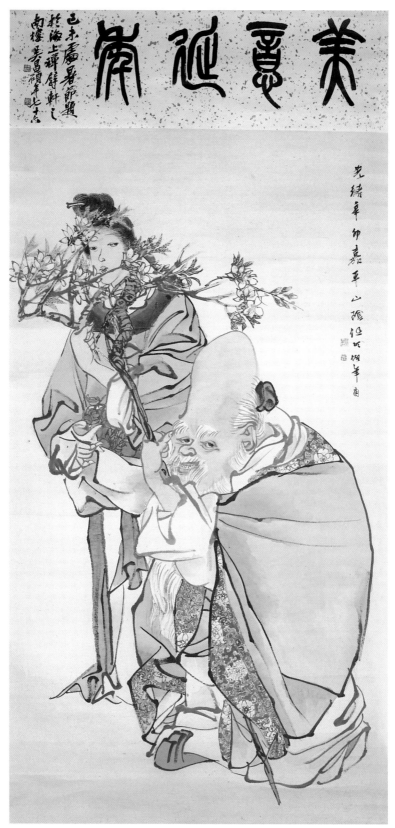

117

SHANG RUI 上睿

zi Jing Rui 靜睿 , Xun Rui 潯睿 ; *hao* Mu Cun 目存 ,
Pu Shizi 蒲室·
1634 – see below for possible dates

Shang Rui, born in present-day Suzhou in Jiangsu province, was a
monk. His painting style was classical, and he also wrote poetry. One
Qing text treats Shang Rui and Mu Cun as two separate painters, and
the date of his death is contentious. The possibilities are 1683, 1686, or
after 1724.

118 Landscape

1703
HANDSCROLL, INK AND COLOUR ON PAPER
INSCRIBED:
葵未秋九月擬文五峰筆法寫奉謚庵老先生正之　蒲室子目存睿
PLUS TITLE AND COLOPHON
NINE SEALS
29 × 385 CM
EA 1978.406
Ex collection Ling Su-hua

118a

118b

118c

118d

118e

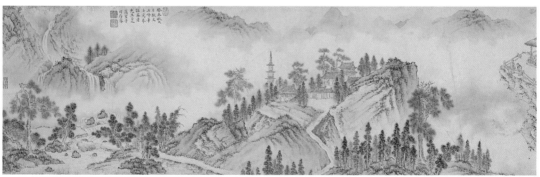

118f

六法氣韻乃天成非功力而能
至此卷筆精墨妙色澤沖和
神韻獨絕晴窗展覽係釋衿
午參上乘禪自能臻此遂識
東宇先生捲離龍中得之首尾
略損重為潢治縱墨如新洵足
珍也可寶藏之
巳邛重陽 易石華品鑒

118g

137

SHEN FUJI 沈福基

Shen Fuji was born in Zhaowen (present-day Changshu) in Jiangsu province, in the Qing dynasty, though his dates are unrecorded. He practised both calligraphy and painting; towards the end of his life he suffered illness and his painting style became increasingly erratic.

119 Landscape

DATED CORRESPONDING TO 1785, 1845 OR 1905

FAN PAINTING MOUNTED AS ALBUM LEAF, INK AND COLOUR ON PAPER

INSCRIBED:

時在乙巳仲春, 法石田翁筆意以應子元仁兄大人即希正之南都□□,
弟沈福基　字草吳中落□池□村屋

D. 49.7 CM

EA 1960.219

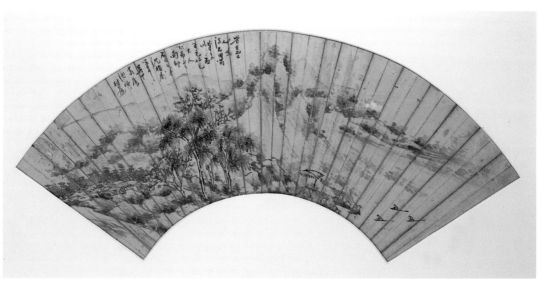

119

SHENG MAOYE 盛茂燁
Also Maohua 茂燁, maoyu 茂煜; *hao* Nian an 念庵, Yan an 研庵
Active c.1607–1637

Sheng Maoye was from Changzhou (present Suzhou) in Jiangsu province. Though Sheng's works are praised in late Ming painting treatises by his contemporaries, few details of his life are known. Most of his extant paintings are preserved in Japan.

120 Landscape

1636

HANGING SCROLL

INK AND SLIGHT COLOUR ON SILK

INSCRIBED:

水寒深見石，秋晚靜聞風，崇禎丙子請和，寫似爾敬詞兄
盛茂燁

ARTIST'S SEAL; FIVE SEALS OF THE EMPEROR QIANLONG
(r.1736–95); TWO FURTHER SEALS

106 × 42.5 CM

EA X.1303

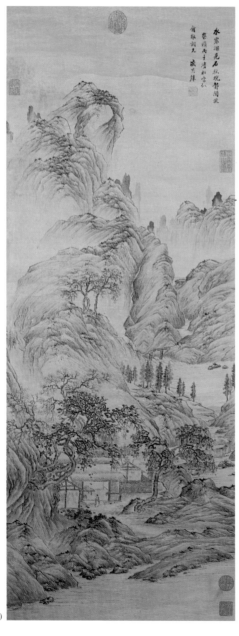

120

SONG WENZHI 宋文治

b. 1919

Song Wenzhi was born in Taicang county in Jiangsu province. Originally an art teacher, he studied painting with Zhu Qizhan and Lu Yanshao, and later with Wu Hufan (q.v.), and in 1957 joined the Jiangsu Chinese Painting Academy. He was later deputy head of Nanjing Art Academy, and toured the country with Fu Baoshi (q.v.) and other artists in 1960. Song Wenzhi is well known for his work of the late 1950s and early 1960s in which contemporary political trends are reflected in traditional style landscapes, and as a landscapist of the Jiangnan region.
Song 1963; Song 1985.

121 Landscape

1964

HANGING SCROLL, INK AND COLOUR ON PAPER

INSCRIBED: 華嶽參天　　一九六四年三月 寫于金陵 文治

SEAL OF THE ARTIST; ONE FURTHER SEAL

90 × 53.5 CM

EA 1965.63

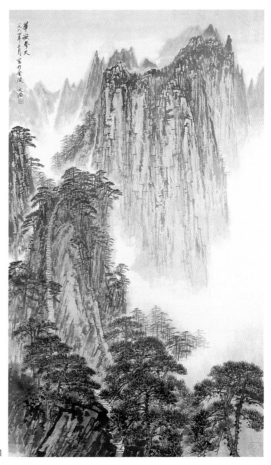

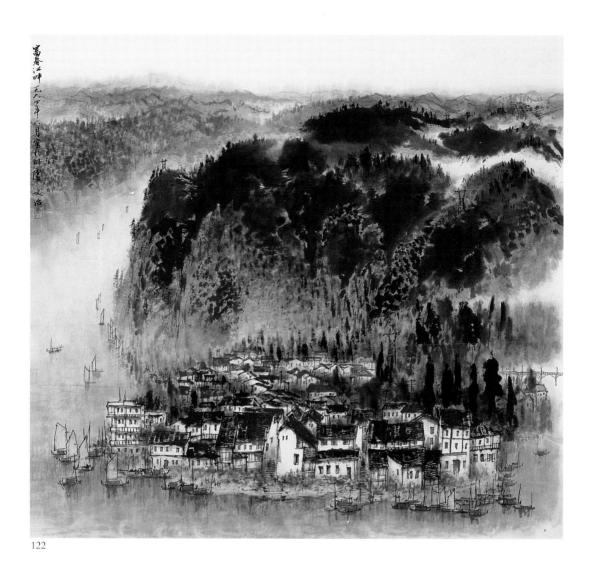

122

122 *Fuchun River*

1964
HANGING SCROLL, INK AND COLOUR ON PAPER
INSCRIBED: 富春江畔　　一九六四年六月　寫于桐廬文治
ARTIST'S SEAL
59 × 65.3 CM
EA 1966.197

TANG DI 湯滌

zi Ding Zhi 定之 , Ding zi 丁子 ; *hao* Yue sun 樂孫 ,
Tai ping hu ke 太平湖客 , Shuang yu dao ren 雙于道人
1878–1948

Tang Di was from Wujin (present Changzhou) in Jiangsu province, and was the grandson of a well-known Qing painter. For many years he taught in Peking, and was prominent in art circles there; towards the end of his life he settled in Shanghai.

123 Landscape

1941

HANGING SCROLL, INK ON PAPER

INSCRIBED:

世外有仙蹤, 山中無俗情, 流霞倒岸影, 涼翠合溪聲, 倚仗招鴻遠,
空亭柏樹清, 行行總真樂, 不是為逃名
辛巳長夏雙于道人湯滌

ARTIST'S SEAL; TWO FURTHER SEALS

101.3 × 47 CM

EA 1962.229

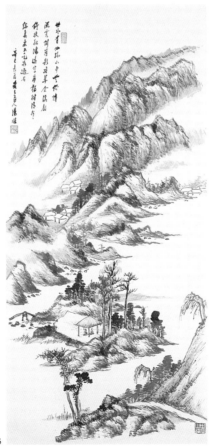

123

124

TAO YIQING 陶一清

b. 1914

Tao Yiqing was born in Peking and most of his career was spent in north China. He studied traditional painting, graduating in 1934 from Jinghua College of Fine Arts in Beijing, and he taught first in Kaifeng and later in Beijing. In 1961 he joined the staff of the Central Academy of Fine Art.

124 Landscape

HANGING SCROLL, INK AND SLIGHT COLOUR ON PAPER
SIGNED: 一清
ARTIST'S SEAL
37.5 × 40.6 CM
EA 1966.193

125 Landscape

1965

HANGING SCROLL, INK AND SLIGHT COLOUR ON PAPER

INSCRIBED:

蕭瑟秋風今又是，換了人間。敬寫主席詞句一九六五年於北京 陶
一清

TWO SEALS OF THE ARTIST

133 × 33.5 CM

EA 1966.196

The inscription quotes Mao Zedong.

Exhibited: Edinburgh 1967, no.48

125

WANG HAO 王浩
zi Xiang Zu 香祖
Qing dynasty

Wang Hao, who was from an impoverished family, is known to have
been active in the region of Wu county near Suzhou in Jiangsu province
where he led a wandering life. He was invited by the Chen family in the
vicinity of Haimen to live with them as a resident painter. He was
known for his calligraphy as well as his painting.

126 Bamboo

FAN PAINTING MOUNTED AS AN ALBUM LEAF, INK ON PAPER
INSCRIBED:

道人寫竹併蒼石， 卻與禪家氣味同，大牴絕無華葉氣，一團蒼秀出
其中，仿板橋道人筆　　古吳逸民王浩竹君作于申浦

ARTIST'S SEAL; ONE FURTHER SEAL
D. 46.8 CM
EA 1965.236

126

WANG QIAN 汪謙
zi Yi Shou 益壽

Qing dynasty

Wang Qian was from Xiao Shan in Zhejiang province. He specialised in figure painting, and appears to have been associated with the Shanghai School.

127 Figure in a boat

1898
HANGING SCROLL, INK AND COLOUR ON PAPER
INSCRIBED:
光緒戊戌年仲冬為卓峰仁兄大人雅屬　蕭山汪謙　益壽
ARTIST'S SEAL
124 × 38.5 CM
EA 1960.239

WANG QINGFANG 王青芳
1900 or after–1956

Wang Qingfang spent his life in Peking, where he studied at the Academy of Painting and was a pupil of both Qi Baishi and Xu Beihong. His work was included in the 1953 National Painting Exhibition; fish seem to have been a favoured subject for his paintings.

128 *Fish playing in the deeps*

HANDSCROLL, INK ON PAPER
INSCRIBED: 魚樂淵深 嶼岑仁兄政二十七年秋□陽山人 王青芳
SEAL OF THE ARTIST; ONE FURTHER SEAL
23.7 × 101 CM
EA 1965.65

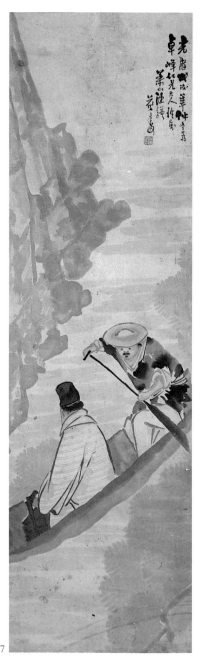

127

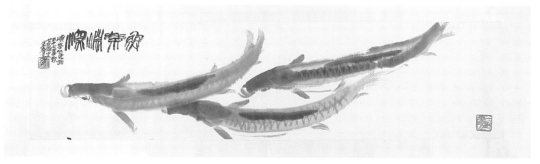

128

WANG SI 王思

zi Qi Qing 畦青

1865–1925

Wang Si was from Jiashan, Zhejiang, and was known for both landscape and figure painting.

129 Figure by a riverbank

1909

FAN PAINTING MOUNTED AS AN ALBUM LEAF, INK AND COLOUR ON PAPER

INSCRIBED: 賓南仁兄大人屬己酉夏日省□子王思寫

ONE SEAL

D. 38.7 CM

EA 1960.217

WANG WEIBAO 王維寶

b. 1942

Wang Weibao, who is as well known for his woodblock prints as for his paintings, was born in Jinjiang county in Fujian province. In 1959 he began studying art in Guangzhou, eventually joining the Guangzhou Studio of Painting. He had meanwhile worked in design departments in industry and publishing, and is primarily a graphic artist.

130 Ducks on water

HANGING SCROLL, INK AND COLOUR ON PAPER

SIGNED: 維寶

ARTIST'S SEAL

47 × 65 CM

EA 1983.219

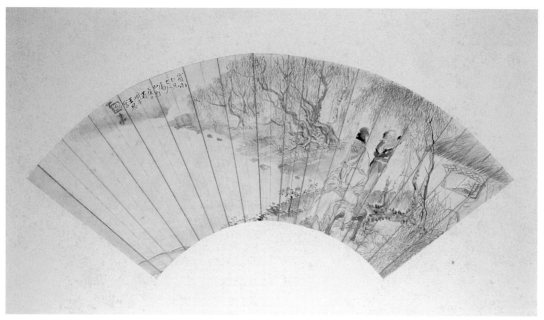

129

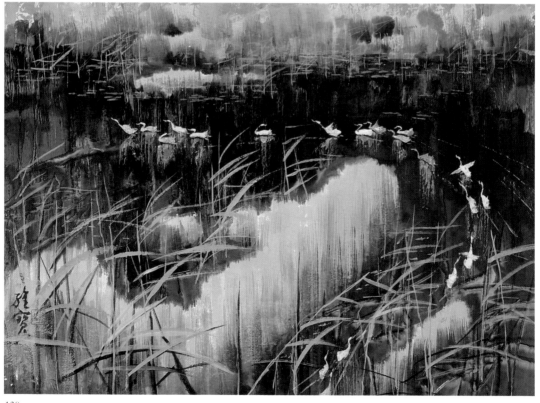

130

131 Landscape with house

1984
HANGING SCROLL, INK AND COLOUR ON PAPER
SIGNED: 維寶　甲子中秋
ARTIST'S SEAL
95 × 58.5 CM
EA 1986.28

WANG XUETAO 王雪濤
zi Chi yuan 遲園; *hao* Ao xue ju shi 傲雪居士
1903–1983

Wang Xuetao was from Cheng'an or Daming, in southern Hebei province. In the early 1920s he went to Peking to study painting. He initially studied Western painting but switched to traditional Chinese painting as a pupil of Chen Hengke (q.v.), Qi Baishi (q.v.) and Wang Mengbai. He later became a founder member of the Beijing Painting Academy.
Wang 1979; Wang 1982; Wang 1983; Wang 1987.

132 Bird on a rock

HANGING SCROLL, INK ON PAPER
SIGNED: 雪濤寫
TWO SEALS OF THE ARTIST; ONE FURTHER SEAL
128.5 × 49.5 CM
EA 1962.122
Exhibited: Edinburgh 1967, no.54

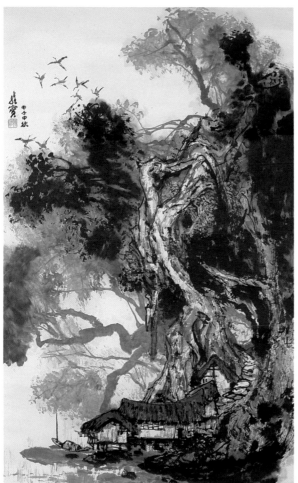

131

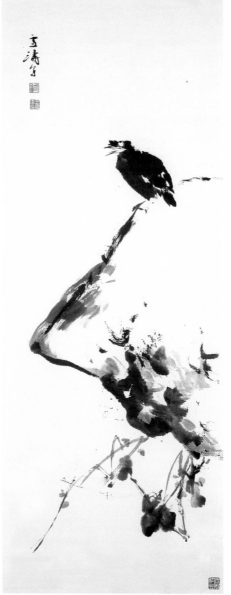

132

133 Vine and insects

HANGING SCROLL, INK AND COLOUR ON PAPER
SIGNED: 雪濤寫
SEAL OF THE ARTIST; ONE FURTHER SEAL
99 × 33 CM
EA 1962.227

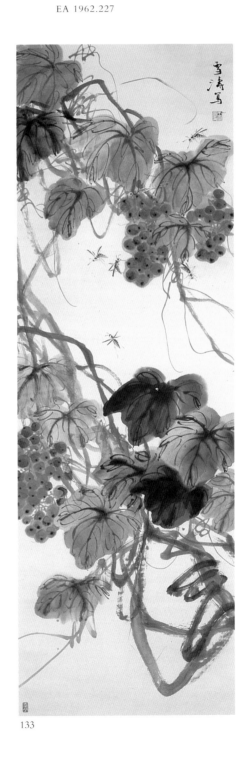

133

WENG TONGHE 翁同龢

zi Shu Ping 叔平, Sheng Fu 聲甫, *hao* Yun zhai 韻齋,
and others
1830–1904

Weng Tonghe was from Changshu in Jiangsu province. He came top in
the public examinations of 1856 and was rewarded with numerous high
ranking official positions. In 1898 he retired from public life. He was a
skilled calligrapher, and also a writer; his poetry and diaries are pub-
lished.
Weng 1935.

134 Landscapes

1902
ALBUM OF EIGHT LEAVES, INK AND COLOUR ON PAPER
THE FIRST INSCRIBED:

1966.2 a
書臺積雪　虞山舊跡十六幀係石谷先生真本，余臨寫已十數過矣，
終不獲一愜意者，此冊杜門匝月絕無口口擾。覺鉤婭設色雖未能合畫
法，而形似可略得矣，壬寅初夏　　瓶盧翁同龢臨併記

THE REST WITH TITLES:

1966.2 b　劍門疊石

1966.2 c　山居積翠

1966.2 d　龍澗晚鍾

1966.2 e　維摩旭日

1966.2 f　三峰蔚秀

1966.2 g　桃源春潤

1966.2 h　秦坡飛瀑

ARTIST'S SEALS
EACH 27.5 × 34.5 CM
EA 1966.2 A–H

書臺積雪

雲山蓓頵十六幀
係石谷先生真本
余擬寫己午敷過
矣終不稜一惬意
有此冊杜門逗月絕
無叨擾寬鍚飯役
色維未能合盂法
而形似為睨淂矣
壬寅初夏
瓶厓翁同龢賕

134a

劍門疊石

134b

134c

134d

維摩旭日

134e

三峯蔚秀

134f

桃源書閣

134g

秦坡飛瀑

134h

WU CHANGSHUO

see Wu Junqing

WU HAN 吳涵

zi Zi Ru 子茹; *hao* Cang kan 藏龕
1876–1927

Wu Han, more commonly known as Wu Cangkan, was from Anji in Zhejiang province and was the second son of Wu Junqing (see below). He too was interested in early scripts, seal carving and calligraphy.

135 Winter

1924
HANGING SCROLL, INK ON PAPER
INSCRIBED: 歲寒　甲子人日畫於井遂軒　安吉　吳藏龕
TWO SEALS OF THE ARTIST; ONE FURTHER SEAL
136.5 × 32.5 CM
EA 1965.6

WU HUFAN 吳湖帆

also Qian 倩, original name Wan 萬; *hao* Qian an 倩菴, Chou yi 醜簃, Yi yan 翼燕, studio name Mei jing shu wu 梅景書屋
1894–1968

Wu Hufan was from Suzhou in Jiangsu province, a grandson of the painter and prominent collector Wu Dacheng. His career was spent largely in Shanghai where he formed a distinguished collection of paintings, and was involved in many institutions and organisations devoted to calligraphy and painting. His own painting style has been regarded as innovative within the orthodox stream of the literati tradition.
Wu 1987; Wu 1991.

136 Landscape

1916

HANGING SCROLL, INK AND COLOUR ON PAPER

INSCRIBED:

郭熙畫石如畫雲。王司農嘗言之。余河陽畫未之見。僅見司農仿本。
今姑□擬之。亦不過就司農範圍而已。因得畫石如雲一語。以寫奉雲
石先生粲正丙辰四月湖帆

ARTIST'S SEAL; ONE FURTHER SEAL

80.9 × 39 CM

EA 1966.198

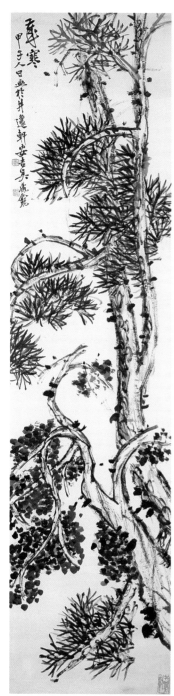

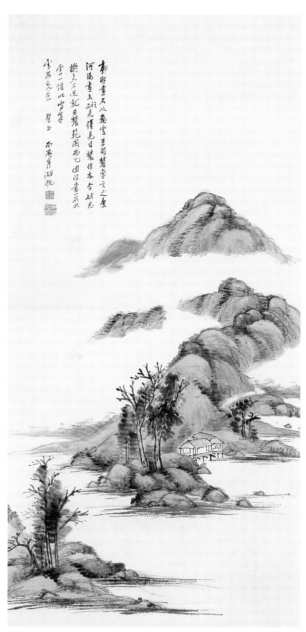

135

136

WU JINGDING 吳鏡汀

ming Xi Zeng 熙曾

1904–1972

Wu Jingding was born in Beijing and worked there throughout his career. He began studying painting at the age of seventeen, at the painting academy attached to Peking University, and in 1920 went to Japan. Before 1949 he taught at the Jinghua Art College, and afterwards mainly at the Central Academy of Fine Art. He travelled throughout China, and specialised in landscape painting.
Wu 1963a.

137 *Snow on Mount Emei*

1961
HANGING SCROLL, INK AND SLIGHT COLOUR ON PAPER
INSCRIBED: 峨眉積雪　辛醜春三月　　鏡汀
ARTIST'S SEAL
68 × 45.2 CM
EA 1964.76

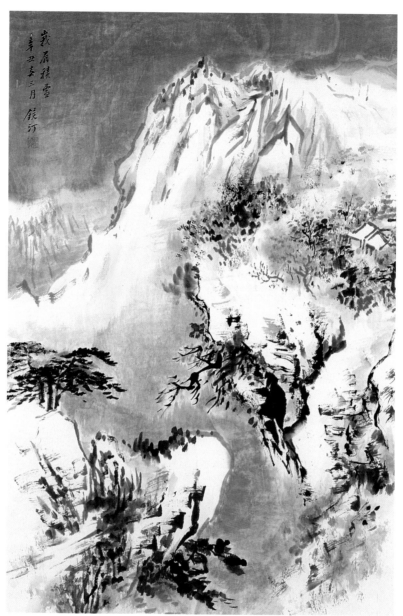

137

WU JUNQING 吳俊卿

zi Changshuo (shi) 昌碩, Cangshuo 倉碩;
hao Fou lu 缶廬, Ku tie 苦鐵, Bo he 破荷,
Lao fou 老缶, Da long 大聾

1844–1927

Wu Junqing, better known as Wu Changshuo, spent his early life in Anji in Zhejiang province. In his late twenties he went to Suzhou and became acquainted with ancient ritual bronze vessels, calligraphy and painting in private collections. He became a poet and calligrapher with a renowned interest in early scripts and epigraphy and only later did he consider himself a painter; he was founding chairman of the Xiling Seal-carving Society. He was an associate of the leading Shanghai School painters of the late nineteenth century, in particular Ren Yi (q.v.), and is regarded as the artist who passed on their styles to the next generation of painters. He achieved great fame and was particularly highly thought of in Japan. Lin 1994a; Tokyo 1984; Wu 1963; Wu 1978; Wu 1979; Wu 1981; Yao 1968; Zhang 1959; Zhu 1943.

138 Wisteria

1915

ALBUM LEAF MOUNTED AS HANGING SCROLL, INK AND COLOUR ON PAPER

INSCRIBED:

繁英垂紫玉, 條繫好風光, 歲歲花長好, 飄香海畫堂
乙卯春仲, 吳昌碩老缶

TWO SEALS OF THE ARTIST

32 × 38.3 CM

EA 1996.79

Presented in honour of Jose Mauricio and Angelita Trinidad Reyes to mark the opening of the exhibition "Modern Chinese Paintings from the Reyes Collection", Ashmolean Museum, 1996.

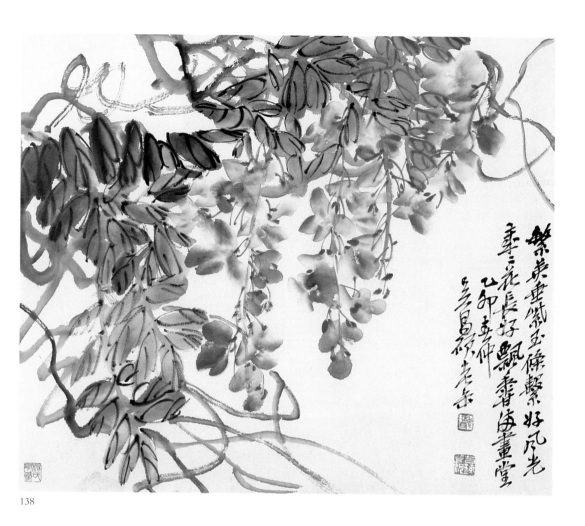

繁英垂紫玉條繫好風光
累累花長好
飄香海畫堂
乙卯立夏
吳昌碩老年

138

WU QINGYUN 吳慶雲

zi Shi Xian 石僊, Shi Qian 石遷;

hao Po mo dao ren 潑墨道人

d. 1916

The year of Wu Qingyun's birth is unknown, though his earliest dated work is from 1857. He was from Nanjing, but lived and worked mostly in Shanghai. He spent some time in Japan and is considered by some to have developed Western stylistic features in his paintings. This is evident more in his use of chiaroscuro, in which he may anyway be indebted to the earlier Qing Nanjing painter Gong Xian, than in any use of perspective.

139 Landscape

1897
HANGING SCROLL, INK AND SLIGHT COLOUR ON PAPER
INSCRIBED: 丁酉春三月白下吳石僊
ARTIST'S SEAL
94.5 × 43.5 CM
EA 1963.1

140 Landscape

1904
HANGING SCROLL, INK AND SLIGHT COLOUR ON PAPER
INSCRIBED: 倣米家筆法　　甲辰秋日蔭墀仁兄大人雅正
TWO SEALS OF THE ARTIST
112.5 × 48.3 CM
EA 1963.2

The inscription states that the brushwork is in the style of the Northern Song painter Mi Fu (1051–1107).

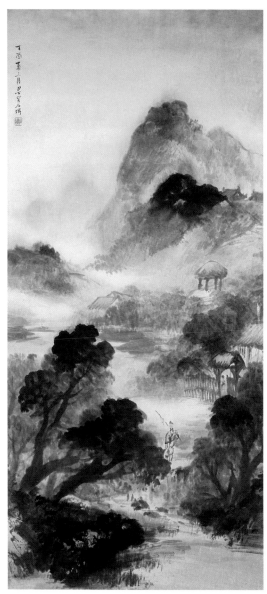

139

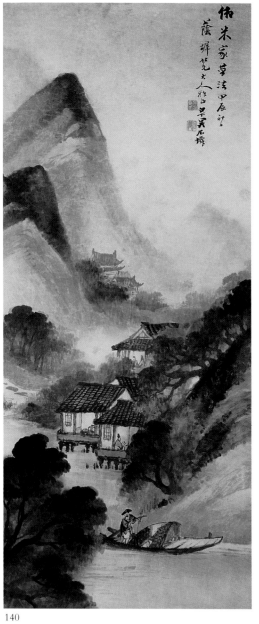

140

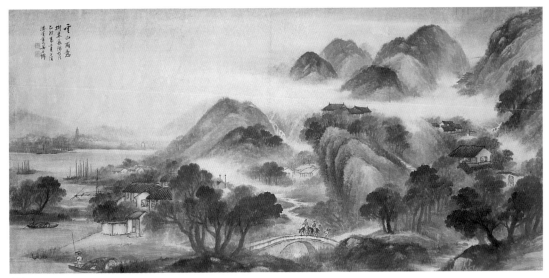

141

141 *Rain in the cloudy mountains*

1915
HANGING SCROLL, INK AND SLIGHT COLOUR ON PAPER
INSCRIBED:
雲山雨意　擬米襄陽筆法乙卯春三月上浣　潑墨道人　吳石僊
TWO SEALS OF THE ARTIST
63.5 × 131.5 CM
EA 1963.3

142 *Stream and willows in mist and rain*

1907
HANGING SCROLL, INK ON PAPER
INSCRIBED: 溪柳煙雨 丁卯春月 仿米襄陽筆法 白下吳石仙
TWO SEALS OF THE ARTIST
104 × 51.3 CM
EA 1965.244

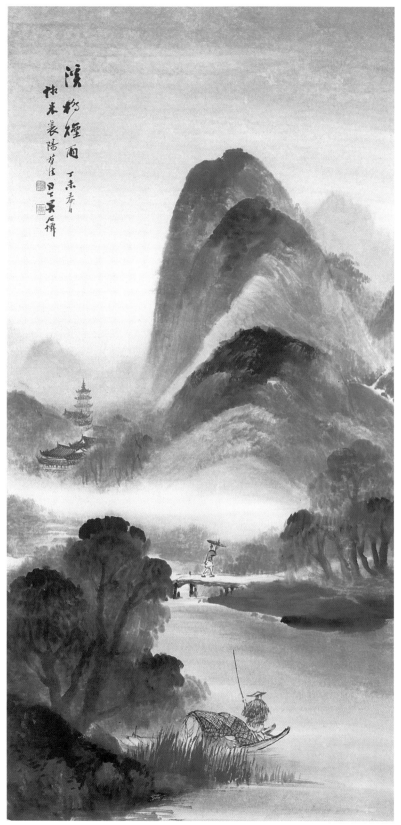

142

WU SHANMING 吳山明

b. 1941

Wu Shanming teaches at the National Art Academy, Hangzhou. In the 1980s he spent two years travelling through Yunnan, Shandong and other widely distant regions of the country, producing many portraits of local people.
Wu 1984.

143 *Rich Land*

1994
HANGING SCROLL, INK ON PAPER
INSCRIBED: 沃原　山明甲戌者
ARTIST'S SEAL
94 × 94 CM
EA 1997.208

Given by Professor Cao Yiqiang

XIAO SUN 蕭愻

zi Qian Zhong 謙中; *hao* Long Qiao 龍樵,
Da long shan qiao 大龍山樵

1883–1944

Xiao Sun was from Huaining in Anhui province, where he first learnt to paint with Jiang Yun (1847–1919). He travelled throughout China and eventually settled in Peking, where he held a succession of teaching posts, and was an active member of Chen Hengke's Society for the Study of Chinese Painting in the 1920s. He was one of the major early twentieth century promoters of the early Qing individualist painter Dao Ji, who was also from Anhui.

144 Landscape

HANGING SCROLL, INK ON PAPER
INSCRIBED:
百尺飛濤荊關遺意如惜墨如金者不足以共語笑。　龍山蕭愻
TWO SEALS OF THE ARTIST
105 × 49 CM
EA 1962.228

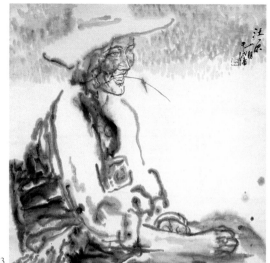

143

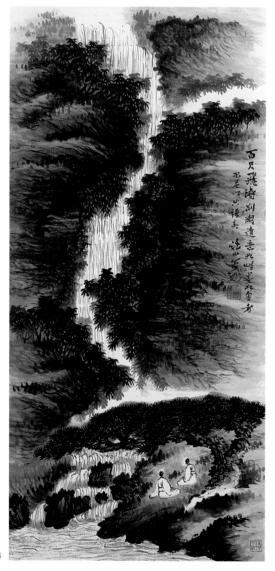

144

145 *Huang Shan in snow*

1942

HANGING SCROLL, INK AND SLIGHT COLOUR ON PAPER
INSCRIBED:

萬山積雪　壬午冬以十百千萬數字成四幀自以為堪珍玩也　　天龍山
樵蕭愻
嘗見耕煙散人撫右丞雪圖工整無比惟嫌刻化太過不若石濤師荒率零
亂益見神趣為不可及此不過形似而已

THREE SEALS OF THE ARTIST; ONE FURTHER SEAL

104 × 49 CM

EA 1962.230

146 *Myriad autumn peaks*

HANGING SCROLL, INK AND COLOUR ON PAPER
INSCRIBED:

千巖秋色　　隨意經構不覺竟似黃鶴山樵山樵早年所作頗工整縝密或
謂之曰此道當為己不可為人。遂改變宗旨，藝乃大進，余以為後之進
即初之工整所成興到臨池乃發揮個人之精氣神格，固為高下，胡雲為
人為己，惟恐欺人以自欺耳　　　龍樵　蕭愻

THREE SEALS OF THE ARTIST

103 × 48.7 CM

EA 1962.232

Exhibited: Edinburgh 1967, no.26.

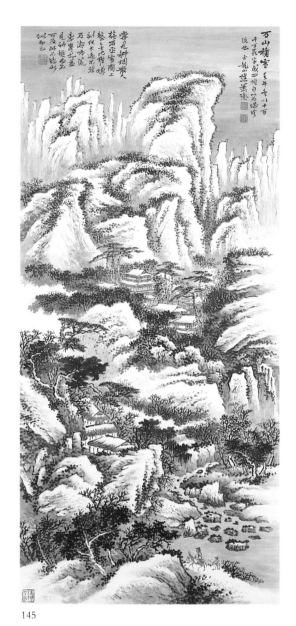

145

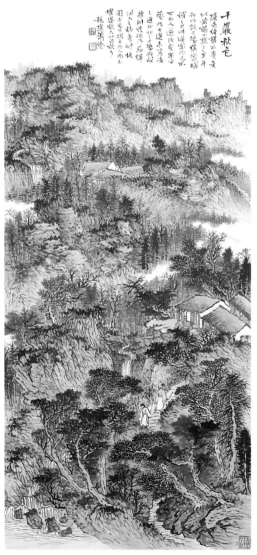

146

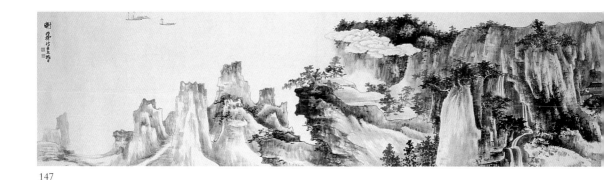

147

XIE ZHILIU 謝稚柳
1910–1989

Xie Zhiliu was from Wujin in Jiangsu province. From his youth he was an associate of Zhang Daqian (q.v.), becoming close to him when they were together in Chongqing from 1937 onwards during the Sino-Japanese War, along with many other artists and academics. From the late 1940s he lived and worked in Shanghai, where he advised the Museum and was professor at the Shanghai Academy. He is one of relatively few twentieth-century painters renowned for meticulous brushwork, after the late Ming tradition.
Xie 1980; Xie 1981; Zheng 1991.

147 River landscape

1961
HANDSCROLL, INK ON PAPER
INSCRIBED: 謝稚柳 時辛醜秋日
TWO SEALS OF THE ARTIST; ONE FURTHER SEAL
28 × 105.5 CM
EA 1964.75

YA MING

see Ye Yaming

YANG BORUN 楊伯潤

zi Peifu 佩夫, *hao* Cha chan 茶禪, Nan hu 南湖

1837–1911

Yang Borun, whose name is sometimes considered Peifu and his *zi* Borun, was from a literati family in Jiaxing, Zhejiang and was resident in Shanghai during the Xianfeng (1851–62) period. He participated in the Yu Yuan Painting Association. He was well-known for his calligraphy, particularly running and grass script, as well as landscape painting.

148 Figures in a landscape

1872

FAN PAINTING MOUNTED AS ALBUM LEAF, INK AND COLOUR ON SILK

INSCRIBED:

夕陽影里各無語・二老居然世外人。壬申七月效先一兄 大人屬正
楊伯潤

ARTIST'S SEAL

D. 27 CM

EA 1965.230

148

YANG TIANBI 楊天壁

zi Su (or Xiu) Ting 宿庭; *hao* Xiu Ting 繡亭
Qing dynasty

Yang Tianbi is not recorded in much detail, but it is known that he was resident in Shangyuan (present-day Nanjing, Jiangsu) in the first half of the nineteenth century. He painted panoramas and historical subjects as well as landscapes and bamboo.

149 *Landscape in the style of Wang Shuming*

DATED EQUIVALENT TO 1793 OR 1853
HANGING SCROLL, INK ON PAPER
INSCRIBED: 癸醜秋九 擬王叔明法 繡亭 楊天壁
ARTIST'S SEAL
118.5 × 40 CM
EA 1962.123

YE YAMING 葉亞明

b. 1924

Ye Yaming, better known as Ya Ming, from Hefei in Anhui province, joined the army at fifteen and two years later was sent to study at Huainan School of Art. After 1949 he moved to Nanjing, Jiangsu province, where he was influenced by Fu Baoshi (q.v.) and Qian Songyan (q.v.). His early career was as a graphic artist producing prints, posters and cartoons; he began traditional painting in 1953 and in 1957, on a visit to the U.S.S.R., became acquainted with Western painting. He has been prominent in the Jiangsu Painting Academy and the Jiangsu Artists' Association.
Ya 1982; Ya 1985.

150 River landscape with boat

HANGING SCROLL, INK AND COLOUR ON PAPER
SIGNED: 亞明
ONE SEAL
45.2 × 55.4 CM
EA 1968.70

149

150

175

YIN XIAOXIA 尹小霞

Qing dynasty

Yin Xiaoxia from Changshu in Jiangsu was a female artist who spe-
cialised in figures, and was particularly well known for her paintings of
noblewomen. Her paintings were reputed to achieve a Buddhist tran-
quility.

151 Figure beneath a tree

FAN PAINTING MOUNTED AS ALBUM LEAF, INK AND COLOUR
ON PAPER
INSCRIBED: 棟卿—兄大人雅屬　小霞尹銓
ARTIST'S SEAL
D. 53 CM
EA X.1405

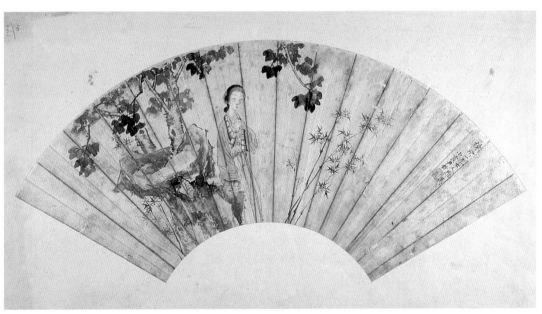

151

YU FEI'AN
See Yu Zhao

YU SHAOSONG 余紹宋
hao Yue Yuan 越園, Yue Yuan 樾園, Han Ke 寒柯
1882–1949

Yu Shaosong was from Longyou in Zhejiang province. He held numerous official positions in education there and was also head of the National Art Training College in Peking. He specialised in landscapes and ink bamboo.

152 Prunus branch

152

HANGING SCROLL, INK ON PAPER
INSCRIBED: 乙酉三月既望 寒柯散人余紹宋燈下寫
TWO SEALS OF THE ARTIST
130 × 30.5 CM
EA 1965.246

YU ZHAO 于照

zi Fei'an 非廠 , Feihan 非闇 ; *hao* Xian ren 閒人

1888–1959

Yu Zhao was from Wanping in Hebei, or from eastern Shandong, and spent most of his life in Peking where he was a member of the Hu She Painting Society. After 1949 he held numerous public positions and at the time of his death was vice-director of the National Painting Academy in Beijing (now the Central Academy of Fine Art). His painting style was always indebted to the traditional bird and flower painters of the Song (960–1279) dynasty and he is well-known as the only painter to write specifically on colour.
Yu 1955; Yu 1988.

153 Chrysanthemum spray

HANGING SCROLL, INK ON PAPER
SIGNED: 非廠
ARTIST'S SEAL
63.5 × 32 CM
EA 1966.194

ZENG SHANQING 曾善慶

b. 1932

Zeng Shanqing is from Beijing, and graduated from the Central Art Academy there in 1950, and from the Academy's Research Department in 1951, having studied under Xu Beihong. He was trained in Western techniques, which at that time were based on Soviet practice. Since 1986 he has lived in the United States.
Horstmann Godfrey 1992a.

154 *Black horse, yellow horse*

C.1992
INK AND COLOUR ON PAPER
TWO SEALS OF THE ARTIST
68 × 43.8 CM
EA 1994.1

The title does not appear, but was used by the artist.

153

154

ZENG YOU-HE 曾幼荷

Tseng Yu-ho, Betty Ecke
b. 1923

Zeng Youhe was born in Peking, and studied painting at Furen University. After graduation she stayed there as assistant to Pu Quan and Gustav Ecke, whom she later married. In 1949 she moved to Hawaii. Tseng 1957.

155 Tree and rock

HANGING SCROLL, FRAMED, INK ON PAPER
INSCRIBED: 怎當他權權椏椏湧上紙頭
　　　　　　幼荷
ARTIST'S SEAL
38.2 × 31.6
EA X.1244
Given by the artist

156 Autumn landscape

1949
ALBUM LEAF, FRAMED, INK AND COLOUR ON PAPER
戊子年秋過闔江時有此景 今憶之 用唐人沒骨法 曾幼荷作於己醜暮夏
TWO SEALS OF THE ARTIST
44 × 52 CM
EA X.1245
Given by the artist

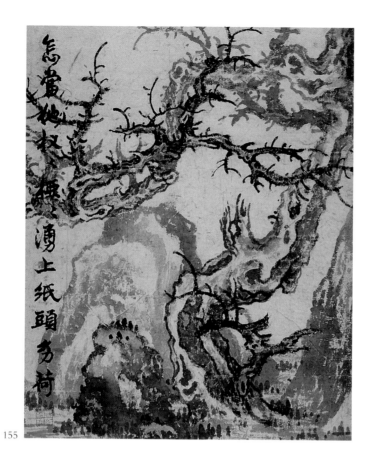

155

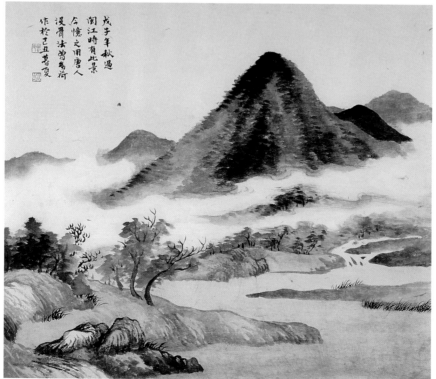

156

ZHA SHIBIAO 查士標

zi Erchan 二瞻, *hao* Meihuo 梅壑,
Mei he san ren 梅壑散人,
Hou yi mao sheng 後乙卯生
1615–1698

Zha Shibiao was from Haiyang near Xiuying in Anhui province and is associated with the Anhui School, renowned for dry brushwork and sparse composition. Zha Shibiao studied for the civil service examinations before the fall of the Ming dynasty, and it has been suggested that his subsequent departure from official life in favour of painting may have been prompted by lack of sympathy for the new rule. His family owned collections of paintings and bronzes and he himself was a connoisseur. In painting he followed his near contemporary Hong Ren and the Yuan master Ni Zan. From the 1670s onwards he lived in Yangzhou.
Cahill 1981, 102–110

157 River landscape

1667
ALBUM LEAF, INK ON PAPER
INSCRIBED: 丁未士標畫
ARTIST'S SEAL
17.1 × 18.2 CM
EA 1980.140

Ex collection Ling Su-hua, purchased with assistance from the National Art Collections Fund

Exhibited: Paris, Musee Cernuschi, 1962–3

Published: Paris 1962, no.6

158 River landscape

1666
ALBUM LEAF, INK ON PAPER
INSCRIBED: 擬衡山先生畫於廣陵旅次
丙午士標
ARTIST'S SEAL
17.2 × 18.3 CM
EA 1980.141

Ex collection Ling Su-hua, purchased with assistance from the National Art Collections Fund.

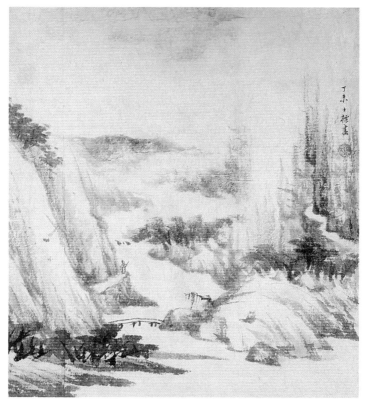

157

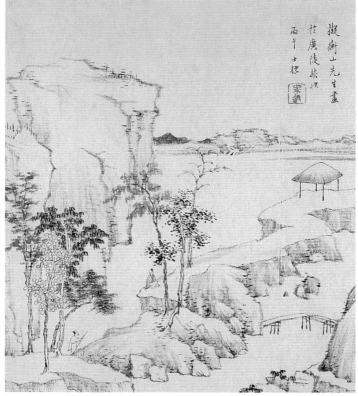

158

159 River landscape

1666

ALBUM LEAF, INK AND COLOUR ON PAPER

INSCRIBED:

柳岸苑簹江上村　較晴星雨數晨昏
農家風景長如此　可有催租吏打門
丙午夏邛上為西樵先生畫並正
查士標

ARTIST'S SEAL

18.9 × 17.5 CM

EA 1980.142

Ex collection Ling Su-hua, purchased with assistance from the
National Art Collections Fund.

160 River landscape

ALBUM LEAF, INK AND COLOUR ON PAPER

INSCRIBED: 山糖雨泛　為西樵先生補圖並正
　　　　　　查士標

ARTIST'S SEAL

18.9 × 17.4 CM

EA 1980.143

Ex collection Ling Su-hua, purchased with assistance from the
National Art Collections Fund.

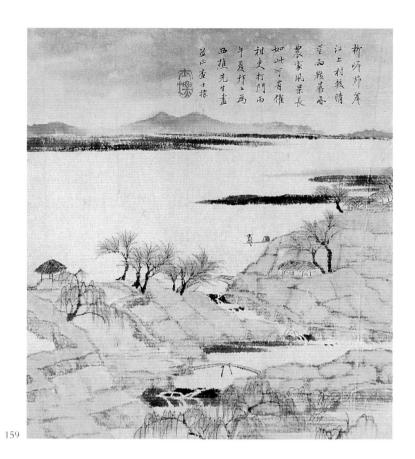

柳岸新晴
江上村墟晴
墨雨粒最香
農家風景長
如此可宵催
祖吏打門雨
午夏邦上為
西樵先生盡
益臣查士標

159

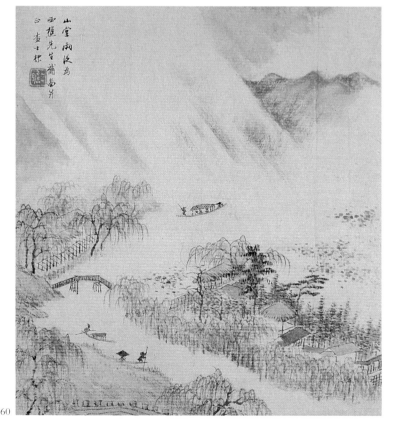

山堂雨後為
西樵先生補畫并
台查士標

160

ZHANG DAQIAN

see Zhang Yuan

ZHANG DENGTANG 張登堂

b. 1943

Zhang Dengtang is from Liaocheng in Shandong province. He paints in traditional style, often depicting rivers and oceans, and is associated with Ji'nan Art Gallery.

161 Summer on Qu River

1980
HANGING SCROLL, INK AND COLOUR ON PAPER
INSCRIBED: 曲江清夏圖　庚申秋月登堂於歷下
ARTIST'S SEAL
98 × 51 CM
EA 1983.240

ZHANG QIZONG 張啓宗

zi Xiaoqian 孝謙 ; hao Qi hu 啓湖

Zhang Qizong, whose dates are not published, was from Qingdao in Shandong province. He was a member of the Hu She painting society, which was active in Peking in the 1920s, and was a critic as well as a painter.

162 Dog beneath bamboo

1931
HANGING SCROLL, INK AND COLOUR ON SILK
INSCRIBED: 辛末二月肖謙　張啓宗畫
TWO SEALS OF THE ARTIST
81.5 × 39.3 CM
EA 1967.13

Purchased with funds made available by the late Sir Herbert Ingram

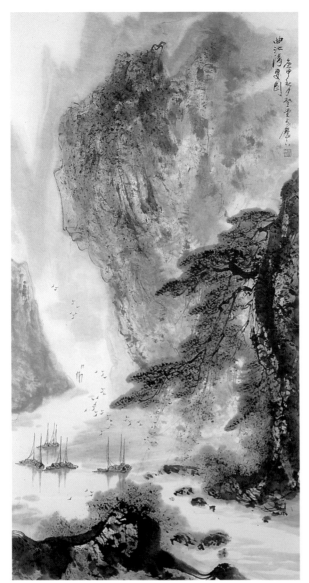

161

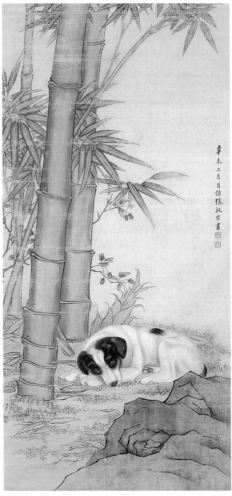

162

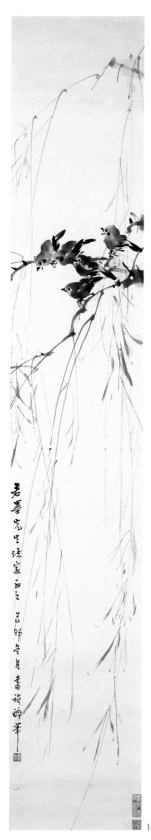

163

ZHANG SHUQI 張書旂
1901–1957

Zhang Shuqi was from Pujiang in Zhejiang province. He studied paint-
ing under Liu Haisu in Shanghai and later taught at the National Central
University, moving with them to Sichuan in 1937. He went to the
United States from 1942, returning to China in 1946, but later settled in
America. He is particularly known for bird and flower painting.
Zhang 1984.

163 Birds on a willow branch

1939–40
HANGING SCROLL, INK AND COLOUR ON PAPER
INSCRIBED: 君墨先生法家正之 己卯冬月書旂醉筆
ARTIST'S SEAL; TWO FURTHER SEALS
134 × 22.5 CM
EA 1964.208

ZHANG YUAN 張爰

b. Zhang Zhengchuan 張正權; *zi* Jiyuan 季爰;
hao Daqian 大千, Da feng tang 大風堂
1899–1983

Zhang Daqian (Chang Dai-chien), born in Neijiang, Sichuan province,
is one of the great figures in twentieth century Chinese painting. In his
late teens he spent two years in Japan studying textile dyeing and weav-
ing, then moved to Shanghai to continue studies in painting and callig-
raphy. He spent the rest of the decade in Shanghai, and the 1930s in
Peking. From 1941 to 1943 he studied the Tang (618–906) dynasty
Buddhist cave murals at Dunhuang, Gansu, making hundreds of copies,
and in 1952 he moved to India after a brief period in Hong Kong. From
1952 to 1976 he lived in South America and in the United States, and
the remainder of his life was spent in Taiwan. Zhang Daqian was a very
skilled painter, who developed an innovative style at the same time as he
was producing copies of works by early masters (several of which are in
public collections), but always working within the traditions of ink
painting.
Fu 1991; Kao 1993; Stanford 1967. For a full bibliography, see Fu 1991.

164 Peony and butterfly

HANGING SCROLL, INK AND COLOUR ON PAPER

INSCRIBED:

葉散幽胭肢雪柳絮咋成白綑□詞已是日來情緒惡那堪風雨又將離
爰

ARTIST'S SEAL

53 × 37 CM

EA 1965.247

165 Landscape

1941

INK AND SLIGHT COLOUR ON PAPER

INSCRIBED:

雷洞坪懸崖萬仞，不可俯視，相傳雷伏洞下聞人語輒震，舊有鐵碑禁
語　辛巳上元寫於大風堂　　大千張爰

TWO SEALS OF THE ARTIST

126.5 × 41 CM

EA 1967.131

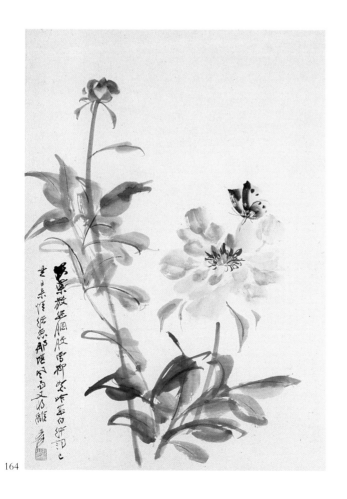

164

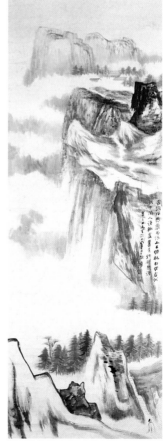

165

ZHAO WANGYUN 趙望雲

1906–1977

Zhao Wangyun was from Sulu in Hebei province. In 1925 he entered Jinghua Art College in Peking and in 1928 began teaching at Peking Normal University. He went on to work in Shanghai and Tianjin, and in 1936 embarked on a decade of travelling around China before settling in 1946 in Xi'an, Shaanxi province, where he spent the rest of his career. Throughout his life he was active in publishing as well as painting.

166 Landscape

1962
HANGING SCROLL, INK AND SLIGHT COLOUR ON PAPER
INSCRIBED: 一九六二年夏初　望雲
ARTIST'S SEAL
67.4 × 43.4 CM
EA 1964.80

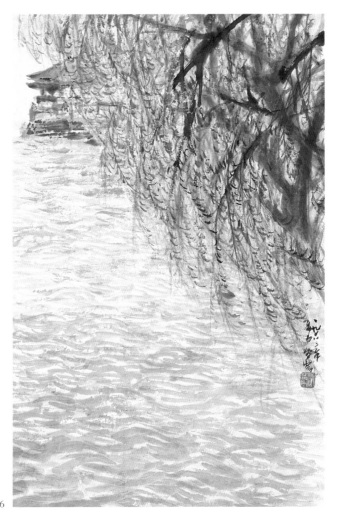

　　166

ZHAO YUNHUO 趙雲壑

ming Qi 起, *zi* Ziyun 子雲
1874–1955 or 1887–1956

Zhao Yunhuo was from Wuxian (present-day Suzhou) in Jiangsu province. He was a very highly regarded pupil of Wu Changshuo (q.v.), and specialised in flower painting.

167 *Pumpkin vine*

1943

HANGING SCROLL, INK AND COLOUR ON PAPER

INSCRIBED:

一斷紛紛瓜蔓牽，誰識君來自田墅。渥丹顏色玉堂仙，不食人間煙火者。癸未仲春之月泉梅村農趙雲壑併題

ARTIST'S SEAL; ONE FURTHER SEAL

82 × 37.3 CM

EA 1966.164

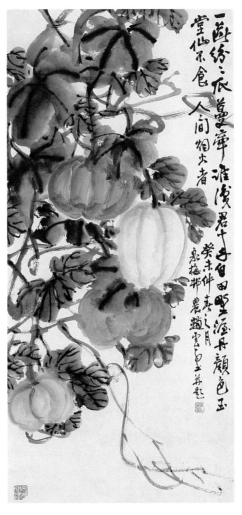

ZHU CHENG 朱偁

ming Chen 琛; *zi* Menglu 夢廬; *hao* Jue wei 覺未
1826–1900 or 1828–1899

Zhu Cheng was from Jiaxing in Zhejiang province, and was active in Shanghai by 1862. Demand for his small-scale paintings, mostly fans, was high and his later works tend to be larger, and bolder in style. He is best known for bird and flower painting.

168 Bird on a flowering branch

1869
FAN PAINTING MOUNTED AS ALBUM LEAF, INK AND COLOUR ON SILK
INSCRIBED: 可臣十七兄大人鑒正　己巳夏四月之吉夢廬朱偁
ARTIST'S SEAL
HT. 23.4 CM
EA 1965.231

ZHU WEI 朱偉

b. 1966

Zhu Wei studied painting at the art academy of the People's Liberation Army, of which he was then a member. He is from Beijing but has exhibited in Hong Kong since 1994.
Zhu 1994.

169 Blossoms

HANGING SCROLL, INK AND COLOUR ON PAPER
INSCRIBED:
朱□ 你好.我前幾個星期去紐約了,我看了台北故宮博物館展覽, 我
在 MET 美術館時看見了, 這個卡片, 想你可能喜歡, 關於幾天你來
的電話, 我不知道怎麼回答你, 現在我誰的女朋友也不想做, 希望你
能理解, 我也給我自己買了這個卡, 掛在我屋千里, 看它的時後讓我
想你畫之物　末□□
31 × 15.5 CM
EA 1996.81

Presented in honour of Jose Mauricio and Angelita Trinidad Reyes to mark the opening of the exhibition 'Modern Chinese Paintings from the Reyes Collection', Ashmolean Museum, 1996

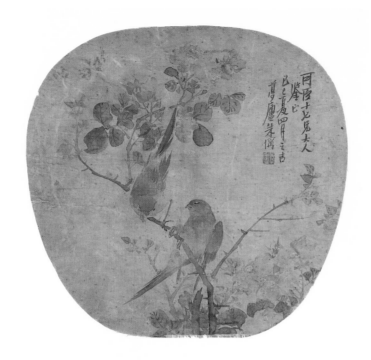

168

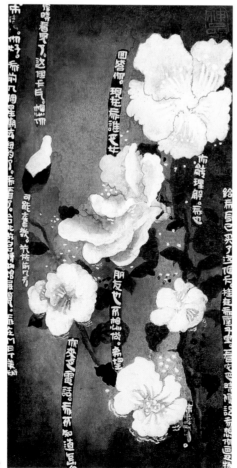

169

ZHU XIULI 朱修立

b. 1938

Zhu Xiuli is from Anhui province, where he still lives and works. He is a member of, and teacher at, the Anhui Painting Academy; he specialises in landscapes.
Zhu 1986.

170 *Village scene*

1980

HANGING SCROLL, INK AND COLOUR ON PAPER

INSCRIBED:

憩耕罷歇牛，飯後午休。指望它今年好豐收　大別山中村頭常見此情景　修立併誌

TWO SEALS OF THE ARTIST; DATE SEAL

67 × 67.3 CM

EA 1983.241

Given by the Friends of the Ashmolean

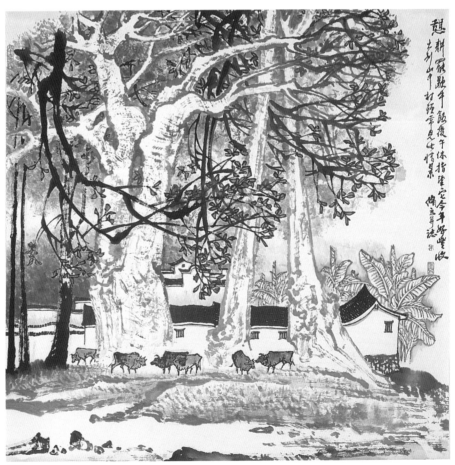

170

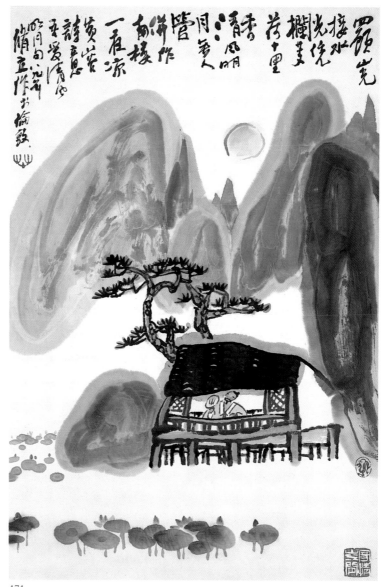

171

171 *Contentment*

1989

HANGING SCROLL, INK AND COLOUR ON PAPER

INSCRIBED:

四顧山光接水光，憑欄夢荷十里香。清風明月無人管，併作南樓一夜涼。黃山谷詩意吾愛清風明月句。八九年修立作於倫敦

THREE SEALS

68.5 × 45.5 CM

EA 1989.194

Given by the artist

APPENDIX ONE

WORKS BY UNRECORDED ARTISTS

The following paintings bear signed inscriptions by artists, or others, whose names do not appear in that form in the biographical works cited in the bibliography.

LIANG CHEN 梁辰

1.1 Birds on a flowering branch

FAN PAINTING MOUNTED AS ALBUM LEAF, INK AND
COLOURS ON SILK
INSCRIBED: 披垣四兄大人雅屬　　星樵　梁辰
ARTIST'S SEAL
D .27 CM
EA 1960.221

LUO XU 羅旭

1.2 Lotus and ducks

HANGING SCROLL, INK AND COLOUR ON SILK
INSCRIBED:
移舟水淺差差綠，倚檻風多柄柄香，多謝浣沙人莫折兩中留得蓋鴛
鴦。　羅旭寫
ONE SEAL
83.5 × 40 CM
EA 1956.544
Given by Sir George Sansom

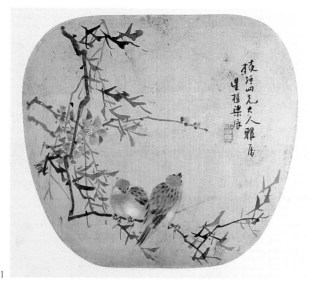

1.1

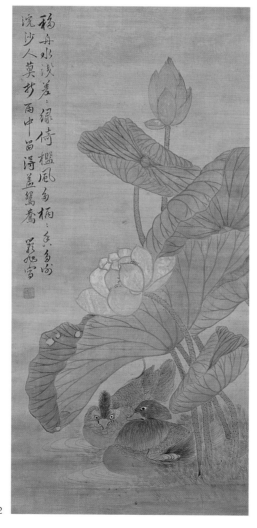

1.2

QIN ZHUQUAN 秦竹泉

1.3 Bamboo and rock

1832

FAN PAINTING MOUNTED AS ALBUM LEAF, INK AND
COLOUR ON PAPER

INSCRIBED:

種竹澆花懶作詩，年年俗氣為誰醫，閑來寫幅謙湘景，正是風停雨到
時　　道光十二年六月初伏日寫　秦竹泉

TWO SEALS

D. 49.5 CM

EA 1968.53

Given by Sir Humphrey Prideaux-Brune

RU BIN 汝濱

1.4 Immortals on waves

1872

FAN PAINTING MOUNTED AS ALBUM LEAF, INK AND
COLOUR ON PAPER

INSCRIBED:

壬申天中節後一日作于螾上客次為春生大兄大人正之弟汝濱

TWO SEALS

D. 55 CM

EA 1965.233

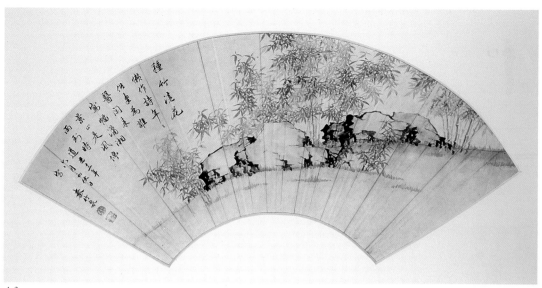

1.3

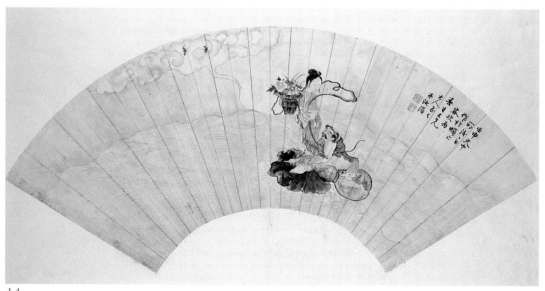

1.4

RUAN LINCHUAN 阮臨川

1.5 Squirrels on a pine

DATED EQUIVALENT TO 1825 OR 1885
HANGING SCROLL, INK ON PAPER

INSCRIBED:

翠攢千片美玉疊萬顆珠繡閣佳人線丹青紙上書乙酉季春月倣趙昌先
生筆意為兄先生　　雅鑒　波文　阮臨川

THREE SEALS

169 × 92 CM

EA 1965.174

WANG QIULING 王秋岑

1.6 *Wen Ji returns to the Han*

HANGING SCROLL, INK AND COLOUR ON PAPER

INSCRIBED:

文姬歸漢　□夢偎駝影·鄉心遂雁飛。昆陵王秋岑寫於海上

ARTIST'S SEAL

88 × 27.5 CM

EA 1966.215

The inscription suggests that Wang Qiuling was active in Shanghai.
For Wen Ji see Su 1980.

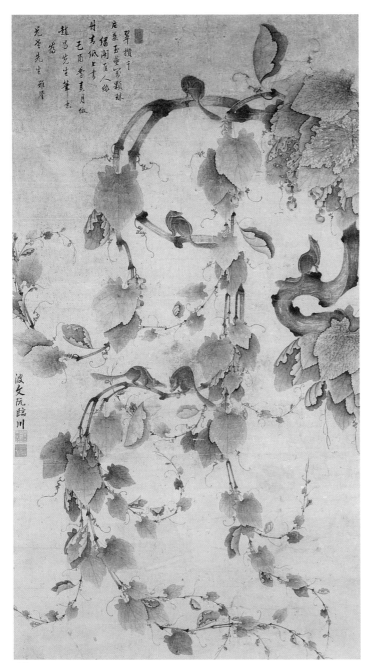

1.5

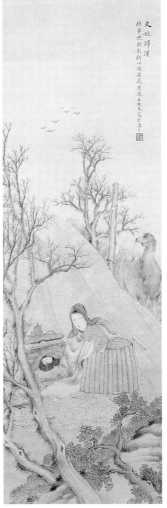

1.6

WANG YUMEI 汪玉梅

1.7 Women in a landscape

FAN PAINTING MOUNTED AS ALBUM LEAF, INK AND
COLOUR ON PAPER

SIGNED: 虎邱汪玉梅小齋女史

D. 48.3 CM

EA 1965.237

Wang Yumei was a female artist who signs herself on this painting as
being at or associated with Huqiu (Tiger Hill) in Suzhou, Jiangsu
province.

YE KEYIN 葉可蔭

1.8 Bird on a flowering branch

FAN PAINTING MOUNTED AS ALBUM LEAF, INK AND
COLOUR ON SILK

INSCRIBED: ☐☐仁兄大人雅屬 葉可蔭

ARTIST'S SEAL, ONE FURTHER SEAL

D. 24.2 CM

EA 1960.222

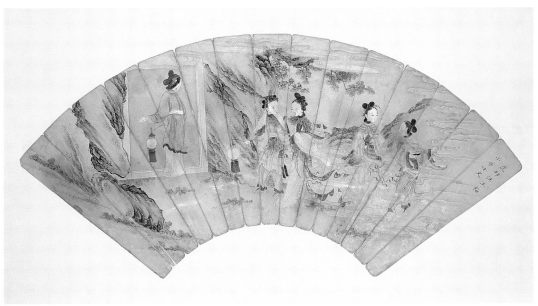

1.7

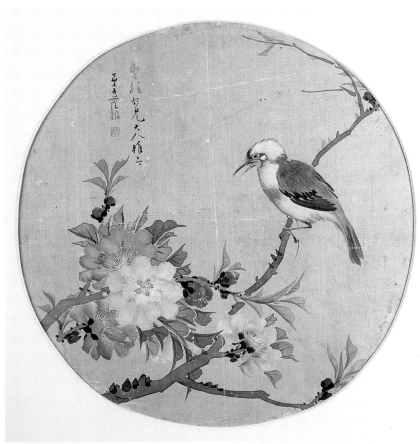

1.8

YI SHAOZUO 伊紹佐

1.9 Squirrels on a pine tree

DATED EQUIVALENT TO 1795 OR 1855

HANGING SCROLL, INK ON PAPER

INSCRIBED:

時乙卯杏月 寫於平川書屋為鳴兄王先生雅玩閩中伊紹佐

ONE SEAL OF THE ARTIST; ONE FURTHER SEAL

129.5 × 45 CM

EA 1960.241

The inscription implies that Yi Shaozuo was from Fujian province.

YI YONG 以庸

1.10 Squirrel on a vine

FAN PAINTING MOUNTED AS ALBUM LEAF, INK ON PAPER

INSCRIBED: 添得新秋□一味□□深□早生香
□在辛卯夏月□香□大兄大人正之
以庸

TWO SEALS

D. 52 CM

1965.234

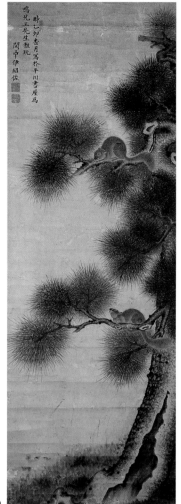

1.9

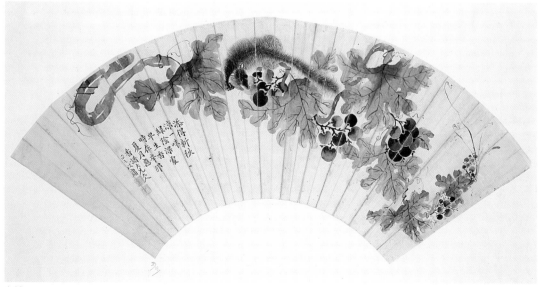

1.10

ANONYMOUS WORKS

2.1 Portrait of a man in the dress of an official of the fifth rank

HANGING SCROLL WITH INK, COLOUR AND GOLD ON PAPER

132 × 61.5 CM

EA 1956.531

2.2 Portrait of a man in the dress of an official of the sixth rank

UNMOUNTED, INK AND COLOUR ON PAPER

96 × 43 CM

EA 1956.590

2.1

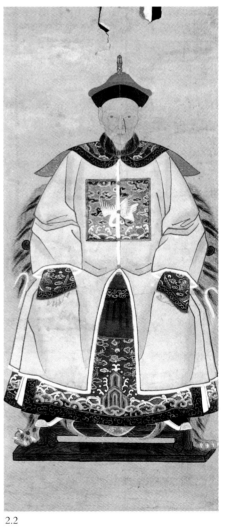

2.2

2.3 Figures in a landscape

HANGING SCROLL, INK AND COLOUR ON SILK
157.5 × 90 CM
EA 1956.599

2.4 Portrait of a woman in the dress of a wife of an official of the sixth rank

UNMOUNTED, COLOUR AND GOLD ON PAPER
131.5 × 75 CM
EA 1956.602

2.3

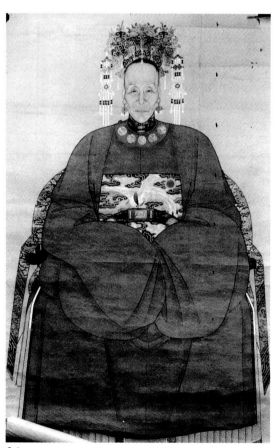

2.4

2.5 Figures in a garden

FRAMED, INK AND COLOUR ON SILK
86 × 17.6 CM
EA 1956.640
Given by Mrs J. Johnson

2.6 Figures in a landscape

FRAMED, INK AND COLOUR ON SILK
86.1 × 17.6 CM
EA 1956.641
Given by Mrs J. Johnson

2.5

2.6

211

2.7 Men and attendants in a landscape

FRAMED, INK AND COLOUR ON SILK

117 × 37.3 cm

EA 1956.642

Given by Mrs J. Johnson

2.8 Figures viewing a dragon amongst clouds

FRAMED, INK AND COLOUR ON SILK

116.6 × 36.7 CM

EA 1956.643

Given by Mrs J. Johnson

2.7

2.8

2.9 Figures in a landscape

FRAMED, INK AND COLOUR ON SILK
117.3 × 37.4 CM
EA 1956.644
TWO SEALS
Given by Mrs J. Johnson

2.10 Figures in a landscape with buildings

FRAMED, INK AND COLOUR ON SILK
TWO SEALS
117.2 × 37.4 CM
EA 1956.645
Given by Mrs J. Johnson

2.9

2.10

2.11 Female figures in a garden

FRAMED, INK AND COLOUR ON SILK GAUZE SUPPORTED
ON PAPER

49.6 × 11.7 CM

EA 1956.650

Given by Mrs J. Johnson

2.12 Female figures in a garden

FRAMED, INK AND COLOUR ON SILK GAUZE SUPPORTED
ON PAPER

49.6 × 11.7 CM

EA 1956.651

Given by Mrs J. Johnson

2.11

2.12

2.13 Landscape

FAN PAINTING MOUNTED AS ALBUM LEAF, INK ON SILK
INSCRIPTION AND TWO SEALS
23.7 × 25.5 CM
EA 1960.220

2.14 Seated female figure

FAN PAINTING MOUNTED AS ALBUM LEAF, INK ON SILK
INSCRIPTION AND ONE SEAL
D. 26.5 CM
EA 1960.223

2.13

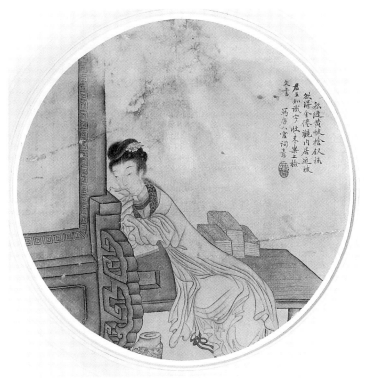

2.14

2.15 River landscape

ALBUM LEAF, INK AND COLOUR ON PAPER
23 × 26 CM
EA 1960.224

2.16 Portrait of a woman in the dress of the wife of an official of the third rank

HANGING SCROLL, INK AND COLOUR ON PAPER
103 × 52 CM
EA 1961.141
Given by Mr. A. J. Deer

2.17 Rider at a bridge

FRAMED, INK AND COLOUR ON SILK
SEAL
127 × 73 CM
EA 1961.144
Bequeathed by Lord Somervell

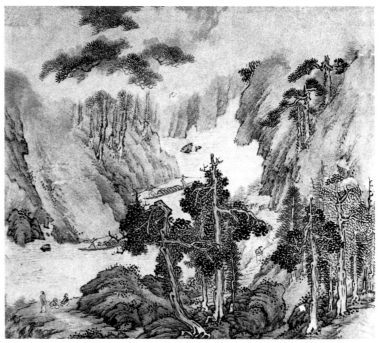

2.15

KINOKUNIYA
B OO KSTORES

SAN FRANCISCO
JAPAN CENTER-KINOKUNIYA BUILDING
1581 Webster St., San Francisco, CA 94115
tel: 415/567-7625 fax: 415/567-4109
e-mail: san.francisco@kinokuniya.com

SAN JOSE
675 Saratoga Ave., San Jose, CA 95129
tel: 408/252-1300 fax: 408/252-2687
e-mail: san-jose@kinokuniya.com

SEATTLE
525 South Weller St., Seattle, WA 98104
tel: 206/587-2477 fax: 206/587-0160
e-mail: seattle@kinokuniya.com

PORTLAND
10500 S.W. Beaverton-Hillsdale Hwy.
Beaverton, OR 97005
tel: 503/641-6240 fax: 503/643-1059
e-mail: portland@kinokuniya.com

LOS ANGELES
123 Astronaut E. Onizuka St.
Los Angeles, CA 90012
tel: 213/687-4480 fax: 213/621-4456
e-mail: los-angeles@kinokuniya.com

COSTA MESA
665 Paularino Ave., Costa Mesa, CA 92626
tel: 714/434-9986 fax: 714/434-6861
e-mail: costa-mesa@kinokuniya.com

KINOKUNIYA PUBLICATIONS SERVICE
OF NEW YORK CO., LTD.

NEW YORK
10 West 49th St., New York, NY 10020
tel: 212/765-7766 fax: 212/541-9335
e-mail: kinokuniya@kinokuniya.com

NEW JERSEY
595 River Rd., Edgewater, NJ 07020
tel: 201/941-7580 fax: 201/941-6087
e-mail: nj@kinokuniya.com

www.kinokuniya.com

2.16

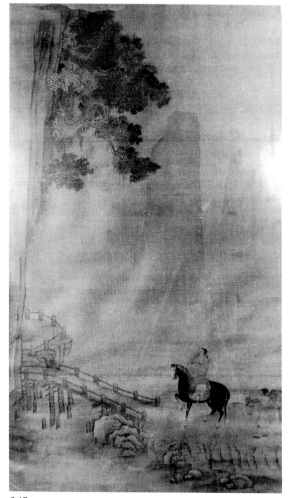

2.17

2.18 Two carp

HANGING SCROLL, INK AND COLOUR ON GOLD-FLECKED
PAPER

ONE SEAL

42 × 64 CM

EA 1961.159

Given by Mrs K. Th. van Hien

2.19 Landscape with figures

FAN PAINTING MOUNTED AS ALBUM LEAF

INK AND COLOUR ON SILK

25.5 × 29 CM

EA 1962.147

Bequeathed by Miss Isabel Ainger

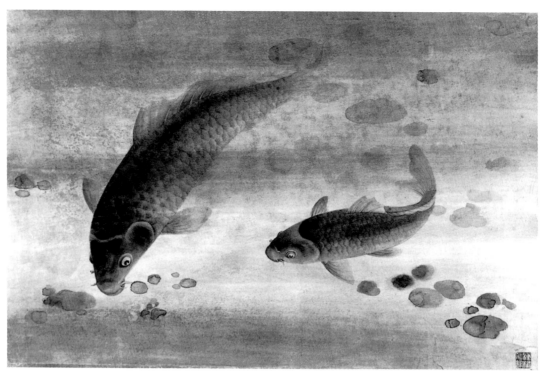

2.18

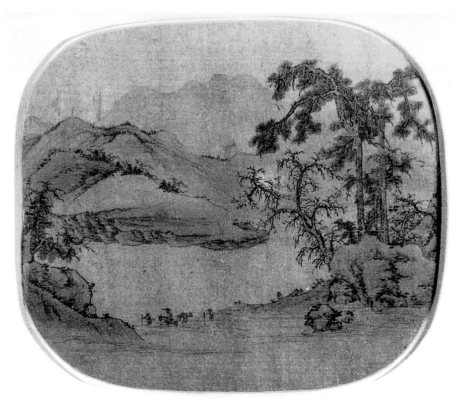

2.19

2.20 Portrait of a woman in the dress of the wife of an official

FRAMED, INK AND COLOUR ON PAPER

80.3 × 48.5 CM

EA 1963.46

Given by Miss Jessie M. Keith

2.21 Lobster fishing

HANDSCROLL, INK AND SLIGHT COLOUR ON SILK

TWENTY SEALS

47 × 316 CM

EA 1965.188

ex Seligman Collection

2.20

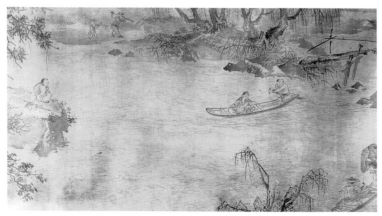

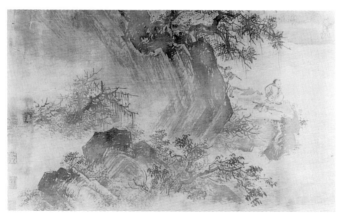

2.21
right to left,
top to bottom

2.22 Birds and lotus

1836

FAN PAINTING MOUNTED AS ALBUM LEAF, INK AND
COLOUR ON PAPER

ONE SEAL

D. 53.8 CM

EA 1965.238

2.23 Hunting expedition in the mountains

FAN PAINTING MOUNTED AS ALBUM LEAF, INK AND
COLOUR ON PAPER

D. 50 CM

EA 1965.239

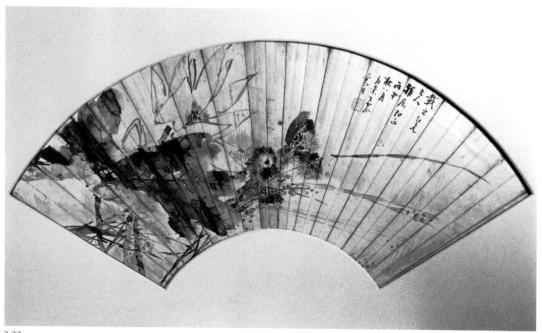

2.22

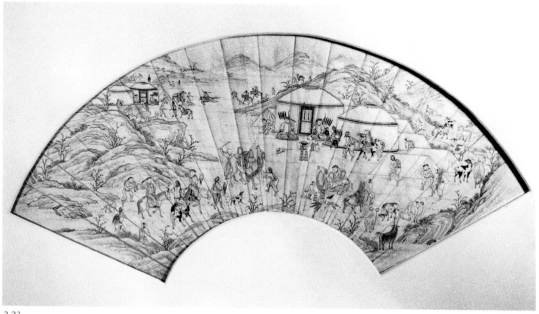

2.23

2.24 Insect and lily

FAN PAINTING MOUNTED AS ALBUM LEAF, INK AND
COLOUR ON PAPER

ONE SEAL

D. 50.8 CM

EA 1966.201

2.25 Roses and praying mantis

FAN PAINTING MOUNTED AS ALBUM LEAF, INK AND
COLOUR ON PAPER

TWO SEALS, ONE OF WHICH ALSO APPEARS ON 2.26 BELOW

D. 54.3 CM

EA 1966.202

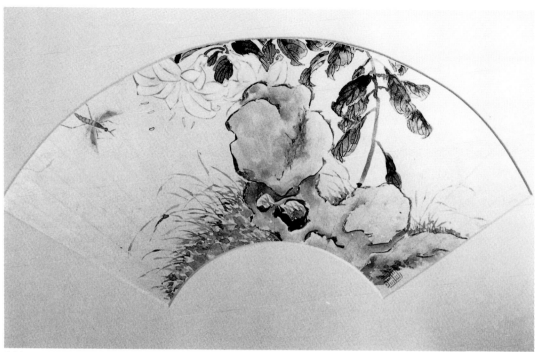

2.24

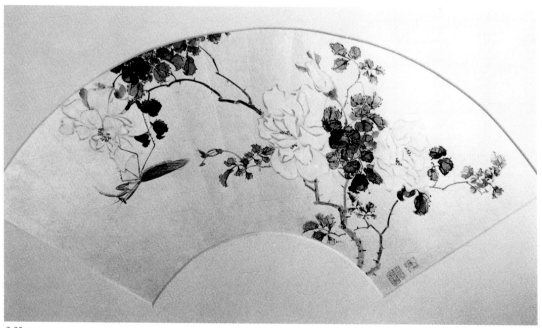

2.25

2.26 Lily and dragonfly

FAN PAINTING MOUNTED AS ALBUM LEAF, INK AND
COLOUR ON PAPER

D. 54.6 CM

ONE SEAL, WHICH ALSO APPEARS ON 2.25 ABOVE

EA 1966.203

2.27 Man playing a *qin* beneath a pine tree

FAN PAINTING MOUNTED AS ALBUM LEAF, INK AND
SLIGHT COLOUR ON SILK

D. 24.8 CM

EA 1972.24

Bequeathed by Mrs. Isabella Cohn

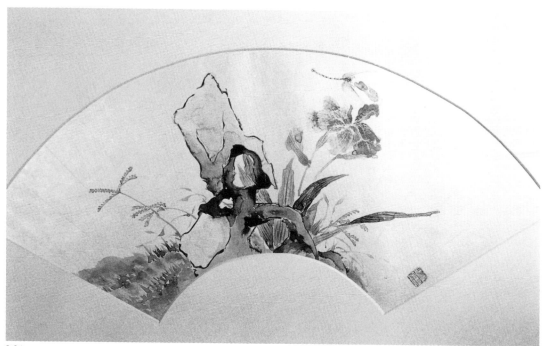

2.26

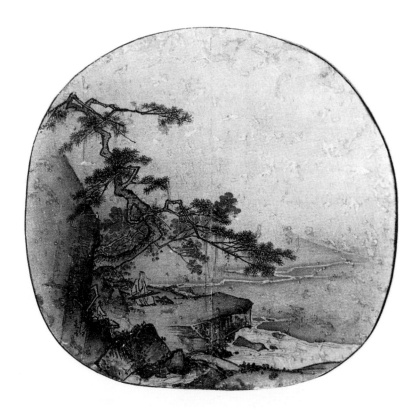

2.27

2.28 Young woman with fruit and flowers

FRAMED, INK AND COLOUR ON SILK

THREE SEALS

117 × 27.5 CM

EA 1980.144

Given by Peter Scarisbrick

2.28

CONCORDANCE
OF REYES AND CURRENT CATALOGUE
ENTRIES

Numbers with the prefix 'R' refer to catalogue entries in *Modern Chinese Paintings: The Reyes Collection in the Ashmolean Museum, Oxford*, Oxford, 1996.

Artist's name	Dates	Catalogue number
Bao Chenchu	1928–	R1, R2
Chan, Paul	1937–	1,2
Chen Chi Kwan	1921–	3
Chen Chongguang	1839–1896	4
Chen Fen	Qing	5
Chen Hengke	1876–1923	6,R3, R4
Chen Shaomei	1909–54	R5,R6
Chen Tianxiao	20th century	7
Chen Wenxi	1906–91	8, R7
Chen Zhe	20th century	9
Chen Zhifo	1896–1962	R8
Chen Zizhuang	1913–76	R9
Cheng Shifa	1921–	10, R10, R11, R12, R13
Cheng Waina	1946–	11
Chou Ch'eng	1941–	12
Chui Xiaoxing	1958–	13
Cui Zifan	1915–	R14
Dai Xi	1801–60	14, 15
Ding Yanyong	1902–78	16, R15
Dong Shouping	1904–	17, 18
Fang Zhaolin	1914–	19, 20
Fei Chengwu	1914–	21
Feng Zikai	1898–1975	R16
Fu Baoshi	1904–65	22, 23, 24, R17, R18, R19, R20, R21
Gai Qi	1774–1829	25
Gao Fenghan	1683–1749	26
Gao Jianfu	1879–1951	27, R22
Gao Made	1918–	R23, R24, R25
Gao Qifeng	1889–1933	28
Gao Qipei	1660–1734	29
Gao Yuan	Qing	30
Gu Tao	20th century	31
Guan Liang	1900–86	32, R26

Artist's name	Dates	Catalogue number
Guan Shanyue	1912–	33, 34, R27
He Tianjian	1890–1977	36
Ho Fung-lin	1944–	37, 38, 39
Hu Guoren	20th century	40
Hu Peiheng	1899–1962	41
Huang Aihong	1914–37	42
Huang Baoyue	20th century	R28
Huang Binhong	1864–1955	43, 44, 45,46, R29, R30
Huang Junbi	1898–1991	47, 48, 49, 50, 51
Huang Qiuyuan	1914–79	R31
Huang Shen	1687–1772	52, 53, 54
Huang Yongyu	1924–	R32, R33, R34
Huang Zhou	1925–	55, R35
Jia Youfu	1942–	R37
Jin Nong	1687–1763/4	56
Jin Xi	Qing	57
Jin Yuan	Qing	58
Kan Taikeung	1942–	R38
Kun Can	1612–1674	59
Lai Shaoqi	1915–	R39
Li Huasheng	1941–	R40, R41, R42
Li Juduan	1898–1961	60–71
Li Keran	1907–89	72, 73, 74, R43, R44, R45, R46, R47
Li Kuchan	1898–1983	75, 76, 77, 78
Li Shizhuo	c.1690–1770	79
Li Wenxin	1927–	80
Li Xiongcai	1910–	R48
Liang Chen	Qing	App.1.1
Lin Fengmian	1900–91	81, R49, R50, R51
Liu Haisu	1896–1994	R52
Liu Maoshan	1942–	R53
Liu Xiling	Qing	82
Lo Ch'ing	1948–	83
Lou Bai'an	1947–	R54
Lu Yanshao	1909–93	R55, R56, R57
Lu Zhi	1496–1576	84
Lui Shou-Kwan	1919–75	85–99
Luo Mu	1622–after 1704	100
Luo Xu	Qing	App.1.2
Luo Yang	Qing	101
Min Zhen	1730–after 1788	102, 103
Ni Tian	1855–1919	104
Nie Ou	1948–	R59
Pan Dinglan	Qing	105
Pan Tianshou	1897–1971	R60, R61

Artist's name	Dates	Catalogue number
Peng Xiancheng	1941–	R62
Pu Ru	1896–1963	R63, R64, R65
Qi Baishi	1863–1957	106. 107, 108, R66
Qi Gong	1910–	109
Qi Shukai	Qing	110
Qian Hui'an	1833–1911	111
Qian Ya (Shoutie)	1896–1967	112, R67, R68
Qian Songyan	1899–1985	113, R69, R70, R71
Qin Zhuquan	Qing	App.1.3
Qin Zuyong	1825–84	114
Ren Xiong	1820–57	R72
Ren Yi	1840–96	115, 116, 117, R73
Ren Zhenhan	1907–91(?)	R74, R75
Ru Bin	Qing	App.1.4
Ruan Linchuan	Qing	App. 1.5
Shang Rui	1634–after 1683	118
Shen Fuji	Qing	119
Sheng Maoye	c.1607–37	120
Shi Hu	1942–	R76, R77
Shi Lu	1919–82	R78, R79
Song Wenzhi	1919–	121, 122, R81, R82
Sun Xingge	1897–	R80
Tang Di	1878–1948	123
Tang Yun	1910–93	R83
Tao Yiqing	1914–	124, 125
Wang Geyi	1896–	R84
Wang Hao	Qing	126
Wang Qian	Qing	127
Wang Qingfang	1900–56	128
Wang Qiuling	Qing	App.1.6
Wang Si	1865–1925	129
Wang Weibao	1941–	130, 131
Wang Xuetao	1903–83	132, 133
Wang Yiting	1867–1938	R85
Wang Yumei	Qing	App. 1.7
Weng Tonghe	1830–1904	134
Wei Dong	1968–	R86
Wu Changshuo	1844–1927	138
Wu Guanzhong	1919–	R87
Wu Guxiang	1848–1903	R88
Wu Han	1876–1927	135
Wu Hufan	1894–1968	136, R89, R90
Wu Jingding	1904–72	137
Wu Qingyun	d. 1916–	139, 140, 141, 142, R91
Wu Shanming	1941–	143
Wu Zuoren	1908–	R92, R93

Artist's name	Dates	Catalogue number
Xiao Sun	1883–1944	144, 145, 146, R94
Xie Zhiguang	1900–76	R95
Xie Zhiliu	1910–89	147, R96, R97
Xu Beihong	1898–1953	R98, R99, R100, R101
Xu Gu	1823–96	R102, R103
Xu Lele	1955–	R104, R105
Ya Ming	1924–	150, R106, R107
Yang Borun	1837–1911	148
Yang Shanshen	1913–	R108
Yang Tianbi	Qing	149
Yang Zhengxin	1942	R109
Ye Keyin	Qing	App. 1.8
Ye Qianyu	1907–	R110
Yi Shaozuo	Qing	App. 1.9
Yi Yong	Qing	App. 1.10
Yin Xiaoxia	Qing	151
Yu Fei'an	1888–1959	153, R111
Yu, Jackson	1911–	R36
Yu Peng	1955–	R112
Yu Shaosong	1882–1949	152
Zeng Shanqing	1932–	154
Zeng You-He	1923–	155, 156
Zha Shibiao	1615–98	157, 158, 159, 160
Zhang Daqian	1899–1983	164, 165, R113, R114, R115, R116, R117, R118
Zhang Dengtang	1943–	161
Zhang Qizong	20th Century	162
Zhang Shuqi	1901–57	163
Zhao Shao'ang	1905–	R120
Zhao Wangyun	1906–77	166
Zhao Yunhuo	1874–1955	167
Zhao Zhunwang	1944–	R121
Zheng Wuchang	1894–1952	R122
Zhou Jingxin	1959–	R123, R124
Zhu Cheng	1826–1900	168
Zhu Wei	1966–	169
Zhu Xiuli	1938–	170, 171
Zhu Qizhan	1892–1996	R125, R126, R127

BIBLIOGRAPHY

BIOGRAPHICAL DICTIONARIES

Contag, Victoria, and Wang, Chi ch'ien, *Seals of Chinese Painters and Collectors of the Ming and Ch'ing periods: reproduced in facsimile size and deciphered*, with an introduction by James Cahill, revised edition with supplement, Hong Kong, 1966 (first published 1940)

Jin, Tongda, ed., *Zhongguo dangdai guohuajia cidian*, Hangzhou, 1992

Laing, Ellen Johnston, *Chinese Paintings in Chinese Publications, 1956–1968: An Annotated Bibliography and An Index to the Paintings*, Michigan Papers in Chinese Studies 6, Ann Arbor, 1969

Laing, Ellen Johnston, *An Index to Reproductions of Paintings by Twentieth-Century Artists*, Michigan Monographs in Chinese Studies 76, Ann Arbor, 1998 (first edition 1984)

Lu, Guojun, ed., *Dangdai shuhua zhuankejia cidian*, Beijing, 1994

Lingnanhua zhenglue, Hong Kong, Shangwu yinshuguan 1961

Molin jinhua, Shanghai, Zhongua shuju edn., 1923

Tsuruta, Takeyoshi, 'Index to Chinese Painters of the Last One Hundred Years', (in four parts), *Bijitsu Kenkyu*, no. 293, May 1974, p. 27–38; no. 294 July 1974, p. 29–34; no. 303 January 1976, p.22–37; no. 307, September 1978 p.21–37

Yu, Jianhua, ed., *Zhongguo meishujia renming cidian*, Shanghai, 1981

Yun, Ruxin, *Minguo shuhuajia huizhuan*, Taipei, 1991 (first edition 1986)

SELECTED GENERAL WORKS

Andrews, Julia F., *Painters and Politics in the People's Republic of China, 1949–1979*, Berkeley and Los Angeles, 1994

Andrews, Julia F. and Shen, Kuiyi, *A Century in Crisis: Modernity and Tradition in the Art of Twentieth-Century China*, New York, 1998

Brown, Claudia and Chou, Ju-hsi, *Transcending Turmoil: Painting at the Close of China's Empire 1796–1911*, Phoenix, 1992

Cahill, James, ed., *Shadows of Mt. Huang: Chinese Painting and Printing of the Anhui School*, Berkeley, 1981

Cleveland Museum of Art, *Eight Dynasties of Chinese Painting: The Collections of the Nelson Gallery-Atkins Museum, Kansas City and The Cleveland Museum of Art*, Cleveland, 1980

Cohen, Joan Lebold, *The New Chinese Painting 1949 – 1986*, New York, 1987

Edinburgh, Royal Scottish Museum, *Chinese Paintings from the Shanghai Museum Collection*, Edinburgh, 2000

Hajek, Lubor, Hoffmeister, A., and Rychterova, E., *Contemporary Chinese Painting*, trans. Jean Layton, London, 1961

Kao, Mayching, ed., *Twentieth-century Chinese Painting*, Hong Kong, 1988

Laing, Ellen Johnston, *The Winking Owl: Art in the People's Republic of China*, Berkeley and Los Angeles, 1988

Li, Chu-Tsing, *Trends in Modern Chinese Painting*, (The C. A. Drenowatz Collection), Ascona, 1979

Murck, Alfreda and Fong, Wen, ed., *Words and Images: Chinese Poetry, Calligraphy and Painting*, New York and Princeton, 1991

Silbergeld, Jerome, *Chinese Painting Style: Media, Methods, and Principles of Form*, Seattle and London, 1982

Sullivan, Michael, *Chinese Art in the Twentieth Century*, Berkeley and Los Angeles, 1959

Sullivan, Michael, *Art and Artists of Twentieth-Century China*, Berkeley and Los Angeles, 1996

Tsao, Jung Ying, *Chinese Paintings of the Middle Qing Dynasty*, San Francisco, 1987

Tsuruta, Takeyoshi, *Kindai Chūgoku Kaiga*, Tokyo, 1974

Washington, National Academy of Sciences, *Traditional and Contemporary Painting in China: A Report of the Visit of the Chinese Painting Delegation to the People's Republic of China*, Washington, D. C., 1980

ARTISTS' MONOGRAPHS

The monographs and exhibition catalogues listed below include publications both on artists represented in this catalogue and on those in the Reyes Collection, presented to the Ashmolean in 1995 and published in S. Vainker, *Modern Chinese Paintings: The Reyes Collection in the Ashmolean Museum, Oxford*, Oxford, 1996. In many of the publications, no author or editor is indicated; these appear under the artist's name or in the case of exhibitions, under the city and venue.

Ai 1981
Ai, Zhongxin, *Xu Beihong yanjiu*, Shanghai, 1981

Ai 1994
Ai, Zhongxin, ed., *Wu Zuoren zuopin ji*, Shenyang, 1994

Avitabile 1989
Avitabile, Gunhild, *Chao Shao-an: Ein Meister der südchinesischen Lingnan-Schule*, Frankfurt am Main, 1989

Bartholomew 1997
Bartholomew, Terese Tse, with Kao, Mayching and Lee, So Kam Ng, *The Charming Cicada Studio: Masterworks by Chao Shao-an*, San Francisco, 1997

Beijing 1979
Beijing, Gugong Bowuyuan, *Ren Bonian renwu huaniao ce*, Shanghai, 1979

Beijing 1982
Beijing, Zhaohua Publishing House, *Selected Paintings of Wu Zuoren and Xiao Shufang*, Beijing, 1982

Beijing 1988
Beijing, Morning Glory Publishers and Nanjing Museum, *Artist's Vision, Poet's Passion: The Paintings of Fu Baoshi*, Beijing,1988

Beijing 1991
Zhongguo Meishuguan, ed, *Huang Binhong jingpinji: Masterpieces of Painting by Huang Binhong*, Beijing, 1991

Brown and Chou 1992
Brown, Claudia and Chou, Ju-hsi, *Transcending Turmoil: Painting at the Close of China's Empire 1796–1911*, Phoenix, 1992

Cai 1960
Cai, Ruohong, *Ren Bonian huaji*, Shanghai, 1960

Chan 1977
Chan, Helen, *A catalogue of Chinese Paintings in the Luis de Camoes Museum, Macao*, Macau,1977

Chang 1970
Chang, Wan-li and Hu, Jen-mou, *The Selected Painting and Calligraphy of the Eight Eccentrics of Yangchow*, 8 vols., Hong Kong, 1970

Changsha 1982
Changsha, Hunansheng bowuguan, *Qi Baishi huihua xuanji*, Changsha, 1982

Chen n.d.
Chen Shaomei huaji, Beijing, n.d.

Chen 1961
Chen, Fan, ed. *Qi Baishi shiwen zhuanke ji*, Hong Kong, 1961

Chen 1964
Chen Wenxi, *Chen Wenxi huaji*, Singapore,1964

Chen 1980
Chen Shaomei huaji, Beijing, 1980

Chen 1981
Chen Chi Kwan Paintings 1940–1980, Taibei, 1981

Chen 1981a
Chen Zhifo huaji, Shanghai, 1981

Chen 1982
Chen Zizhuang zuopin xuan, Chengdu, 1982

Chen 1983
Chen Shaomei huaji, Changsha, 1983

Chen 1986
Chen Shaomei huaji, Tianjin, 1986

Chen 1987
Chen, Zizhuang, *Shi Hu huaji*, Tianjin, 1987

Chen 1988
Chen Zizhuang huaji, Sichuan, 1988

Chen 1996
Chen Zizhuang huaji: Paintings by Chen Zizhuang, Chengdu, 1996

Cheng n.d.
Cheng Shifa huaji, Beijing, n.d.

Cheng 1979
Cheng, Shifa, *Cheng Shifa huaniao xizuo*, Shanghai, 1979

Cheng-Ward, 1991
Cheng-Ward, Waina, *A Brush with Tao: The way to Harmony, Wildlife Paintings*, Singapore, 1991

Chongqing 1988
Chongqing shi bowuguan, *Qi Baishi yinhui*, Chongqing, 1988

Cui 1992
Cui, Junhao, ed. *Qi Baishi zhuanke yishu de yanjiu*, Taipei, 1992

Ding 1983
Ding, Yiyuan, ed., *Xugu yanjiu*, Tianjin, 1983

Ding 1989
Ding, Xiyuan, ed., *Ren Bonian: nianpu, lunwen, zhencun, zuopin*, Shanghai, 1989

Dong n.d.
Dong Shouping huaji, Beijing, n.d. (prob. 1979)

Edinburgh 1967
Edinburgh, Scottish National Gallery of Modern Art, *Loan Exhibition of Modern Chinese Painting, 3rd June to 2nd July*, 1967, Edinburgh, 1967

Fang 1951
Recent Paintings by Fang Zhaoling, Tokyo, 1951

Fang 1968
Fang, Chao-ling, *Fang Chao-ling: Paintings*, London, 1968

Fang 1972
Fang Zhaoling, *A World beyond all Books: Paintings and Calligraphy by Fang Zhaoling*, London, 1972

Fang 1981
Fang Zhaoling Painting and Calligraphy: Catalogue of an exhibition held in Beijing, Shanghai, Nanjing and Wuxi, with contributions by Fang Zhaoling, Han Suyin, Michael Lau and Luis Chan, Hong Kong, 1981

Fang 1983
Fang Zhaoling, *Portfolio*, Hong Kong, 1983

Fang 1988
*Chinese Painting by Fang Zhao Ling:Catalogue of an exhibition at Fung
Ping Shan Museum*, University of Hong Kong, Hong Kong, 1988

Fang 1992
Works by Fang Zhaoling, Hong Kong, 1992

Fang 1999
Fang, Zhaoling and Daisaku, Ikada, *Dengxin tianlai*, Hong Kong, 1999

Farrer 1992
Farrer, Anne, *Wu Guanzhong: A twentieth-century Chinese painter*,
London, 1992

Farrer 1995
Farrer, A., ed., *Contemporary Chinese Painting: The Art of Zhu Qizhan*,
London, 1995

Fei 1957
Fei, Chengwu, *Brush Drawing in the Chinese Manner*, London, The
Studio Publications, The How to do it Series, number 73, 1957

Feng 1956
Feng, Zikai, *Selections from Feng Tse-k'ai's Drawings of Children*, Beijing,
1956

Feng 1977
Feng, Zikai, *Selected Colour Cartoons of Feng Tzu-kai*, Hong Kong, 1977

Feng 1986
Feng, Zikai, *Zikai Fengjing huaji*, Beijing, 1986

Fu 1958
Fu Baoshi fangwen jiekesiluofake xiesheng zuopin xuanji, Nanjing, 1958

Fu 1960
Fu, Baoshi, *Zhongguo gudai shanshuihua shi de yanjiu*, Shanghai, 1960

Fu 1981
Fu Baoshi huaji, Shanghai, 1981

Fu 1983
Fu Baoshi hua xuan, Beijing, 1983

Fu 1991

Fu, Shen C.Y. and Stuart, Jan, *Challenging the Past: the Paintings of Chang
Dai-chien*, Washington DC, 1991

Fu and Guan 1964
Fu Baoshi, Guan Shanyue dongbei xiesheng huaxuan, Liaoning, 1964

Gai n.d.
Gai Qixiang Hongloumeng lin ben, Shanghai, n.d.

Gao 1977
Gao Jianfu huaji, Vol.1, no.38 in Wang Yunwu, ed., *Jingyin lidai shuhua
zhenpin ji*, Taipei, 1977

Gao 1983
Nanfushanren xiaowen cungao, Shanghai, 1983

Giacalone 1990
Giacalone, Vito, *The Eccentric Painters of Yangzhou*, New York, 1990

Gong 1982
Gong, Chanxing, ed., *Ren Bonian yanjiu*, Tianjin, 1982

Gu 1962
Gu, Linwen, *Yangzhou bajia shiliao*, Shanghai, 1962

Guan 1964
Guan Shanyue zuopin xuanji, Guangzhou, 1964

Guan 1979
Guan Shanyue huaji, Guangzhou, 1979

Guan 1984
Guan, Liang, *Guan Liang huiyi lu*, Shanghai, 1984

Guan 1991
Guan, Shanyue, *The Copy-Paintings of Dunhuang Murals by Guan Shanyue*, Hong Kong, 1991

Guangdong 1979
Guangdong guohua xuan, Guangzhou, 1979

Gugong 1979
Gugong Bowuyuan, ed., *Ren Bonian renwu huaniao ce*, Shanghai, 1979

Gugong 1992
Gugong Bowuyuan, *Haishang siren jingpin: Gugong Bowuyuan cang*, Hebei and Hong Kong, 1992

Guo 1980
Guo Moruo yimo, Shijiazhuang, 1980

Hangzhou 1999
Hangzhou, China National Art Academy, ed., *Lin Fengmian zhi lu (The Approach of Lin Fengmian)*: Lin Fengmian baisui danchen jinian, Hangzhou, 1999

Hangzhou 1999a
Hangzhou, China National Art Academy, *Lin Fengmian yu ershi shiji zhongguo meishu: guoji xueshu taolunhui lunwenji*, 2 vols., Hangzhou, 1999

He 1982
He Tianjian huaji, Shanghai, 1982

Hong Kong 1964
Hong Kong, City Hall Art Gallery, *Lui Shou Kwan*, Hong Kong, 1964

Hong Kong 1968
Hong Kong, City Hall Museum and Art Gallery, *Fu Pao-Shih*, Hong Kong, 1968

Hong Kong 1973
Hong Kong, City Hall Art Gallery, *Paintings by Ting Yen-yung: Selections from the Exhibition held at L'Universite Paris*, Hong Kong, 1973

Hong Kong 1979
Hong Kong Arts Centre, *A Retrospective Exhibition of the Works of Ting Yen-yung*, Hong Kong, 1979

Hong Kong 1980
Hong Kong Arts Centre, *An Exhibition of Works by Huang Binhong*, Hong Kong, 1980

Hong Kong 1981
Hong Kong, Hong Kong Museum of Art, *The Art of Gao Qifeng*, Hong Kong, 1981

Hong Kong 1981a
Hong Kong, Chinese University Museum, *Guangdong shuhua lu*, Hong Kong, 1981

Hong Kong 1985
Hong Kong, Fung Ping Shan Museum*, Hong Kong in Ink Mood: Landscape Paintings by Lui Shou-Kwan*, Hong Kong, 1985

Hong Kong 1986
Hong Kong, Ting Yen Yung Art Club, Hong Kong, *Professor Ting Yen Yung Works*, Hong Kong, 1986

Hong Kong 1987
Hong Kong, The Hong Kong Institute for the Promotion of Chinese Culture, and The Chinese Artists Association, Shaanxi Branch, *Shi Lu: A Retrospective*, Hong Kong, 1987

Hong Kong 1988
Hong Kong, Hong Kong Museum of Art, *The Art of Xu Beihong*, Hong Kong, 1988

Hong Kong 1994
Hong Kong, Plum Blossoms (International) Ltd., *Zhu Wei: The Story of Beijing*, Hong Kong, 1994

Hong Kong 1995
Hong Kong, Hong Kong Museum of Art, *Homage to Tradition: Huang Binhong 1865–1955*, Hong Kong, 1995

Hong Kong 1995a
Hong Kong, Hong Kong Museum of Art, *Lingnan Spirit: A Retrospective of Yang Shanshen*, Hong Kong, 1995

Horstmann Godfrey 1992
Charlotte Horstmann and Gerald Godfrey Ltd., *Weaving Farming Fishing Feasting: original watercolours of Yangtze Village Life*, Hong Kong, 1992

Horstmann Godfrey 1992a
Charlotte Horstmann and Gerald Godfrey Ltd., *Zeng Shan Qing*, Hong Kong, 1992

Hu 1994
Hu, Zhiliang, *Fu Baoshi zhuan*, Nanchang, 1994

Huang 1955
Huang Binhong shanshui huaji, Shanghai, 1955

Huang 1961
Chen, Fan, ed., *Huang Binhong hua yu lu*, Hong Kong, 1961

Huang 1961a
Huang Binhong hua yu lu, Shanghai, 1961

Huang 1962
Huang Binhong shanshui xiesheng ce, Beijing, 1962

Huang 1963
Huang Zhou zuopin xuanji, Beijing, 1963

Huang 1966
Huang, Junbi, *Huang Junbi huaji: di liuji: Paintings by Hwang Chun Pi*, n.pl., 1966

Huang 1978
Huang, Binhong et al., *Huang Binhong changyong yin ji*, Hangzhou, 1978

Huang 1980
Huang, Zhou, *Bai lu tu*, Nanjing, 1980

Huang 1980a
Huang Yongyu huaji, Hong Kong, 1980

Huang 1982
Huang, Yongyu, *Huajia Huang Yongyu xiangxi xiesheng*, Changsha, 1982

Huang 1984
Huang Binhong shanshui xiesheng, Hangzhou, 1984

Huang 1985
Huang, Yongyu, *Guanji zaji,* Hong Kong, 1983

Huang 1986
Huang Zhou's Paintings, Hong Kong, 1986

Huang 1987
Huang, Junbi, *One Hundred Paintings by Master Jun-Bi Huang*, New York, 1987

Huang 1988
Huang Zhou huaji, Shanghai, 1988

Huang 1989
Huang Yongyu, Hong Kong, 1989

Jiangsu 1985
Jiangsu meishu chubanshe, ed., *Yangzhou baguai huaji*, Jiangsu, 1985

Jin 1959
Jin, Nong, *Jin Dongxin hua xuan*, Beijing, 1959

Jin 1983
Jin Nong shanshui renwu: Landscapes and figure paintings by Jin Nong, Beijing, 1983. Reproductions of album leaves in the Palace Museum, Beijing

Jin 1985
Jin, Nong, *Jin Nong ce ye*, Nanjing, 1985

Kao 1993
Kao, Mayching, ed. *The Mei Yun Tang Collection of Paintings by Chang Dai-chien*, Hong Kong, 1993

Kao 1995
Kao, Mayching, ed., *The Art of the Gao Brothers of the Lingnan School, Guangdong Painting* Series 2. Art Museum, The Chinese University of Hong Kong, 1995

Kuo 1989
Kuo, Jason C. *Innovation within Tradition: The Painting of Huang Pin-hung*, Williamstown, 1989

Lai 1983
Lai Shaoqi huaji, Beijing, 1983

Lam 1972
Lam, Oi, *An Album by Huang Pin-hung*, Stockholm, The Museum of Far Eastern Antiquities Monograph series Volume 2, 1972

Leong 1991
Leong, Jane Wai Yee, *The Art of Dai Xi (1801–1860)*, Arizona State University, 1991

Li 1959
Li Keran shuimo shanshui xiesheng huaji, Beijing, 1959

Li 1962
Li Keran shuimo shanshui xiesheng huaxuan, Beijing, 1962

Li 1963
Li, Jitao, ed., *Gao Fenghan*, Shanghai, 1963

Li 1978
Li Kuchan huaji, Beijing, 1978

Li 1979
Li, Yu, ed., *Ren Bonian: Qing mo de shimin huajia, Zhongguo huajia congshu: 2*, Taipei, 1979

Li 1980
Li Kuchan huaji, Shanghai, 1980

Li 1981
Li Kuchan huaxuan, Shanghai, 1981

Li 1984
Li Xiongcai's Landscape Painting Manual, Guangzhou, 1984

Li 1985
Li Xiongcai huaji, Guangzhou, 1985

Li 1986
Li, Lang, ed., *Huajia Li Keran*, Beijing, 1986

Li 1987
Li, Xiang Ming, *Li Kuchan zhuan*, Chengdu, Zhongguo xiandai mingren zhuanji congshu, 1987

Li 1989
Li, Kuchan, *Kuchan huaxuan*, Shanghai, 1981

Li 1990
Li Keran: The Painter who spanned the Present Century, Hong Kong, 1990

Li 1994
Li Wenxin huaji, Chengdu, 1994

Liao 1982
Liao, Jingwen, *Xu Beihong yisheng: wode huiyi*, Beijing, 1982. Trans.
Zhang, Peiji, *Xu Beihong: Life of a Master Painter*, Beijing, 1987

Lin 1978
Lin Fengmian huaxuan, Shanghai, 1978

Lin 1979
Lin Fengmian huaji, Shanghai, 1979

Lin 1994
Lin Fengmian quanji (The Collected Works of Lin Feng Mian) 2 Vols.,
Tianjin, 1994

Lin 1994a
Lin, Shuzhong, ed., *Wu Changshuo nianpu*, Shanghai, 1994

Liu 1933
Liu Haisu guohua, Shanghai, 1933

Liu 1979
Liu, Gangji, *Huang Shen*, Shanghai, 1979

Liu 1981
Liu Haisu youhua xuanji, with an introduction by Zhu Jinlou, Shanghai,
1981

Liu 1983
Liu Haisu zuopin xuanji, Beijing, 1983

Liu 1984
Liu, Haisu, *Haisu yishu jiping: comments on Liu Haisu's Works of Art*,
Fuzhou, 1984

Liu 1992
Liu Maoshan zuopin xuan: Selected Works of Liu Maoshan, Hong Kong,
1992

Lo 1990
Lo Ching huaji, Taipei, 1990

Lo 1990a
Lo Ching shi hua (Paintings by Lo Ching), Taipei, 1990

Lo 1993
Lo Ching shuhua sanshinian zhan, Taipei, 1993

London 1969
London, South London Art Gallery, *Paintings by Lui Shou Kwan*,
London, 1969

Lu 1981
Lu Yanshao huaji, Hong Kong, 1981

Lu 1981a
Lu, Yanshao, *Zhongguo mingshan shengjingtu*, Shanghai, 1981

Ma 1990
Ma, Hongzeng, ed., *Qian Songyan yanjiu*, Nanjing, 1990

Nanchang 1992
Nanchang, Jiangsu sheng zhengxie, Xinyu shi zhengxie wenshi ziliao yanjiu weiyanhui, ed., *Fu Baoshi*, Jiangxi wenshi ziliao xuanji: 44, Nanchang 1992

Nanjing 1959
Nanjing Bowuyuan, ed., *Gao Qipei huace*, Nanjing, 1959

New York 1962
Sickman, Laurence, ed., *Chinese Calligraphy and Paintings in the Collection of John M. Crawford, Jr.*, New York, 1962

Nishida 1976
Nishida, Odo, *Collection of Poetry, Calligraphy, Painting and Seal-engraving by Ting Yen-yung*, Japan Shirajii College of Calligraphy, 1976

Oxford 1983
Oxford, Ashmolean Museum, *Ling Suhua: a Chinese painter and her friends*, Oxford, 1983

Pan 1979
Pan Tianshou huaxuan, Shanghai, 1979

Pan 1979a
Pan Tianshou zuopin ji, Hangzhou, 1979

Pan 1980
Pan Tianshou zuopinji, Hangzhou, 1980

Pan 1983
Pan Tianshou meishu wenji, Beijing, 1983

Pan 1984
Pan Tianshou ciye xuan, Hangzhou, 1984

Pan 1986
Pan, Gongkai, ed., *Pan tianshou pingzhuan*, Hong Kong, 1986

Pan 1996
Pan Tianshou shuhuaji, 2 vols., Hangzhou, 1996

Pan 1997
Pan Tianshou tanyi lu, Hangzhou, 1997

Pan 1997a
Pan Tianshou huaji, Taipei, 1997

Paris 1962
Paris, Musee Cernuschi, *Quelques Peintures de Lettres, XIV–XX siecles de la Collection Ling Su-hua*, Novembre 1962–Fevrier 1963, Paris, 1962

Paris 1973
L'Universite Paris VII, *Peintures et Sceaux de Ding Yanyong*, Paris, 1973

Pasadena 1995
Pasadena, Pacific Asia Museum, *A Collection of Paintings by Cui Zifan: A Contemporary Master of the People's Republic of China*, Pasadena, 1995

Pu 1996
Guancang Pu Xinyu shuhua: The Painting and Calligraphy of Pu Hsing-yu from the Collection of the National Museum of History, Taipei, 1996

Qi 1952
Qi Baishi huaji, (Rongbaozhai), 1952

Qi 1958 (?)
Baishi laoren xieji huace, Beijing (?), 1958(?)

Qi 1963
Qi, Baishi, *Qi Baoshi zuopinji*, (3 Vols.), Beijing 1963

Qi 1978
Qi Baishi huaji, Beijing, 1978

Qi 1980
Qi Baishi shufa zhuanke, Beijing, 1980

Qi 1982
Qi Baishi huaxuan, Beijing, 1982

Qi 1985
Qi Gong shufa zuopin xuan, Beijing, 1985

Qian 1979
Qian Songyan huaji, Beijing, 1979

Qian 1980
Qian Songyan zuopin xuanji, Beijing, 1980

Qian 1984
Qian Songyan huaxuan, Beijing, 1984

Qin 1985
Qin, Lingyun, *Yangzhou bajia conghua*, Shanghai, 1985

Rahman-Steinert 1996
Rahman-Steinert, Uta, *Chen Chi-Kwan, Geb. 1921: Chineisische Malerei*, Berlin, 1996

Ren 1962
Ren Bonian huaxuan, Beijing, 1962

Ren 1983
Ren Bonian shanmian huace, Shanghai, 1983

Ruitenbeek 1992
Ruitenbeek, Klaas, *Discarding the Brush: Schilderen zonder pensel: Gao Qipei (1660–1734) and the art of Chinese finger painting, en de Chinese vingerschilderkunst*, Amsterdam, 1992

Rychterova 1963
Rychterova, Eva, *Li Ko-jan*, Prague, 1963

Shanghai 1983
Shanghai Bowuguan, ed., *Xugu huace*, Chengdu, 1983

Shi 1979
Shi Lu huaji, Beijing, 1979

Shi 1984
Shi Lu zuopin xuanji, Beijing, 1984

Shi 1990
Shi Lu shuhuaji: Shi Lu – Painting and Calligraphy, Hong Kong, 1990

Silbergeld 1993
Silbergeld, Jerome and Gong, Jisui, *Contradictions: Artistic Life, the Socialist State, and the Chinese Painter Li Huasheng*, Seattle and London, 1993

Singapore 1949
Singapore, The China Society, Singapore, *Chen Wenxi huaji*, Singapore, 1949

Song 1963
Song Wenzhi zuopin xuanji, Beijing, 1963

Song 1985
Song Wenzhi shanshui huaxuan ji, Hefei, 1985

Stanford 1967
Paintings: Chang Dai-chien, with a preface by Michael Sullivan, Stanford University Museum, Stanford, 1967

Su 1980
Su, Xingjun, *Minghua jianshang: Wen Ji gui Han tu*, Shanghai, 1980

Taipei 1992
Taipei, National Palace Museum, *Ming Lu Zhi zuopin zhanlan tulu (Exhibition of selected works by the Ming dynasty painter Lu Chih)*, Taipei, 1992

Taipei 1996
Taipei, National Museum of History, *Qi Baishi huaji*, Taipei, 1996

Tang 1985
Tang Yun huaji, Shanghai, 1985

Teng 1976
Teng, Wei-hsiung, *Collection of Seals by Ting Yen-yung*, Hong Kong, 1976

Till 1987
Till, Barry, *The Art of/L'Art de Xu Beihong 1895–1953*, Victoria, B. C., 1987

Till 1988
Till, Barry, *The Art of Chao Shao-an*, Victoria, B. C., 1988

Tokyo 1914
Ko Shin gacho, Tokyo, 1914

Tokyo 1984
Go Sho seki jiten (Wu Changshuo dictionary), Tokyo, 1984

Tregear 1979
Tregear, Mary, 'The Four Seasons by Kao Ch'i-P'ei', *Oriental Art*, New

Series vol. xxv No. 1, Spring 1979, p. 60–61

Tsao 1993
Tsao, Jung Ying, *The Paintings of Xugu and Qi Baishi*, San Fransisco, 1993

Tseng 1957
Tseng Yu-ho: peintures recentes, Paris, 1957

Vainker 1996
Vainker, Shelagh, 'A Landscape by Fu Baoshi: Traditional Painting in modern China', *Apollo* vol. CXLIII No. 409 (New Series) March 1996, p.9–12

Vainker 1996a
Vainker, Shelagh, *Modern Chinese Paintings: The Reyes Collection in the Ashmolean Museum, Oxford*, Oxford, 1996

van der Meyden 1992
van der Meyden, Hans, 'The Life and Works of Ren Bonian (1840–1896): An Attempt to strip the artist's biography of some apocryphal fabrications', *Oriental Art*, New Series, vol. xxxviii, No.1, Spring, 1992, p.27–40

Wang n.d.
Wang, Gailu, *Huang Binhong xiansheng nianpu*, n.pl., nd.

Wang 1976
Wang, C.C., *Ch'i Pai-shih, The Vesatile Genius*, Fort Thomas, 1976

Wang 1979
Wang, Xuetao, *Xieyi huaniao caochong bufen*, Beijing, Rongbaozhai huapu series, 1979

Wang 1982
Wang Xuetao huaniao huaxuan, Shijiazhuang, 1982

Wang 1983
Wang Xuetao huaxuan, Beijing, 1983

Wang and Li 1984
Wang, Zhende and Li, Tianxin, ed., *Qi Baishi tanyilu*, Zhengzhou, 1984

Wang 1985
Wang, Jiwen and Wang, Bomin, ed., *Huang Binhong huaji*, Shanghai, 1985

Wang 1987
Wang Xuetao huaji, Beijing (Rongbaozhai), 1987

Wen 1936
Wen, Yuan-ning, *A Note on Mr. Kao Chien-fu's Paintings*, Reprinted for Editorial Commentary of T'ien Hsia Monthly, May, 1936

Weng 1935
Weng Songchan yi hua yi ce, Shanghai, 1935

Wong 1972
Wong, Shiu Hon, *Gao Jianfu hualun shuping (Gao Jianfu's theory of*

painting), Hong Kong, 1972

Wong 1979
Wong, Wucius, ed., *Lui Shou-kwan, 1919–1975*, Hong Kong, 1979

Woo 1986
Woo, Catherine Yi-yu Cho, *Chinese Aesthetics and Ch' Pai-shih*, Hong Kong, 1986

Wou 1987
Wou Tso-jen; ou la modernite dans la tradition de l'encre: Siao Chou-fang et les fleurs de Chine, Paris, 1987

Wu 1943 (?)
Wu Changshuo shuhuaji, n.pl., 1943 (?)

Wu 1958
Wu, Pu, ed., *Binhong caotang ben yin shiwen*, Hangzhou, 1958

Wu 1963
Wu Dongmai, ed., *Wu Changshuo*, Shanghai, 1963

Wu 1963a
Wu Jingding zuopin xuanji, Beijing, 1963

Wu 1978
Wu Changshuo zhuanke xuanji, Shanghai, 1978

Wu 1979
Wu Changshuo shigu wen moji, Shanghai, 1979

Wu 1979a
Wu Guanzhong huaxuan, Beijing, 1979

Wu 1979a
Wu Guanzhong caihua sumiao xuan, Tianjin, 1979

Wu 1981
Wu Changshuo xingshu zi tie, Hangzhou, 1981

Wu 1984
Wu Shanming huaxuan, Shanghai, 1984

Wu 1984a
Wu Guanzhong guohua xuan 2 vols., Chengdu, 1984

Wu 1987
Wu Hufan huaji, Shanghai, 1987

Wu 1991
Wu Hufan shanmian xuan, Shanghai, 1991

Wu 1996
Wu Zuoren, Zhongguo jinxiandai mingjia huaji, Beijing, 1996

Wu 1997
Wu Guanzhong huazhan tulu: Arts of Wu Guanzhong, Taipei, 1997

Xie 1980
Xie Zhiliu, Chen Peiqiu huaji, Hong Kong, 1980

Xie 1981
Xie Zhiliu huaji, Shanghai, 1981

Xu 1937
Xu, Beihong, *Xu Beihong huaji: di er ce*, Shanghai, 1937

Xu 1954
Xu, Beihong, *Xu Beihong huaxuan ji*, Beijing, 1954

Xu 1960
Xu Beihong youhua, with a preface by Ai Zhongxin, Beijing, 1960

Xu 1961
Xu, Xinyi, *Yangzhou baguai huaji: Paintings of the Eight Eccentrics of Yangzhou from the collection of the Nanjing Museum*, Wenwu chubanshe, 1961

Xu 1983
Xu Beihong: huiyi Xu Beihong zhuanji, Beijing, 1983

Xu 1984
Xu Gu huace, Beijing, 1984

Xu 1985
Xu Beihong sumiao, Beijing, 1985

Xu 1986
Xu, Yingzhang, *Gao Qipei nianbiao*, n.pl., 1986

Xu 1988
Xu, Chengwei and Wang, Zhongde, ed., *A Collection of Wang Yiting's Calligraphy and Painting*, Shanghai, 1988

Xu 1995
Xu Beihong Centenary Album: Collection of the Chang Family, Hong Kong, 1995

Xu 1997
Xu, Hong, *Pan Tianshou zhuan*, Hangzhou, 1997

Xue 1996
Xue, Feng and Xue, Xiang, ed., *Kun Can*, Changchun, 1996

Ya 1982
Ya Ming huaji, Nanjing, 1982

Ya 1985
Ya Ming jin zuo xuan, Fuzhou, 1985

Yang, 1979
Yang, Renkai, ed., *Gao Qipei*, Shanghai, 1979

Yang 1981
Yang Shanshen de yishu: The Art of Yang Shen-sum, Hong Kong, 1981

Yang 1986
Yang, Shu-hwang, *Xu Bei-hong, Liu Hai-su, Lin Feng-mian: Les peintres les plus importants de l'Ecole de Shanghai et l'influence de l'art francais*, Thèse de Doctorat du troisieme cycle, Presentee a l'Universite de Paris IV, Paris, 1986

Yang 1989
Yang, Renkai, *Gao Qipei huaji*, 1989

Yao 1968
Yao, Mungo K.L., ed., *Wu Changshuo Qi Baishi shuhua xuanji*, *Paintings of Wu Ch'ang Shuo and Ch'i Pai shih*, Taipei, 1968

Ye 1992
Yeh Ch'ien Yu, Hong Kong, 1992

Yu 1955
Yu, Fei'an, *Zhongguohua yanse de yanjiu*, Beijing, 1955

Yu 1988
Yu, Fei'an, trans. Silbergeld, J. and Mc Nair, A., *Chinese Painting Colors: Studies of their Preparation and Application in Traditional and Modern Times*, Hong Kong and Washington, 1988

Zhang 1959
Zhang, E. and Wu, Yige, ed., *Wu Changshuo huaji*, Beijing, 1957

Zhang 1984
Zhang Shuqi huaji, Beijing, 1984

Zhang 1984a
Zhang Daqian linmo Tunhuang bihua: Zhang Daqian's Reproductions of Dunhuang Frescoes, with a preface by Ye Qianyu, Hong Kong 1984

Zhang 1989
Zhang, Cixi, ed., *Qi Baishi de yi sheng*, Beijing, 1989

Zhao 1984
Zhao Shao'ang, *Zhao Shao'ang zuopin xuanji*, Beijing, 1984

Zhao 1985
Zhao Shao'an xiaopin xuanji: Album Paintings by Chao Shao-an, Taipei, 1985

Zheng 1990
Zheng, Chao and Jin, Shangyi, ed., *Lin Fengmian lun*, Hangzhou, 1990

Zheng 1991
Zheng, Zhong, *Xie Zhiliu xinian lu*, Shanghai, 1991

Zheng 1999
Zheng, Chao, ed., *Xi hu lunyi: Lin Fengmian ji qi tongshi yishu wenji*, 2 vols., Hangzhou, 1999

Zhu 1943
Zhu Zongyuan, ed., *Wu Changshuo shuhuaji*, n.pl., 1943

Zhu 1986
Zhu Xiuli huaji, Hong Kong, 1986

Zhu 1988
The Painting of Zhu Qizhan, New York, 1988